TALES FROM A GLOBALIZING WORLD

Edited by Daniel Schwartz

With 227 photographs, 118 in colour and 109 duotone

Thames & Hudson

DEZA
DDC
DSC
SDC
COSUDE

Under the auspices of
**SWISS AGENCY
FOR DEVELOPMENT
AND COOPERATION**
Swiss Ministry of Foreign Affairs

Texts by Thomas Kern, Cristina
Nuñez, Daniel Schwartz, Andreas
Seibert and Carsten Stütz
translated from the German
by David Wilson.

First published in the United
Kingdom in 2003 by Thames &
Hudson Ltd, 181A High Holborn,
London WC1V 7QX

www.thamesandhudson.com

British Library Cataloguing-in-
Publication Data
A catalogue record for this book
is available from the British Library

ISBN 0-500-28432-6

Printed and bound in Germany
by Steidl Verlag und Druck

HALF TITLE Migrant construction
workers in the Pearl River Delta
sometimes have nothing but a
bed on site. Phoenix City, China.
2002. Photo Andreas Seibert.

TITLEPAGE Stealth bomber on the
US Army cinema screen at SFOR
(Stabilisation Force) Eagle Base.
Bosnia-Herzegovina. 2002.
Photo Ziyo Gafic.

LEFT La Courneuve.
Chez Monsieur Fofana (Mali).
They came to Paris in 1963.
Photo Bertien van Manen.

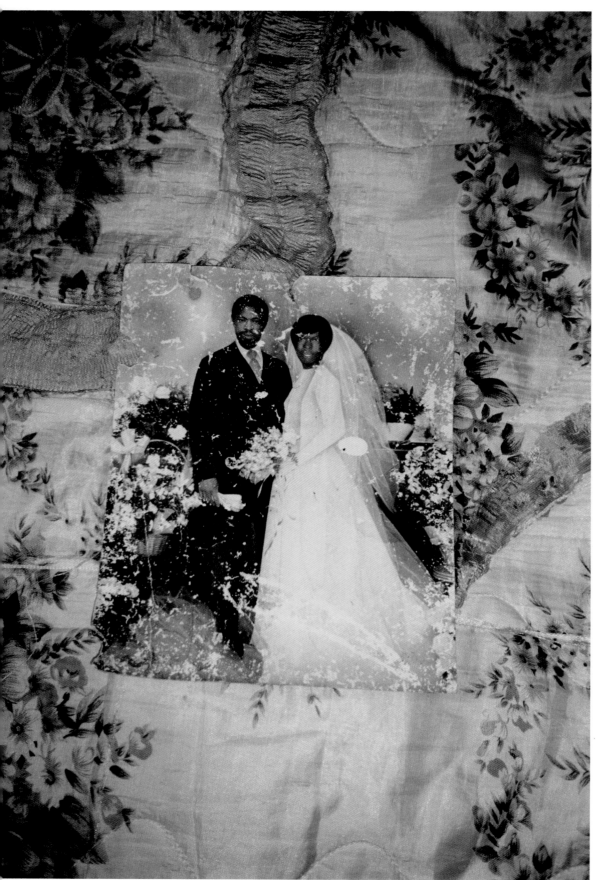

TALES FROM A GLOBALIZING WORLD

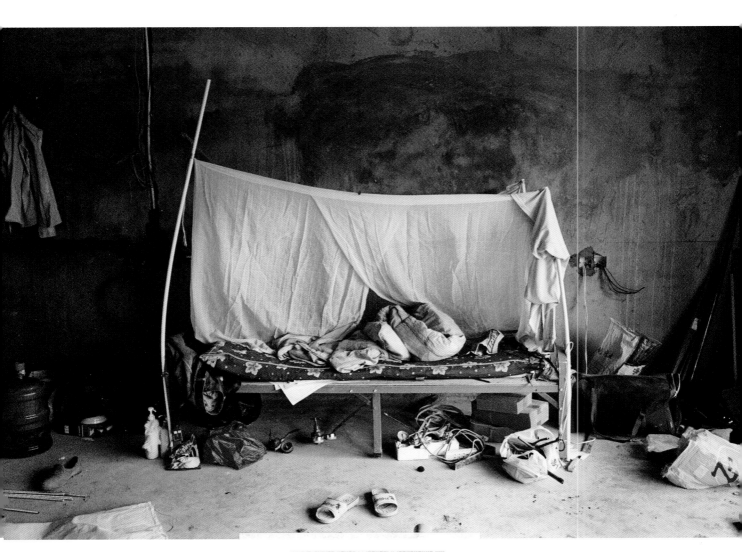

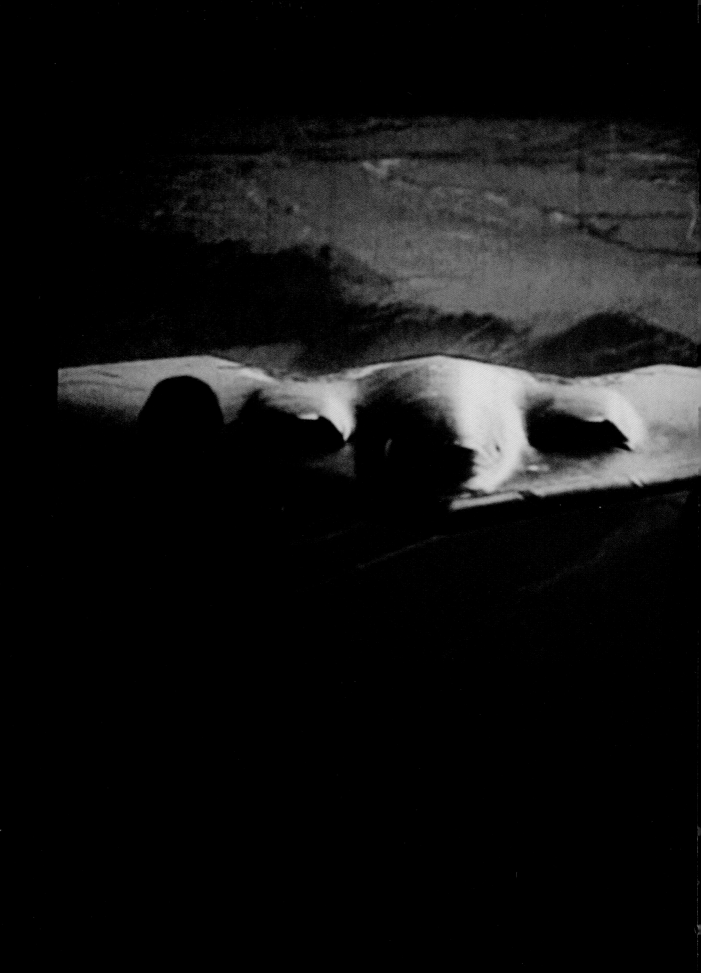

CONTENTS

ONE WORLD, OR SOMETHING OF THAT SORT
DANIEL SCHWARTZ

The sun had stopped shining on Borneo. The monsoon rains had evaporated before they reached the ground. The largest island in the archipelago lay wreathed in thick smoke. In Sarawak, Bandar Seri Bagawan, and beyond the sea in Singapore and on Sumatra schoolchildren wore protective masks. Under the blanket of smoke, the brown coal deposits were burning underground, setting fire to the roots of the last ironwood trees of the rainforest. The trees were still standing while inside they were turning into carbon. The fires were hard to locate and almost impossible to extinguish – but not because the satellites orbiting the earth above the Equator couldn't pinpoint them through the smoke. The fires spread along the woodcutters' roads which led to the illegal palm oil and banana plantations, and jumped across the slash-and-burn clearings on which the transmigrants depended, and through the rubbish dumps of the boom towns, deep into the very heart of the island. And there, right beneath the Equator, the satellite dishes on the longhouses were turned face up towards the invisible sky. The muezzin's call to evening prayers was cut short by a fit of coughing.

The Dyaks lived in this area. A few months earlier they had attacked Madurese immigrants because their domestic animals had been grazing on holy sites. And now these descendants of head-hunters, their fighting cocks in their arms, stood between the scorched market stalls and the skeletons of the rubber trees. They peered red-eyed through the slits in their woollen caps at the trucks taking the hardwood to the crumbling landing-stages on the Mahakan, or at the buses carrying the workers from Sulawesi, on the other side of the Makassar Strait, to the goldmine. This belonged to a multinational company. Its entrance was protected with steel gates, and Indonesian soldiers kept out trespassers.

Absolutely everything was in a state of total confusion. This was in April 1998.

November 1994. For a week I had accompanied a group of young people from the slums of Jakarta as they toured Indonesia's capital in search of a living. They worked as mobile teams – difficult for the authorities to catch. They sang and played music in the public buses, and they waited outside the supermarkets for rich women whose bags they could carry to the car park. They sold newspapers at the traffic lights on main roads, and at the port they collected lumps of ice from the fishing boats to sell to the restaurants. If they found any stray dogs,

they would beat them to death slowly with clubs to prevent the cramps that toughen the flesh, and then they burnt off the skin before cooking them under the bridges of the Ciliwung. Once a day we all went to a Kentucky Fried Chicken.

February 1998. The wave of arson attacks on Chinese property that began in the small towns on Java gathered speed on its way to Jakarta. The locals had hurriedly painted *Pribumi* (native) and *Milik Islam* (Muslim owner) on the whitewashed walls and closed metal shutters of their businesses, and in between lay the devastated properties targeted by the arsonists. Stinging clouds of smoke hung over the three-hundred-year-old Chinese pagoda in the Glodok district, where the members of this small but powerful ethnic minority had stuffed bundles of 'hell-money' into the stoves to ask the gods to save them and their goods from becoming the scapegoats of a collapsing economy. The police patrolled the streets in armoured cars, but were part of the problem rather than its solution. Rumours spread that the police and military had instigated these riots. The shelves of the pawnbroker's shops were loaded with plastic bags full of yellow gold and watches. At Sunda Kalapa port the boats, or *praus* were loaded with Thai rice

meant for the islands in the archipelago, but the plunging currency and the sharply rising prices had forced a suffering people into self-service: as the fifty-kilo sacks of rice were unloaded from the lorries, the porters slit them with their hooks, and young women from the slums in the neighbouring suburb of Tanjung Priok pushed their fingers into the holes and held up their plastic bowls to catch the trickling streams of grain. The ceaseless coming and going of the porters masked the theft, but in any case the supervisors paid scant attention.

The government mounted a PR campaign to save the rupiah. On the sides of petrol tankers stood the exhortation: 'Rupiah Yes. Dollar No', and in downtown Jakarta, Suharto had gigantic posters put up with the slogan 'Aka Rupiah' (I love the rupiah'). To prove how much Suharto loved the national currency, he summoned the press to record him exchanging foreign notes for rupiah. The *ulema* mounted a *jihad* against speculation and against the hoarding of basic foods – practices that were against the laws of Islam. Soon after that Jakarta went up in flames.

On the eve of Suharto's resignation, the migrants from the overpopulated rural regions of Java, who in 1994 were sorting

out rubbish along the tracks leading away from the Senen railway station, were still there, washing their dishes on the excrement-covered chippings just an arm's length away from the wheels of the passing trains. Their numbers had grown. In the slum district of Kota, fathers sat with their children and their rods, fishing in the plastic-choked, stagnant sewers that lay between the densely crowded hovels on their rotting black stilts. Cardboard had now been replaced by timber from the scaffolding around office blocks in the new business centres of the city, for whose sake whole housing estates had been razed to the ground. Now these towering symbols of the 'future tiger state of Asia' stood there as unfinished monuments to economic ruin.

The first to be hit by the crisis were the migrants from the archipelago. Nobody needed day labourers any more. They passed their time in the damp and darkness of the slums, the women suckling their children, and the men playing cards for greasy, crumpled rupiah notes. They had no legal possessions of their own. They had nothing to pawn, let alone to serve as security for credit which perhaps might have once been given by the dubious banking institutions now liquidated by

the government. These migrants had risked everything to come here, and had managed to settle themselves in the urban no-man's-land which belonged to no one, and for which there was no responsible administrative body. From this base, they had tried every possible means to gain access to the economic world. They belonged to the lowest economic class in what used to be called the Third World. Now they had fallen into the black holes of the fast-growing Fourth World. These pockets of social exclusion, developing in the North as well as the South, are increasingly becoming a global phenomenon of underdevelopment – growth without adequate development.

Not far away from these migrants sat the transnational nomads of the First World, freezing in the air-conditioned lobbies of the grand hotels. Their discussions were accompanied by the rushing sound of fountains tumbling from grotesque heights, the shallow classical tinklings of the pianist beneath the sweeping curves of the marble staircase and the dulcet tones of the string quartet

surrounded by the heavily laden dessert trolleys. What they were discussing was the deferral of credits from the World Bank and the Asian Development Bank, and the tactics of a besieged President Suharto as he struggled to soften the austerity measures demanded by the International Monetary Fund and the controversial plan of a currency board to peg the rupiah to the dollar. How long would companies from the Northern hemisphere leave their regional representatives here? Would it be better to send their families home before a total descent into chaos? These were the subjects discussed by the global movers and shakers on those last days as they stood pissing at their reflections mirrored in the stainless steel men's cloakroom of the Café Batavia the smartest of restaurants in a colonial building of old Jakarta, left over from the days of Dutch rule.

In Joseph Conrad's novel *Victory* (1915), the Tropical Belt Company goes bankrupt: 'The world of finance is a mysterious world in which, incredible as the fact may appear, evaporation precedes liquidation.' The action takes place in Surabaya

on Java, and on Samburan – the name Conrad gives to Pulau Laut, an island off Borneo which now belongs to Indonesia. For the benefit of its shareholders, the Company had earlier printed a prospectus: 'On it Samburan was represented as the central spot of the Eastern Hemisphere with its name engraved in enormous capitals. Heavy lines radiated from it in all directions through the tropics, figuring a mysterious and effective star – lines of influence or lines of distance, or something of that sort.'

Even in its earlier phases, globalization was difficult to pin down. Then as now, abstract plans illustrated the system of worldwide production and distribution, but they say nothing about local conditions, and very little of note about winners and losers. Nothing, for instance, about today's factory towns outside Jakarta. The Indonesian women glueing brand-name sports shoes together are working not to buy these shoes but rice and cooking-oil, whose prices had rocketed sky high.

On my first visit to Jakarta in 1994, my subject was the effects on Java of

migration to the cities. A visible phenomenon. A regional, Third World phenomenon. In 1998, there was the agony of a national economy built on nepotism, locked into the global financial structure and, through a fault in the system, driven to the point of total collapse. An invisible phenomenon. The object of my assignment – money and values – had 'evaporated', even as a virtual entity. A global phenomenon. It is one of the trends that, cumulatively, are beginning to give our modern world a new geography, covered with crisscrossing streams: the mass movement of migrants trying to escape from hunger or war, or to find a better life; the rows of binary figures rushing through fibre-optic cables to form the virtual structures of the financial world; the flow of products whose individual components are manufactured separately thousands of miles apart, and transported in containers unchecked by any authority until they arrive to be assembled and then shipped out again; interactive operations across vast distances day and night, disregarding time zones; the dissemination of bacteria, viruses, spores, through modern

air travel; the ceaseless reproduction and communication of knowledge; the flood of toxic, nuclear, technological waste; the networks of terrorists and their opponents.

The commission in 1994 to document the situation in the slums of Jakarta came from the Swiss Agency for Development and Cooperation (SDC) of the Swiss Ministry of Foreign Affairs, and was part of a group project. Since then SDC has supported a series of photography projects involving authors and institutions from both the South and the North. It was Walter Fust, SDC Director, who in 2001 initiated *Tales from a Globalizing World*. Knowing of my own photographic projects on globalization, started in the mid-1990s, Mr Fust proposed that, under the auspices of SDC, I should conceive, curate and produce a group project on the theme.

This book is the result of a vision shared by a group of people, and also of the actual process of carrying out this extraordinary project. All concerned in it were totally committed and gave of their best. While our aim was to create a thoughtful and coherent book, the finished work can only be one of

many different approaches to a subject characterized by constant change. *Tales from a Globalizing World* takes into account the impossibility of effectively contributing to the discussion on the process of globalization through the eyes of a single observer. In order to be able to visualize the faultlines of globalization and its constructive and destructive forces, there was perhaps no alternative but to compose several pieces putting forward distinctive viewpoints that both comment on and complement one another. The project therefore brings together ten photographers who in terms of cultural background, journalistic experience as well as artistic strategies could not be more diverse. By uniting their individual photographic perspectives, the project combines selected facets of globalization to build a picture of the new reality that is shaping the increasingly fast-changing world we live in.

ANDREAS SEIBERT SOMEWHERE FROM NOWHERE

The future belongs to the city. By 2020 it is predicted that two-thirds of the world's population will be living in cities. In the south Chinese Pearl River Delta, a megalopolis is taking shape whose dimensions will exceed anything that has ever been seen before. There are already between 40 and 50 million people living in this massive conurbation, which is being developed as a bridgehead between the national Chinese economy and that of the world market.

Within the fifty thousand square kilometres, nineteen thousand square miles, that make up the Pearl River Delta in the southern Chinese province of Guangdong, a new city of unknown dimensions is rising up out of the soil. At the moment you won't find it on any map, and satellite pictures of the Hong Kong-Shenzhen-Guangzhou-Zhuhai-Macao region will at present show you only the outline of twenty-six large towns which are rapidly expanding towards one another. In the near future, the countryside that separates these towns will no longer exist. Instead of the towns, there will be one single conurbation, which will change the course of global trade and global capital. This process is being driven by two vital factors: the influence and consequences of globalization, and the phenomenon of migrant workers. The two go hand-in-glove.

Twenty years ago, Guangdong was a poor province – peasant country, ignored by Peking. Places like Dongguan, which now has a population of a million, did not even exist. In 1978, Communist China began very cautiously to open up its markets, and Zhuhai – near Macao – and Shenzhen, a sleepy little town of 20,000

basking across from Hong Kong and living mainly on its fishing industry, were suddenly declared 'special economic zones'. Business people came from Taiwan and Hong Kong, although the delta still remained a small enclave where the economic planners experimented with the free market. But all this changed in 1992, when Deng Xiaoping gave his official blessing to the economic development of the province. Since then foreign capital has flooded into Guangdong. Transforming the delta into a world trading area necessitates a new infrastructure to cope with the massive increase in goods and communications, and so there are now several airports under construction and new container ports that will combine to make up the biggest dock facility in the world; motorways and bridges are being built, and a system based on fibre-optics is being set up in addition to the telecommunications system. The Pearl River Delta region is now attracting no less than 30 per cent of all foreign investment, and is producing 40 per cent of all Chinese exports – and that's without counting Hong Kong. In just twenty years, the 20,000 inhabitants of Shenzhen have grown into four million.

There is a lot to do in the Pearl River Delta. Workers are in demand, and China has plenty. Already over 100 million Chinese have left their villages in the poorer provinces to seek their fortune here. They stream into the towns, looking for work and often arriving with nothing at all to their names. They rarely have residence permits, and are desperate for jobs. They have as few rights as they have possessions, and many lack the experience to deal with life outside their own familiar surroundings. Many of them fall victim to unscrupulous business people, and things are not made any easier by the fact that all the good jobs are usually kept for the locals. The *min gong*, or 'people's workers' as these migrants are called in China, can only get the work that nobody else wants to do.

The personal stories that they told me were all very similar. Back in their villages there is not enough work, or even no work at all. They can see no future living in the country, and then they hear from friends, or sometimes through the papers or TV, that there's money to be had in the cities, and especially on the coast. They go with these friends or acquaintances who have found themselves a niche in the town, and

present themselves on the labour market. And so it often happens that when you go to factories, building sites or docks, you find whole groups of workers from the same place. But very few of them intend to stay for ever in the town. Their goal is to return home to their village as soon as they've earned enough to build a house or set up their own business. If they don't fall ill, or have an accident, or lose their job, this can take them a minimum of five years. If they do go back home, they take with them not only money but also experience and, in the more successful cases, connections who will help them establish their own businesses. The migrant worker who returns to his rural village is often made for life, but only in his own village.

The first time I visited the Pearl River Delta, I fully expected to find a lot of disillusioned victims of exploitation. But, to my surprise, the migrant workers I spoke to very rarely complained about their situation. Even if many of them had been brought down to earth, and some were openly disappointed because they'd thought it would be a lot easier to make money, hardly anyone was even thinking of breaking camp and going home. Certainly not the taxi driver who told me how stiff the competition was in Guangzhou, and who owned his taxi, sharing it with a colleague who did the night shift. And not the young and ragged dock worker who was spending his day off playing billiards with a friend in a little restaurant. And not the man from Sichuan Province who, in order to pay his children's school fees, was working twenty-four hours a day as a watchman at a closed-down building site in the 'special economic zone' of Zhuhai.

The fact that the *min gong* are resigned to their fate, however, certainly doesn't mean that they're happy with it. I don't go along with the view that I kept hearing from the local inhabitants – that the migrants came to the town of their own free will, nobody forced them to do this work, and they were better off here than back home in the country. The fact that they left their villages of their own accord and can earn better money here does not in any way justify the conditions under which they now have to live. And yet it has to be said that when the migrants compare their present working conditions with what they've left back home – and what else can they compare them with? – they describe their current situation as 'pleasant'. Anyone who knows anything about the dreadful conditions in the poor Chinese provinces can scarcely be surprised.

Economists point to the cautious and considered manner in which the Chinese are transforming their Communist planned economy into an open market. There can be no doubt that most Chinese are better off now than they were twenty years ago, but at the same time the gulf between levels of pay has widened alarmingly in this relatively short period. For instance, a young electrical engineer in Guangzhou will have no trouble at all finding a job that will pay him 7000 renminbi ($840) a month, whereas a farm labourer in a poor province will be lucky to earn more than 300 renminbi ($36).

The demand for workers will remain high for the foreseeable future, but the numbers of migrant workers will continue to rise. In the circumstances, there can be little hope of any improvement in their living conditions. If there are five workers available for every job, wages are bound to remain low. It is estimated that in ten years there will be 200 million people coming from the villages in the hinterland to look for work in the towns, and they will earn their money cleaning windows, sweeping the streets, working on building sites. The profits from all this will go to the businessmen and the exporters.

Whenever people talk about the growing inequalities of Chinese society, the point is always made that the widening gap between town and country must be reduced, and that the country needs a more intensive process of modernization. Today it is the migrant workers who are mainly responsible for bringing money back into the stagnant rural regions. But when it comes to getting a fair share of the profits that they are helping to create, they remain outsiders.

This is a situation that needs to be taken seriously, because this growing inequality is potentially a source of dangerous unrest: it can never be good for society if its most honest and most enterprising members suddenly find themselves thrust into the worst possible conditions.

THEY COME FROM THE IMPOVERISHED RURAL PROVINCES in the Chinese hinterland (overleaf). Many of them set out for the cities five or even ten years ago in the hope of improving their job prospects. They work on building sites and in factories, become porters or lorry drivers, clean windows or scavenge in the rubbish dumps. The *min gong*, as these migrant workers are called, are generally looked down on in China. Estimates put the number of workers on the move today at around 100 million. Guangzhou, China. September 2002.

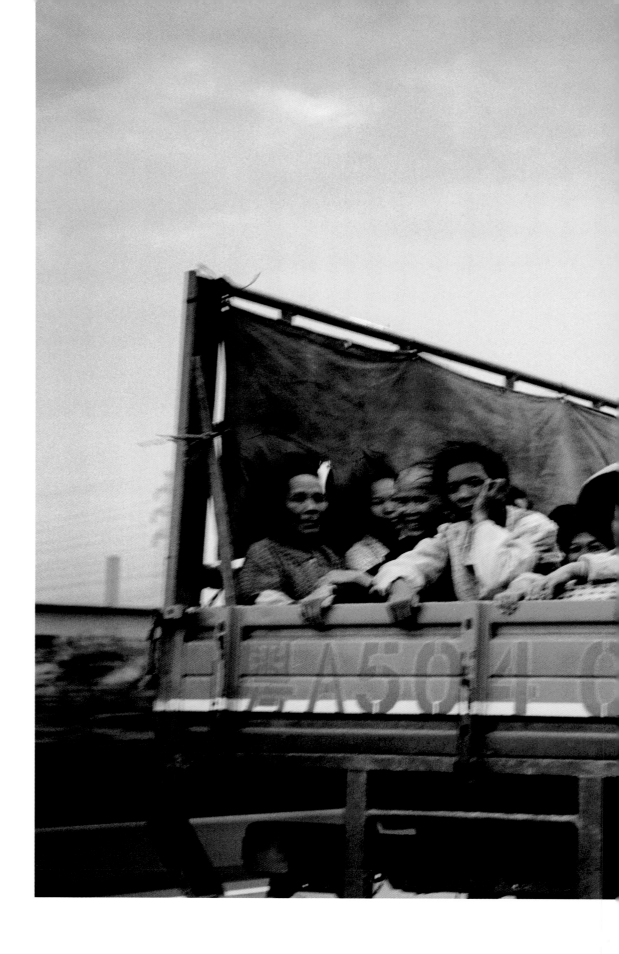

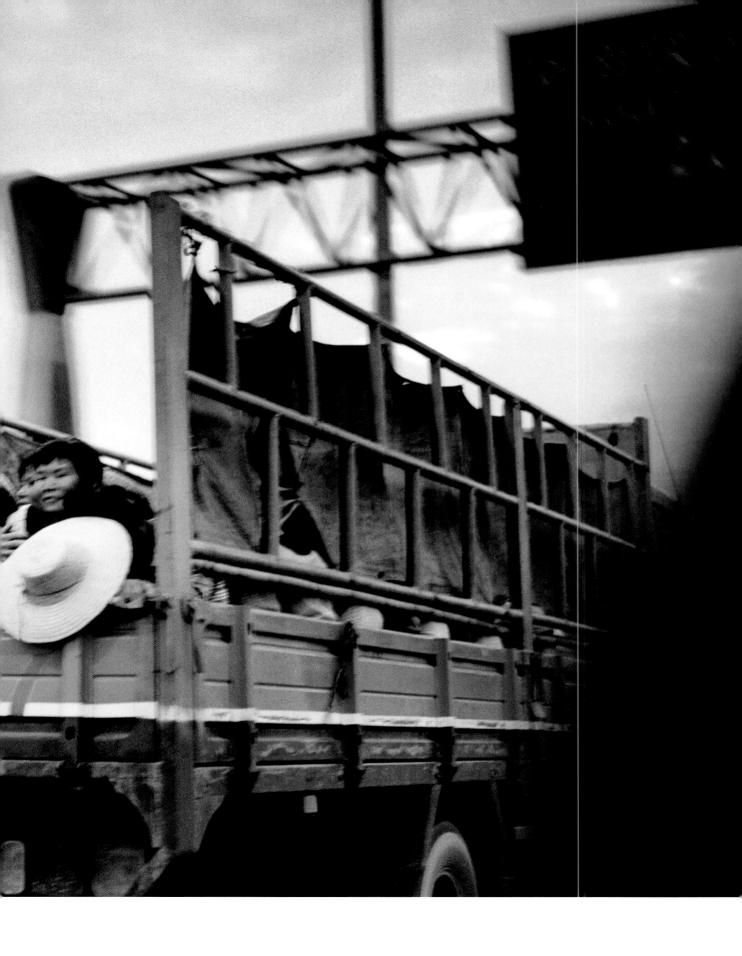

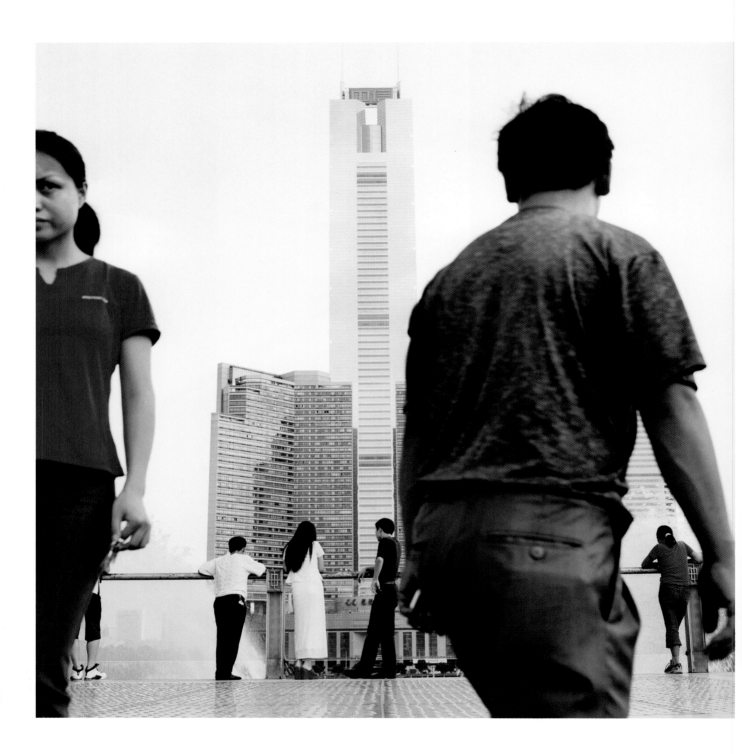

WITH A POPULATION OF SIX MILLION,
Guangzhou aims to replace Hong Kong as a trade and finance centre. Since central government in Peking gave the go-ahead in 1992 for the development of a free market economy in the southern provinces, capital investment has flooded into the Guangzhou-Shenzhen-Macao-Zhuhai-Hong Kong region. The number of large towns has grown from five to twenty-six in the last twenty years – a process that has been further accelerated since Hong Kong and Macao were handed back to China. The Pearl River Delta is currently producing around 40 per cent of all goods exported from China, and it is absorbing a third of all direct foreign investments. Observers speak of a 21st-century Manchester.

In the near future, the towns, which are still separated by a rural belt, will have expanded into one gigantic conurbation. The tallest building in Guangzhou is still an attraction. People come to gaze at it in astonishment, and can hardly believe that it is real. Guangzhou, China. September 2002.

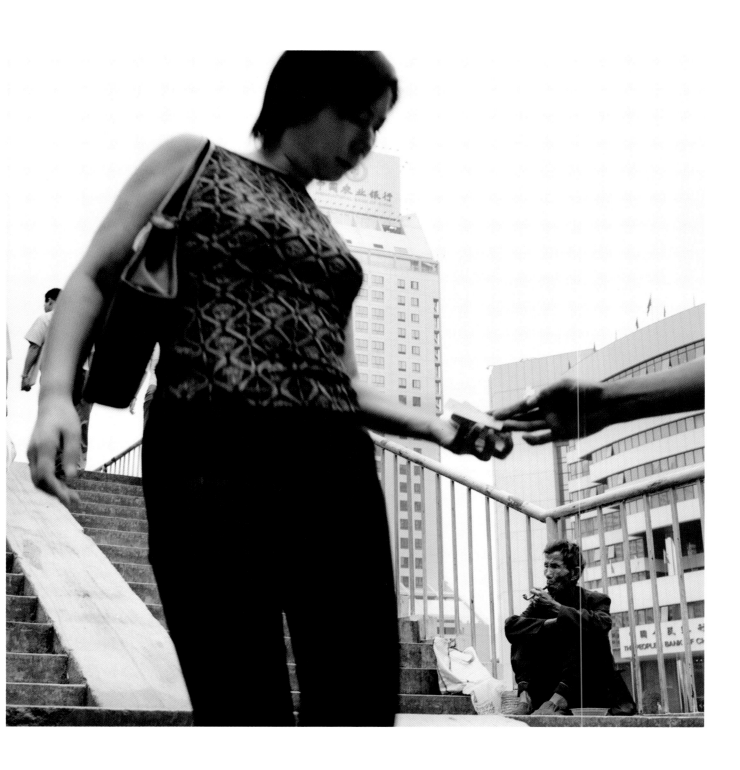

PUBLICITY MATERIAL IS HANDED OUT from the Stock Exchange in the 'special economic zone' of Shenzhen. The boom has resulted in a continuing demand for labour in the Pearl River Delta. It is estimated that the number of people currently living here is around 46 million. In many of the towns, more than half are without official residence permits. They come from the poor provinces in the hinterland, and many of them previously worked on the land. Shenzhen, China. September 2002.

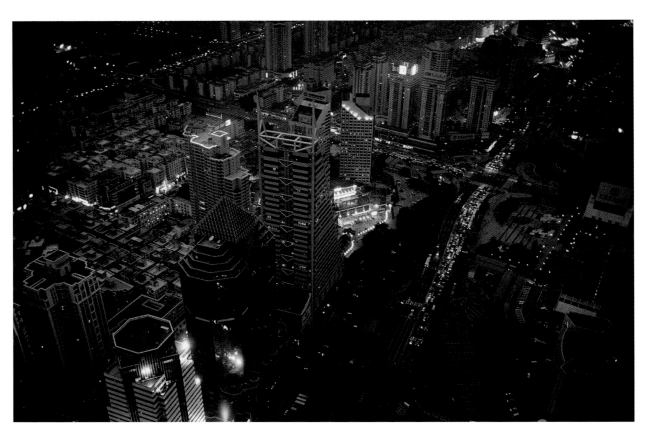

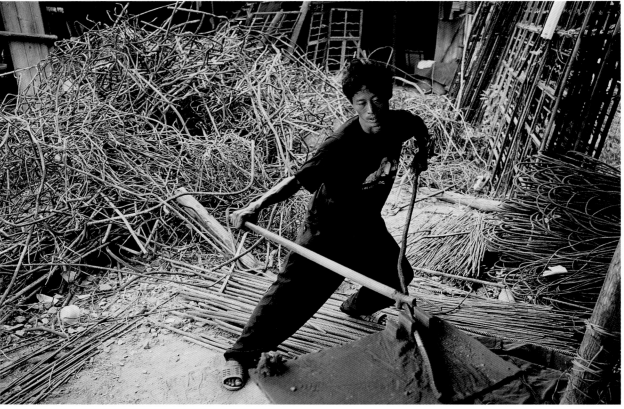

SHENZHEN WAS AWARDED the status of 'special economic zone' in 1978 as part of China's initial, cautious approach to opening up the market (opposite, above). At the time, Shenzhen had a population of around 20,000, most working in the fishing industry. Today the area produces watches, toys, microchips, CDs, shoes, designer jeans, TV sets and fake handbags bearing the logos of Italian fashion houses. There are now four million people living in Shenzhen, and there is no end in sight to this population explosion – the city is one of the fastest expanding industrial zones in the world. Shenzhen, China. September 2002.

TRAVELLING THROUGH the Pearl River Delta is like travelling through waste country. Sometimes the whole region seems like one gigantic building site. Between fields of rice and plantations of lemon and bananas, there are housing estates, factories, shopping centres and golf courses. Many of the migrant workers who come to the Pearl River Delta looking for employment find it on the building sites. In a little tumbledown workshop, reinforcing steel from demolished buildings is processed for reuse (opposite, below). The pieces are bent in a machine, and then they are sold to be used on one of the countless building sites. Foshan, China. September 2002.

OLD TRADITIONAL QUARTERS are torn down and replaced by huge modern blocks. Just as they were a hundred years ago, the houses are often demolished without the aid of machines, simply with sledgehammers and muscle power (right). China has plenty of hands to do the work. Guangzhou, China. September 2002.

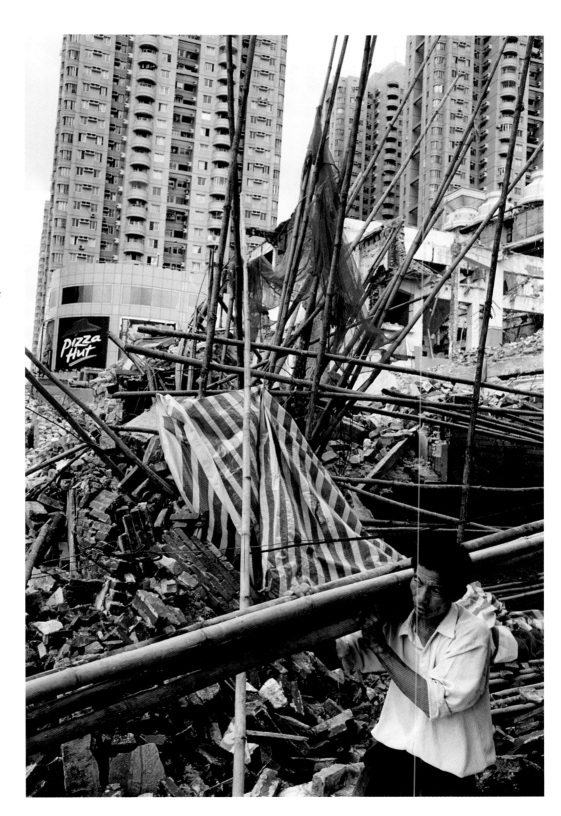

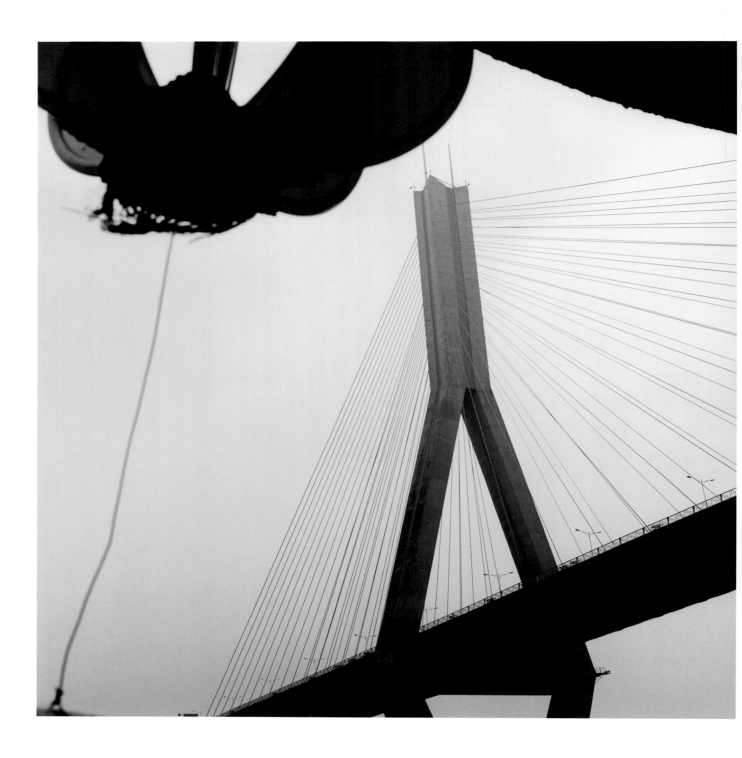

THE PEARL RIVER DELTA is only partially linked to the national economy of China: many of the goods that are produced here are for export to the rest of the world. The infrastructure that will connect the region to the global system of trade and finance is still not fully in place. Factories and workshops are scattered all over the 50,000 square kilometres of the region, and the vast urban sprawl is still split up by rural settlements, farmland and wasteland. At the moment there are five airports under construction, along with several container ports, all of which will eventually combine into the biggest port capacity in the world. Motorways and bridges over the various arms of the river will provide essential connections between the different sections of the system. Bridges such as the one at Guangzhou will replace the old ferries that still carry cyclists and pedestrians across the river.
Guangzhou, China. December 2002.

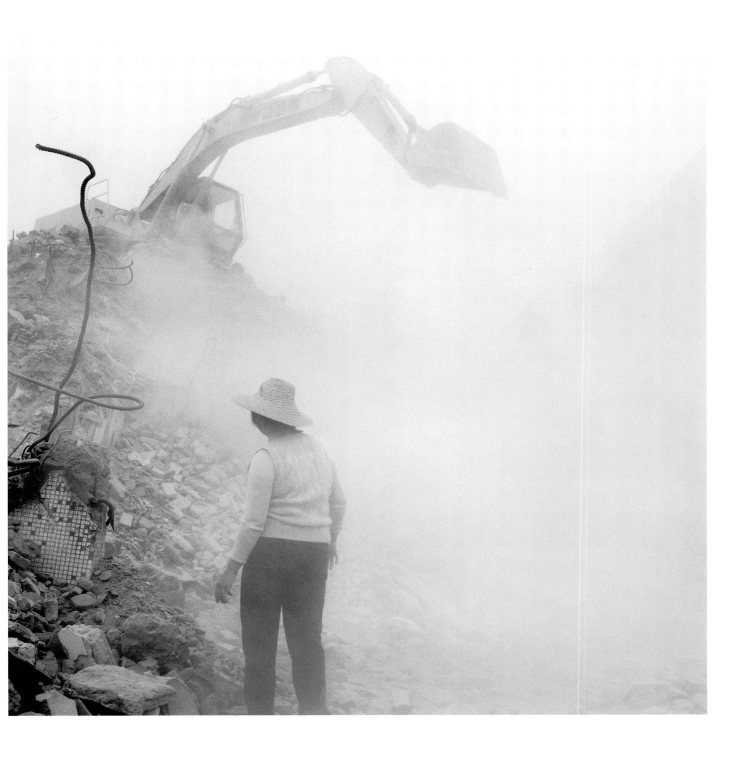

THE AIR IS SO THICK that you could almost cut it with a knife. Twenty years ago, Dongguan – now a city with a population of a million – did not even exist. When I was about to take a photograph of one of the smoking factory chimneys, a man came up to me and introduced himself as the mayor. He asked me not to take any photos. Obviously he was afraid that I might damage the city's image. Even houses that are no more than fifteen years old are being demolished to make way for new and bigger buildings. Women migrants collect pieces of reinforcing steel from the rubble in order to sell them. Dongguan, China. December 2002.

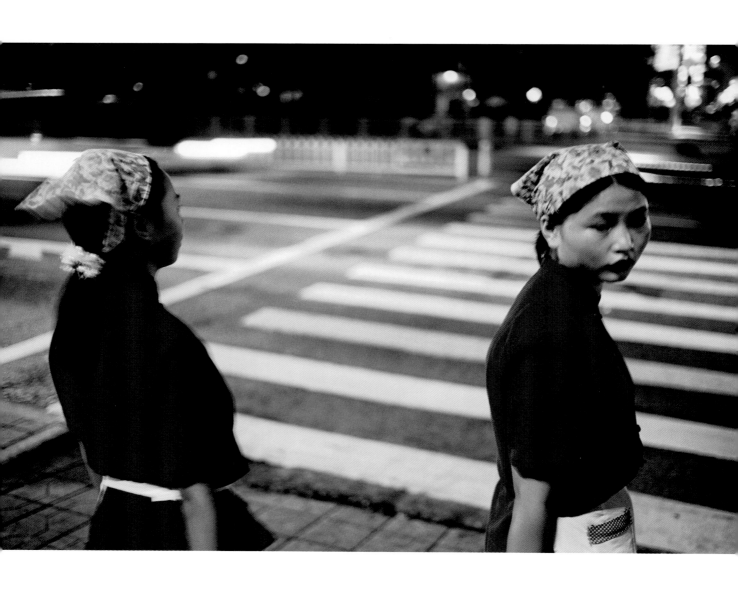

TWO WOMEN MIGRANT WORKERS at night
in the 'special economic zone' of Shenzhen.
Guangdong Province, China. September 2002.

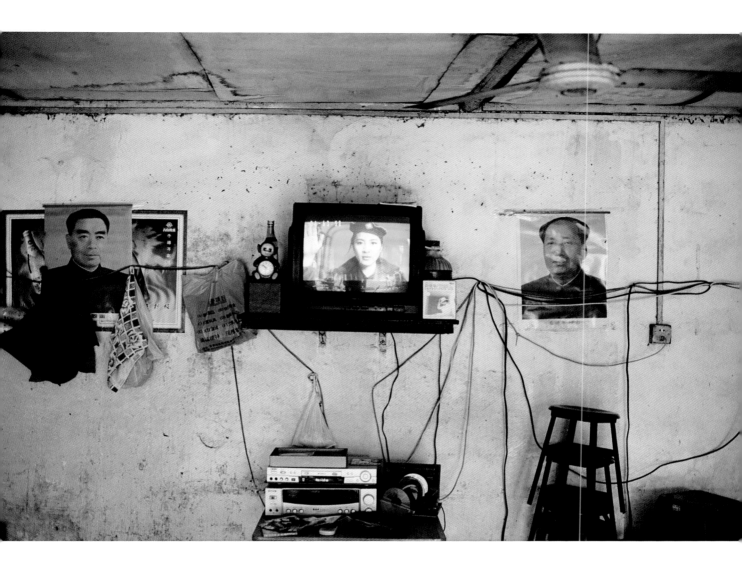

ON THE SOUTHERN SIDE OF GUANGZHOU,
Party Chairman Mao Zedong meets President Zhou
Enlai in an empty restaurant, while the television
continues to entertain the non-existent customers.
Guangdong Province, China. December 2002.

I MET THIS MIGRANT WORKER on the building site at Nansha, where a new port is under construction. He was from Hunan Province, and was searching the area for bits of steel, wire and any other materials that he could sell. I asked him how much he earned in a month. My interpreter repeated the question several times, but he didn't seem to understand. Later his wife turned up, and said that she and her husband lived from this work, which enabled them to put aside 400 renminbi ($48) a month. In the background is a large sign on the front of an unfinished building: 'We are constructing a five-star hotel and only use the very best materials.'
Guangdong Province, China. December 2002.

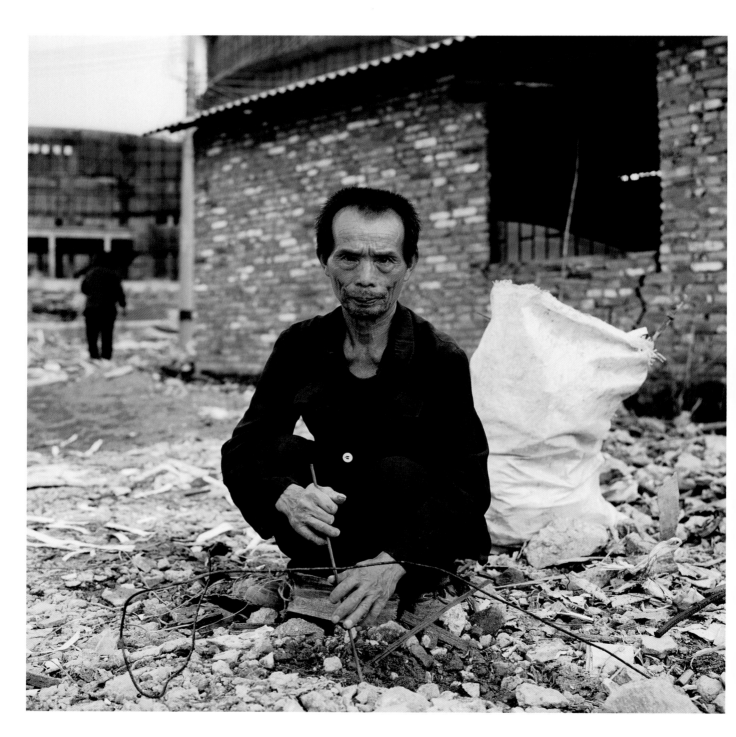

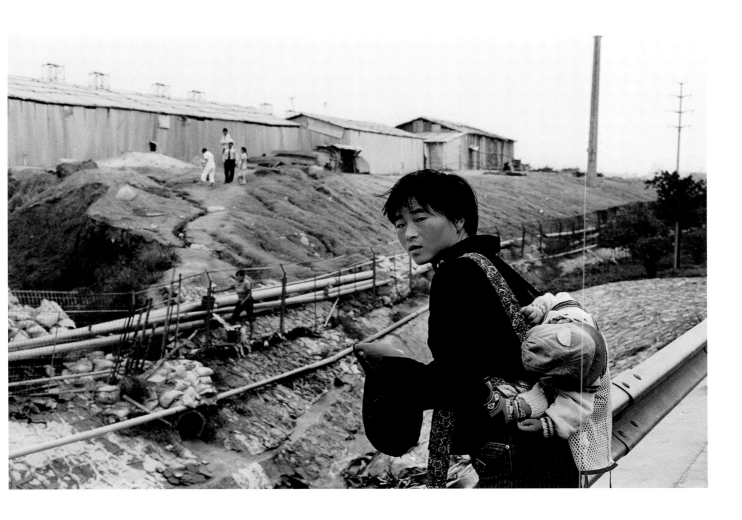

THE BUILDING SITE MOVES, GROWS, EXPANDS
and changes direction, and the accommodation of the
migrant workers moves with it. When the temporary
tin huts are in the way of a new building project, they
are simply taken down and put up again somewhere
else. Nobody bothers about whether the new position
might be good, bad or even dangerous for the workers
who must live there. This young woman lives with her
husband and child in one of the tin shacks on the
gigantic building site of Phoenix City, which can be
seen in the background. In order to get 'home', she
must first walk along a main road which is full of
heavy lorries, then she has to climb over a crash barrier,
clamber down a small but steep embankment, cross
a stinking stream, squeeze through a wire fence, and
finally climb up a muddy mound – all this with her
baby on her back. A prospectus advertising Phoenix
City recommends enjoying the good things of life:
'One doesn't live only to work but also to enjoy life.
If possible, don't put yourself in an unpleasant
situation. The world is there for you to shape and
to enjoy.' Phoenix City, China. September 2002.

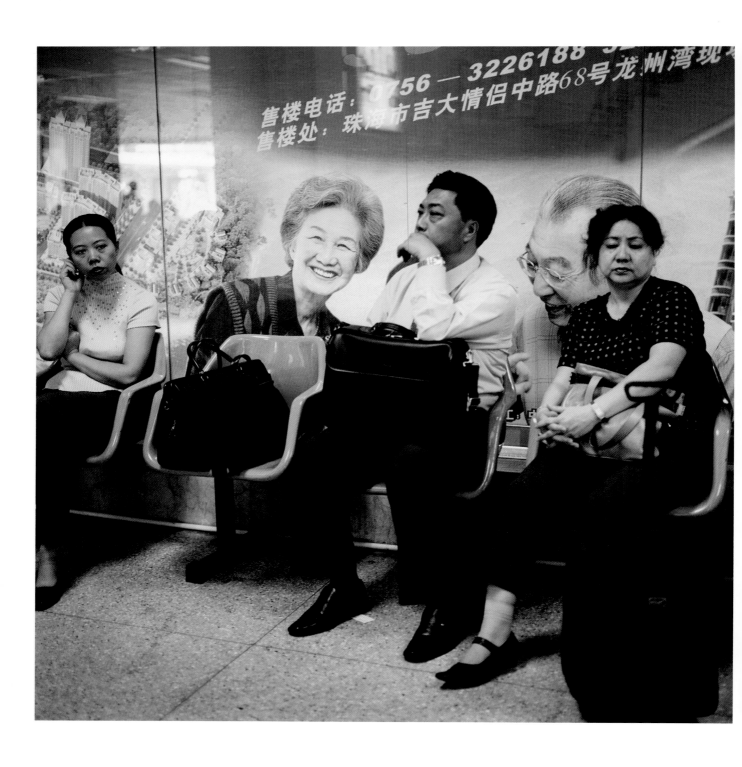

AT THE FERRY TERMINAL in the 'special economic
zone' of Shenzhen, a poster is advertising new homes.
Shenzhen, China. September 2002.

IN THE NORTHERN PART OF GUANGZHOU a migrant worker from Shaanxi Province was searching through a rubbish tip. He was very friendly, and took his time telling me about his situation: he had lost his job a little while ago, and now he was looking for things that he might be able to sell. He kept repeating that he was only working at the tip temporarily. He was ashamed of the work, and he didn't want me to photograph his face. Nor did any of the other people working at the tip. Soon a large warehouse is to be built on this site.

Guangzhou, China. November 2002.

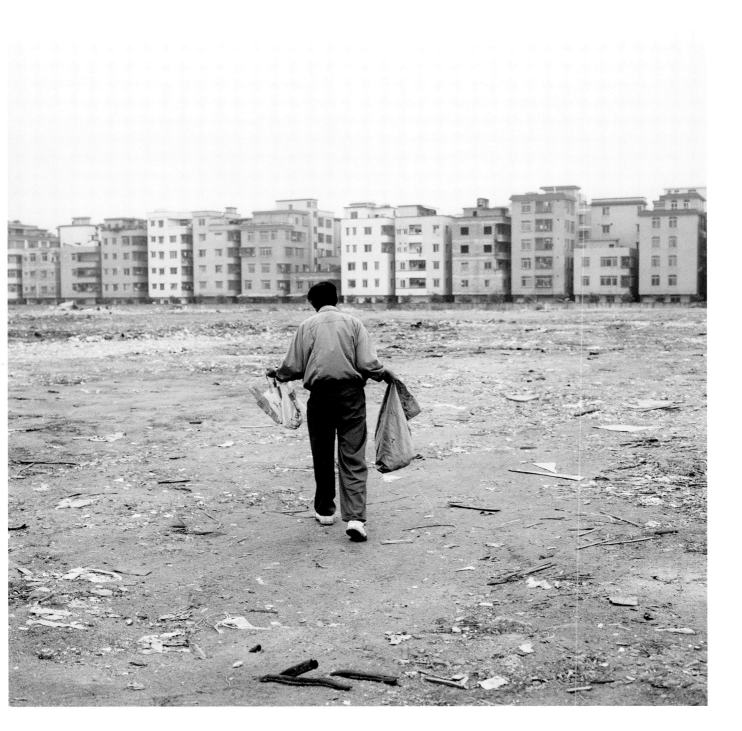

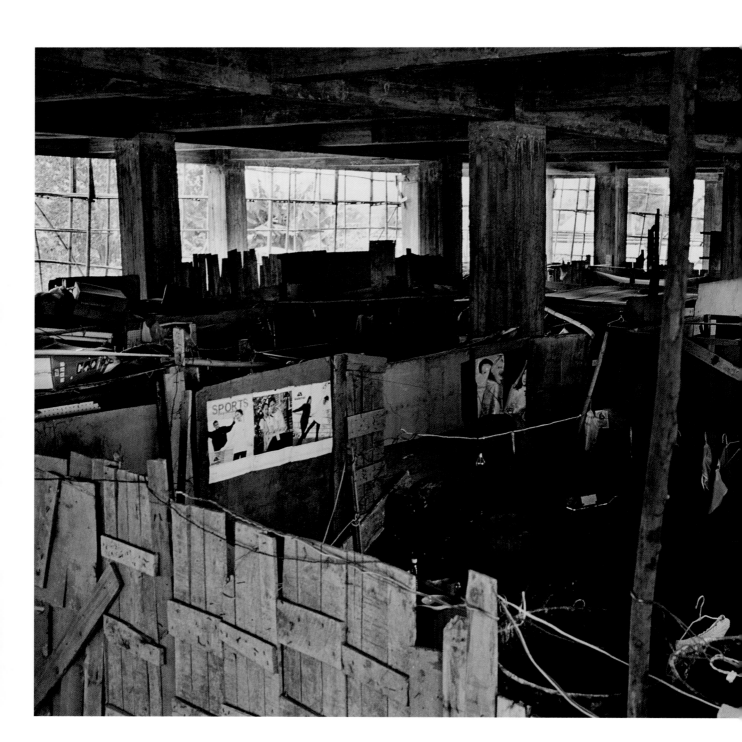

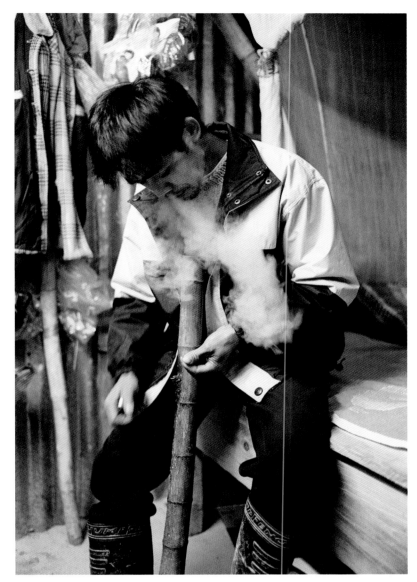

MIGRANT WORKERS make their homes inside
the concrete skeleton of an unfinished building
(opposite). Guangzhou, China. November 2002.

IN A FEW YEARS, WHEN HE HAS EARNED ENOUGH,
Mr Guo – who is the foreman of a group of migrant
workers on the site of Phoenix City – would like to go
back to his home village in Hunan Province. In the little
room (above) that he shares with his wife are a bed, a
chair and a kind of table. I asked him whether he would
like to live in one of the houses that he and his group are
helping to build. For a moment he looked at me with an
expression of disbelief, and then he smiled. Of course,
he said, he would love to, but he would never be able to
afford it. The room was cold, and you could hear every
noise from next door through the thin partition wall.
Phoenix City, China. December 2002.

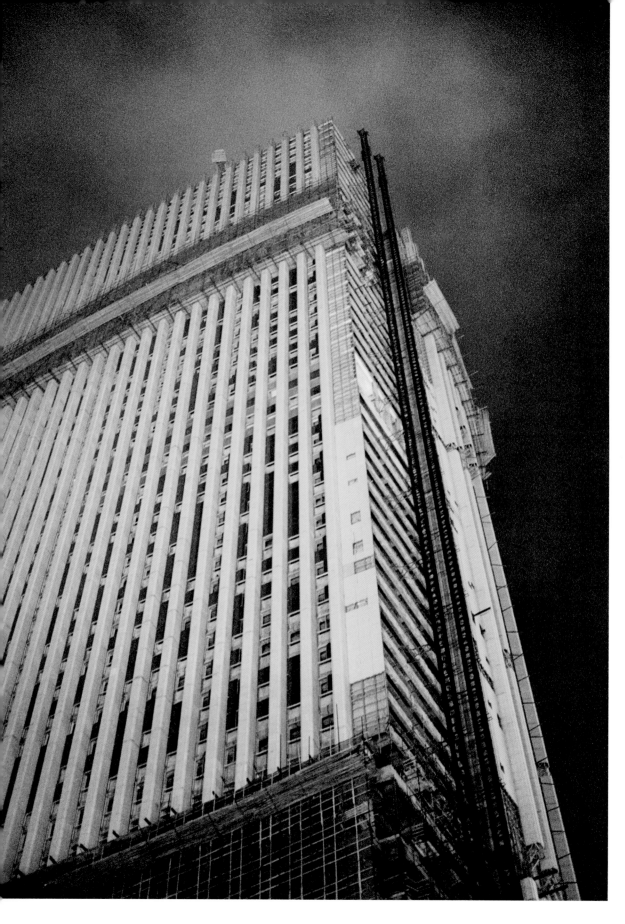

'DAPENG INTERNATIONAL COMMERCIAL PLAZA'
is sixty storeys high and is still under construction.
The prospectus, which was given to me by a friendly
watchman, offers 'great possibilities of valuable
business advantages'. Entry to the site is forbidden.
Guangzhou, China. December 2002.

THE MIGRANTS WORKING ON THE PHOENIX CITY
project are generally offered accommodation in very
simple tin huts (below). These are dark, hot in summer
and cold in winter. They do have electricity, though
only at certain times of the day, but no running water.
The hut used by this group is divided into four large
rooms separated by thin walls of metal and wood.
Each of these rooms has its own entrance and

accommodates ten to fifteen workers. Every worker
has his own bed and about three square metres of
'privacy'. The kitchens, where only the women do the
cooking, are a good hundred metres away. The sanitary
arrangements are also at some distance from the living
quarters. Men and women live separately, but married
couples live in the men's quarters.
Phoenix City, China. December 2002.

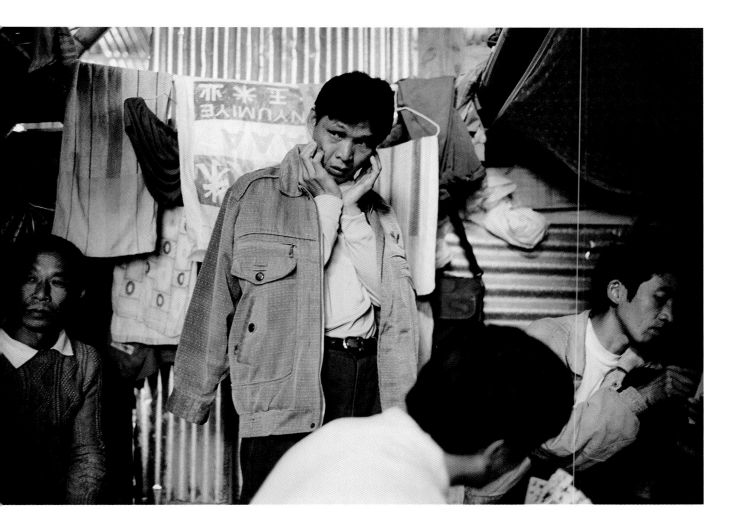

HUMEN BRIDGE (below) is 3.7 km (2¼ miles) long and connects the towns of Nansha and Dongguan. Humen means something like 'Tiger Gate'. The Hong Kong tycoon Gordon Wu has commissioned a 29-km (18-mile) bridge to connect Zhuhai, Macao and Hong Kong; work is to begin in 2003, and the cost is estimated at $2 billion. Nansha, China. December 2002.

ON THE PERIPHERY OF THE PHOENIX CITY SITE, I met this migrant worker from Sichuan Province (opposite). As foreman of a group of workers, he was earning 2,000–3,000 renminbi ($240–360) a month. I asked him if he would be going home to celebrate the Chinese New Year. He laughed and said: 'No, I have to work.' Phoenix City, China. December 2002.

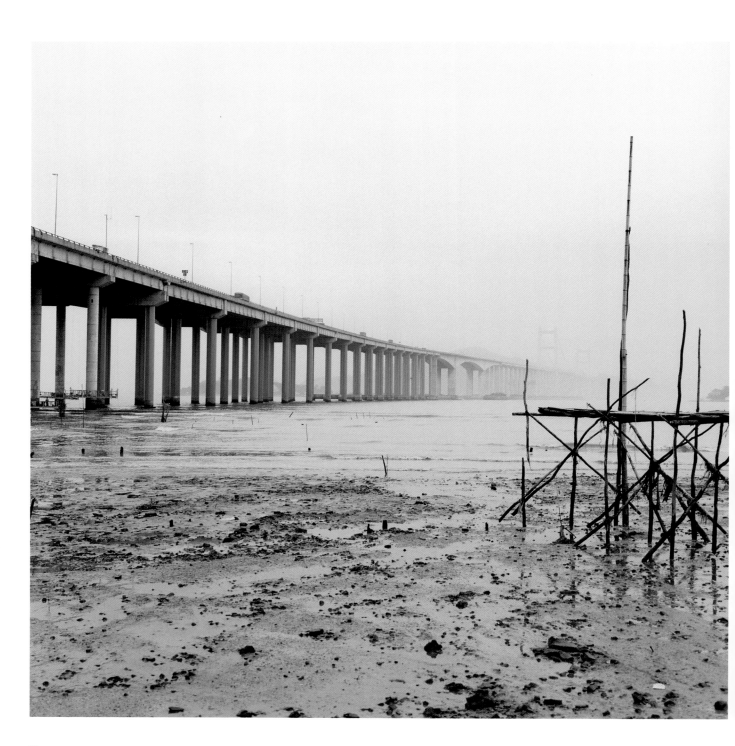

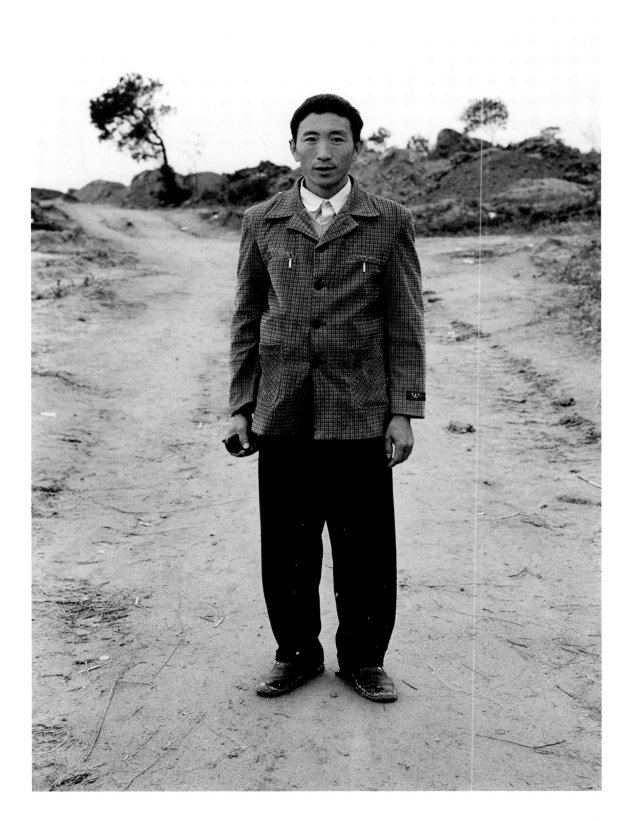

THOMAS KERN HOMELAND OF GLOBALIZATION

From the future of the planet back to the past. The ideological dream of a world of open borders and free movement of goods and finance was developed in the USA before they exported it. 11 September confronted the superpower with the consequences of a process that it had championed during the 20th century.

On 11 September 2001, the American soul was hurt to its depths. A new war was declared. Civil rights were restricted for reasons of security. On 11 September 'evil' had snaked its way through the window, or more likely through the television set, right into the American living-room. It was not only New York that was affected, for the chimaera of fear spread itself all round the USA. The feeling that they may not be altogether blameless for the state of the world is gnawing at some Americans' image of themselves. Many Americans have never left the confines of their big country. The conviction that the US not only protects the great ideals of freedom and justice, but should also convey them to all corners of the earth – if necessary through the medium of war – is a defining factor in American foreign policy and the American attitude towards the outside world. Whether these convictions are shared by all the people who live in the USA is not so clear. The individual stands alone in the country where each man is free to forge his own destiny.

GOD BLESS AMERICA

Mass destruction, mass consumption, mass culture – they have all come about through the technology of mass production. Efficiency, speed and the conquest of nature are still the dominant values in this present-day society. Back in 1913, the USA was already responsible for nearly a third of the world's industrial production. What had not happened was the integration and coexistence of the many immigrants from here, there and everywhere, who gathered together under the roof of a single nation.

Strong religious, ethnic and racial differences had and still have to be overcome. If nationhood is a form of imaginary community, then America really exists only in the imagination. In a country where it remains so unclear what actually is 'American', there is all the more fear of the 'Un-American'.

UNITED WE STAND

Trinity Site. At eight o' clock sharp, the gate opens. The sightseers have been waiting since the early hours, and now in convoy they stream through this military no-go area to a fenced-in piece of land where on 16 July 1945 the first atomic bomb test took place. Since 1975 the place has been designated a national monument, and twice a year it is opened up for a few hours to allow the visitors in. On the very spot where fifty years ago there stood a steel construction 30 metres (98 feet) high on which the first bomb was set off, there now stands an empty transparent cube, 50 centimetres (20 inches) high. Buses arrive at the car park outside this area. Two teachers from Montana walk around with a Geiger counter. Most of the visitors belong to the generation that survived the Second World War, and they have come to experience the myth of the bomb which many believe brought an end to that war. People wander around, and stop to look at a model of the 'Fat Man' – the bomb that was dropped on Hiroshima. On the fence, someone has stuck a few historical photographs that capture the moment of the explosion. At the exit, you can buy hot dogs and cold soft drinks. The teachers' Geiger counters register nothing, because

radioactivity has dwindled to normal. The bomb does not make its presence felt. There is nothing to see.

Flint. When I visited the assembly plant for Chevrolet trucks and pick-ups, there was a glimpse of the city's past, when hundreds of thousands of people were working to produce the 'American Dream'. The woman standing on the production line asked no questions. The dream was over. It could only be a matter of time before the factory closed. And there were people standing in an orderly line waiting for their food handouts from the Inner City Church.

The idea that racial segregation ended with the Civil Rights Movement and the designation of a day to honour Martin Luther King was refuted by what I found in Flint. The river that runs through the town marks the border between black and white. There is scarcely any mixing, unless it's at the workplace – for those who have a workplace. Privately they have little or nothing to do with one another. Even the churches are divided not just by denomination but also, and especially, by colour, as if they were all worshipping a different God. General Motors left long ago, and even the malls and the shopping centres are all situated just outside Flint's city limits to avoid paying tax. Today the city is bankrupt, and the State of Michigan has had to take over the business of government, leaving the Mayor without a job.

A few weeks later I took a trip through the south-west of the country. The people I met didn't seem to have even the vaguest idea about the world outside America. I wondered what the power of this country amounted to – a power to which no one must ever attribute evil, which has nothing but the best of intentions, which wants to set an example to the rest of the world. The feeling of insecurity was also very strong here, and with it a degree of confusion. Politics are unfathomable, the economy even more so, and everything foreign is a threat. The idea that this is the best of all worlds remains strongly rooted, and you can only sense that there may be doubts.

Back in San Francisco, I drove my children to school in the morning, and thought about the desert that I'd left behind. In the interior of this continent is a vast wasteland, a colourless, melancholy country of sand and stone. Wastelands are hostile to humans. You can build expressways to run through them, or small prefabricated towns, but the people who live here remain strangers to this country. The emptiness fills them with fear, and they put up their defensive walls to keep it out. Where people have managed to bring nature under control, they have done it through violence.

On the Interstate 25, I met a traveller who had packed all his worldly goods on a handcart which he pulled along behind him. His name was Amador, and he was Mexican. When I spoke to him, he answered without stopping. Where was he going? To Ciudad Juarez – back to Mexico.

NEW MEXICO. Early morning. A brief encounter with Amador, a traveller, en route along the Interstate 25 to Ciudad Juarez, 100 km, over 60 miles away, on the Mexican side of the border with El Paso, Texas. Truth or Consequences, New Mexico, USA. 2002.

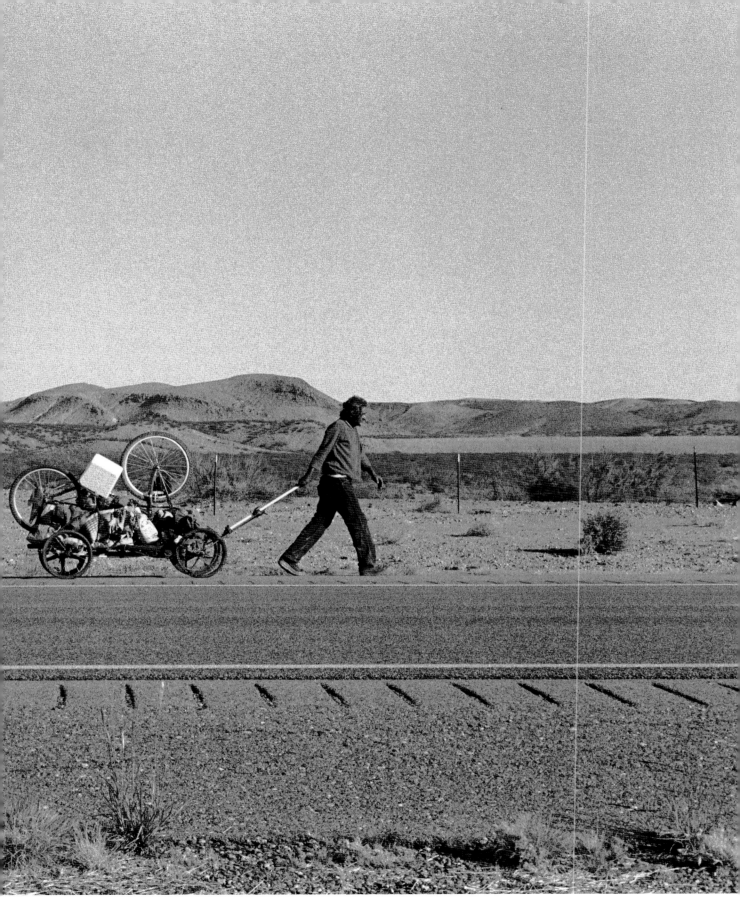

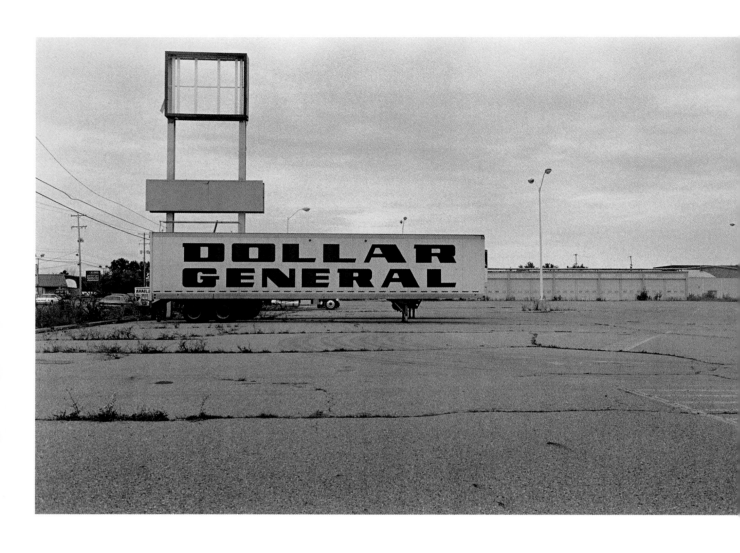

REMAINS OF A LIQUIDATION. Dollar General was a discount store
which even here, in the northern part of Flint, was forced
to close its doors. The car park, with the trailer still standing in
it, remains empty, and is slowly becoming overgrown with the
weeds crawling out of the cracks in the tarmac (above).
Flint, Michigan, USA. 2002.

OUTSIDE THE ENTRANCE TO THE ALADDIN CASINO,
(opposite, above). Las Vegas, Nevada, USA. 2002.

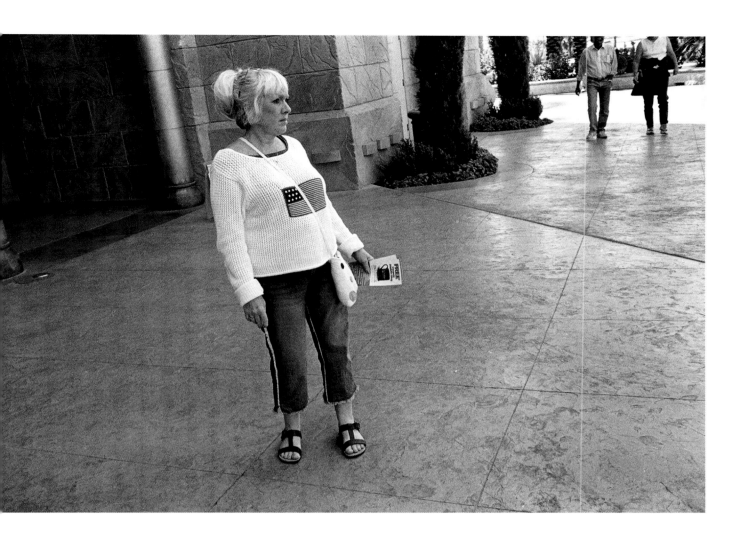

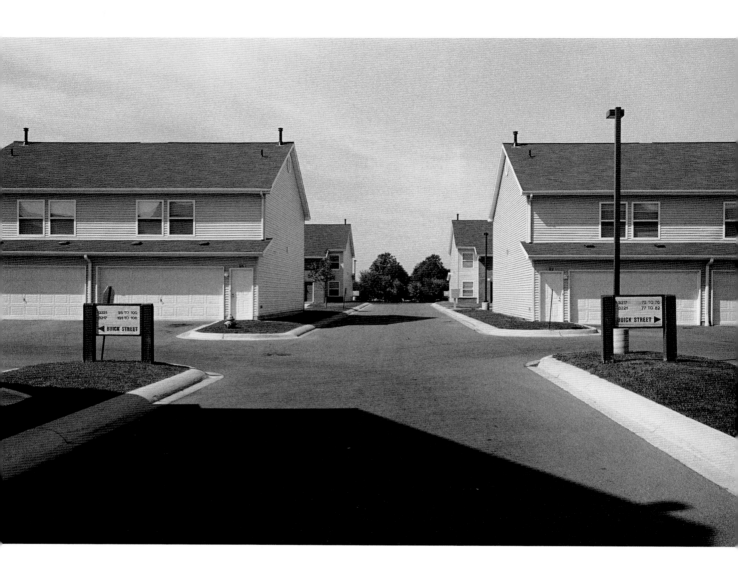

THE NEWEST BUILDINGS on a social housing estate
right in the heart of the completely impoverished
northern area of Flint. The new street name – Buick
Street – suggests a certain degree of cynicism.
Flint, Michigan, USA. 2002.

MANOEUVRES AT FORT IRWIN. A barracks and training ground in the middle of the Mojave Desert. In anticipation of war with Iraq, different units of the United States Army practise desert warfare. Fort Irwin, California, USA. 2002.

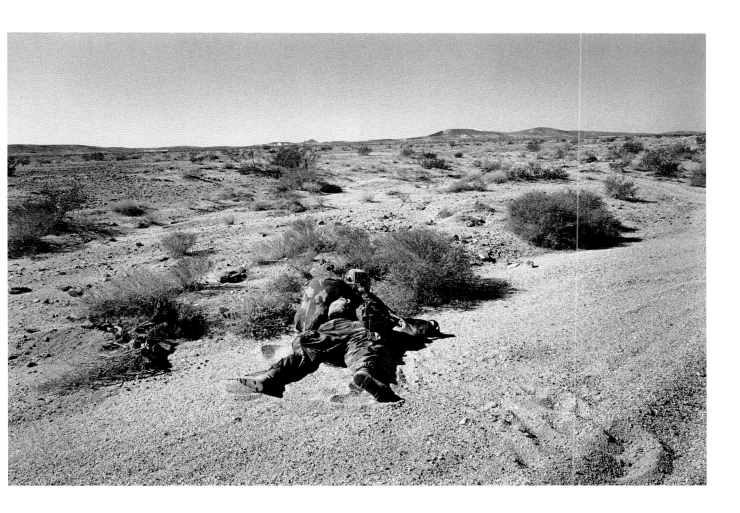

GENERAL MOTORS

Commercial Truck Center. Back
in 1947 there had been a Chevrolet
and Fisher Body works on the site
of the present plant. The demand
for large SUVs (Sport Utility
Vehicles) and pick-up trucks
has made the last few years very
successful for this assembly plant.
There are 3,200 workers here paid
by the hour, along with 300
employees on a fixed salary.
Flint, Michigan, USA. 2002.

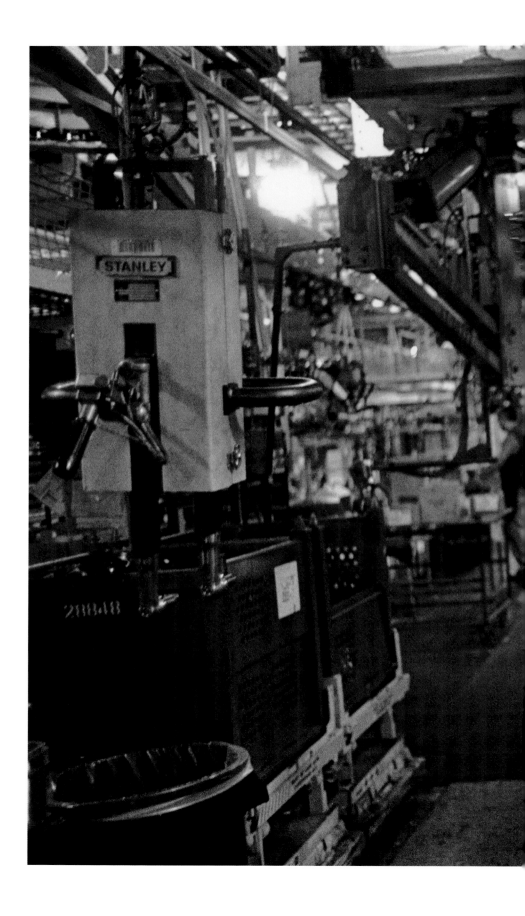

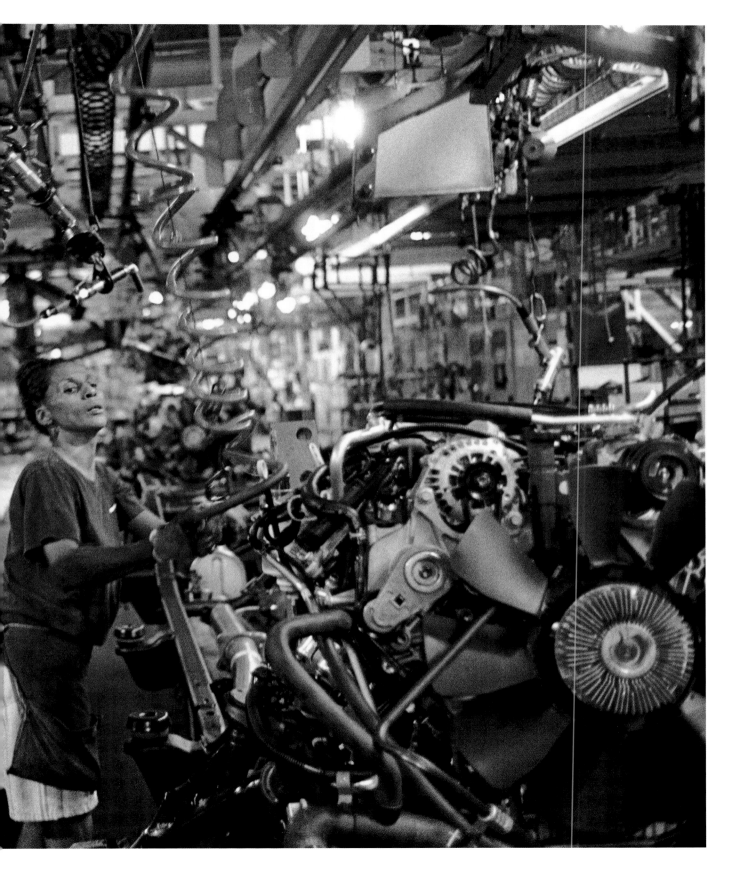

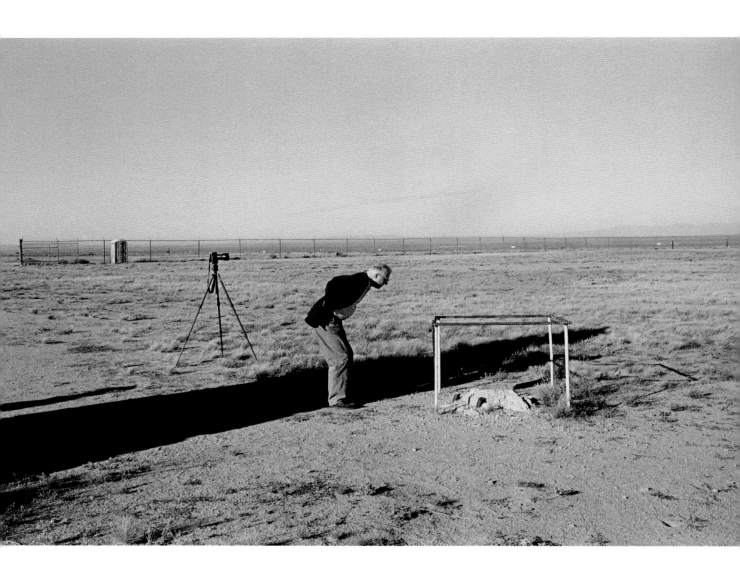

TRINITY SITE IS THE NAME OF THE AREA where
on 16 July 1945 the first atomic bomb test took place.
The fenced-in site was declared a national monument in
1975. For several years now, it has been opened up twice
a year to the general public, and there is a small sculpture
denoting the exact spot where more than 50 years ago
the bomb was exploded on a steel structure that was
30 metres, 98 feet, high. Socorro, New Mexico, USA. 2002.

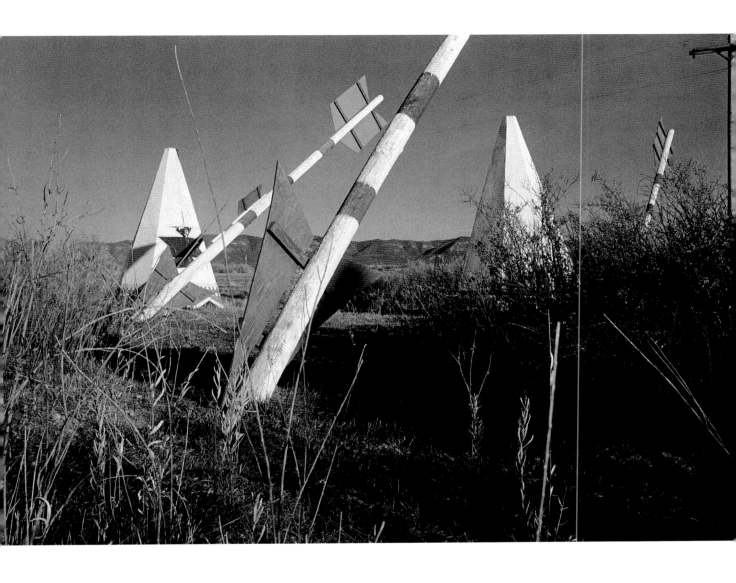

WOODEN TEPEES AND OUTSIZE TOTEM POLES
made from telephone masts are there to attract
tourists to a shop selling Indian handicrafts.
Durango, Colorado, USA. 2002.

REMEMBERING 11 SEPTEMBER, 8 am. The police guard of honour get ready for a short procession through the town centre of Flint, to honour the victims of the attack on the World Trade Center on 11 September 2001. Flint, Michigan, USA. 2002.

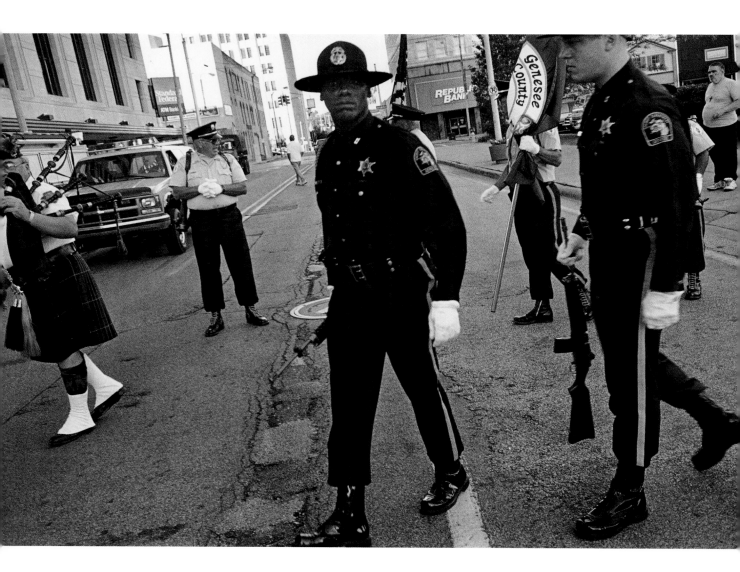

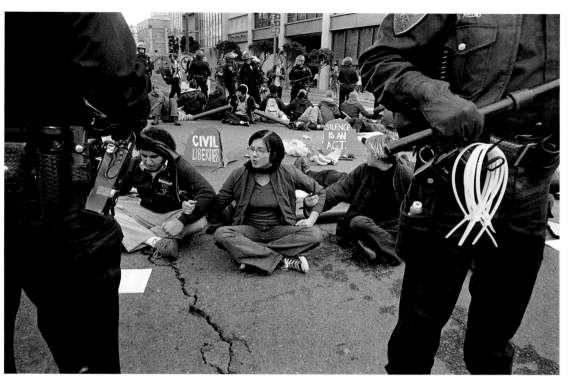

7 AM BLOCKADE ON VAN NESS, one of San Francisco's major streets. Protesters, most of them very young, linked arms and sat down on the street. The protests on the first day of war continued all day, leading to over 1,000 arrests. San Francisco, USA. 20 March 2003.

GRAFFITI ON THE PAVEMENT of Saginaw Street, in the city centre. Flint, Michigan, USA. 2002.

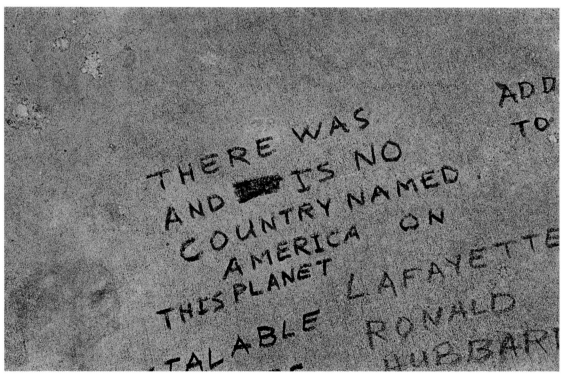

EXHIBITION AT WHITE SANDS MISSILE RANGE.
Dozens of exhibits relating to the history of rocket
science, from early experimental short-range models
with poor accuracy through to the intercontinental
rockets of the 1980s with their atomic warheads.
Withe Sands, New Mexico, USA. 2002.

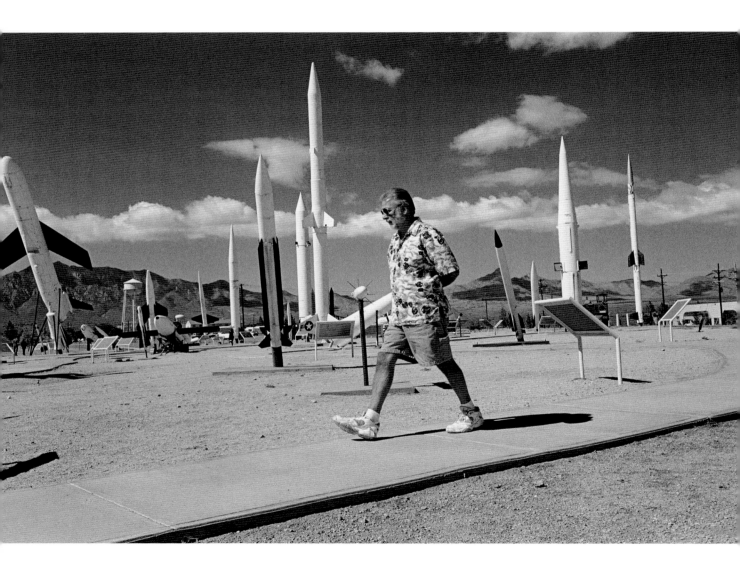

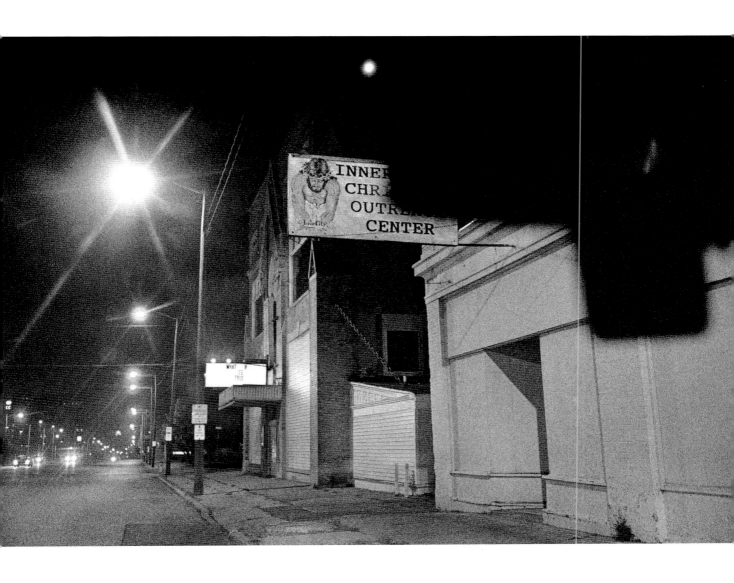

'WHAT IF IT'S TRUE…' Illuminated signs for the inner-city Christian Outreach Center. At the top of the prayer list are the pastor and his family, followed by the finances of the church, and some way further down come 'our government and President Bush'. Flint, Michigan, USA. 2002.

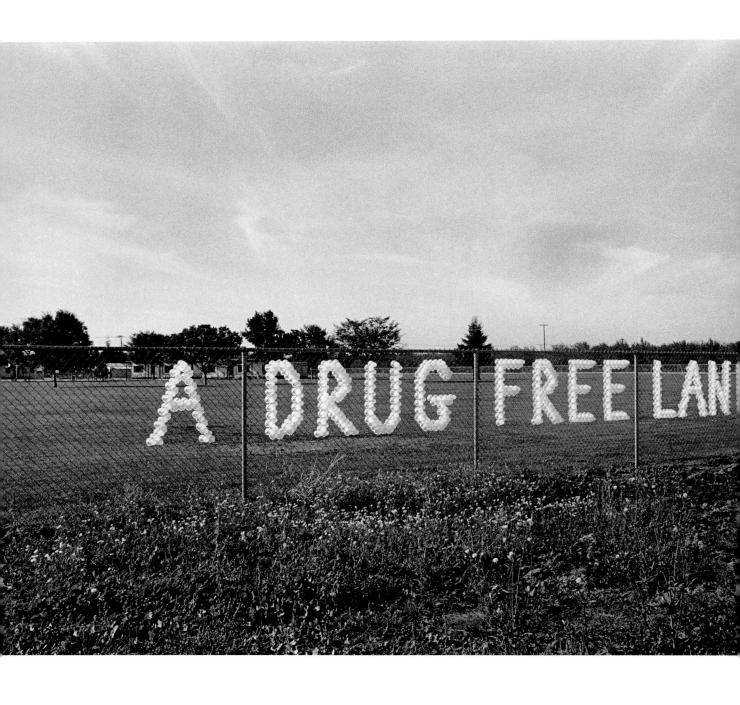

'A DRUG FREE LAND' – mottos, slogans and
news items greet the American driver wherever he
goes, including here in Central Valley, in California's
agricultural heartland. Oakdale, California, USA. 2002.

THESE GIRLS ARE DOING what the whole nation is advised to do – they get together, moved by a speech given at the International Institute to commemorate the events of 11 September 2001.
Flint, Michigan, USA. 2002.

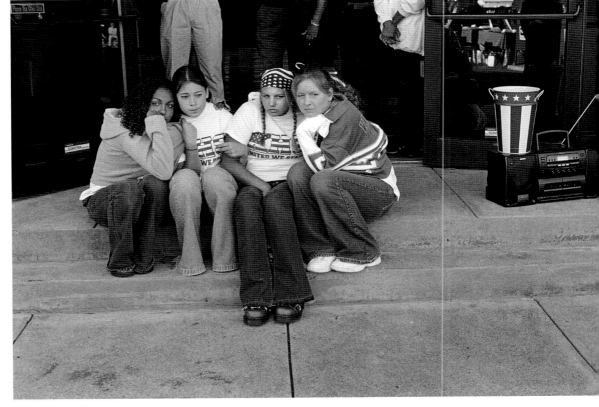

GUN SHOW AT THE CONFERENCE CENTRE IN RENO.
Such exhibitions are always on tour in the USA. The
extremely lax gun laws in Nevada make Reno a favourite
target for these trade fairs, and you can buy virtually
any model here, from the historic Colt, through modern
handguns and hunting rifles, right up to semi-automatic
weapons, ammunition and the latest devices for target
practice. Reno, Nevada, USA. 2002.

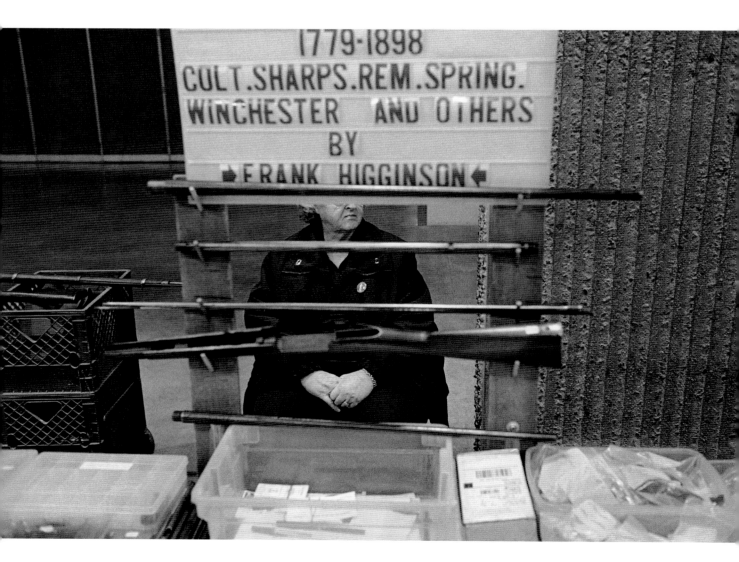

ON THE WAY HOME TO THE ARAB OUTSKIRTS
of Dearborn, between the highways and the chimneys
of the car factories. Dearborn, Michigan, USA. 2002.

VIEW FROM A HOTEL WINDOW (above).
Las Vegas, Nevada, USA. 2002.

QUEUE OUTSIDE A PRIVATE AID ORGANIZATION
that hands out food to the needy for three hours
twice a week (below). The distribution centre is
three blocks north of the river which divides the
town between blacks and whites.
Flint, Michigan, USA. 2002.

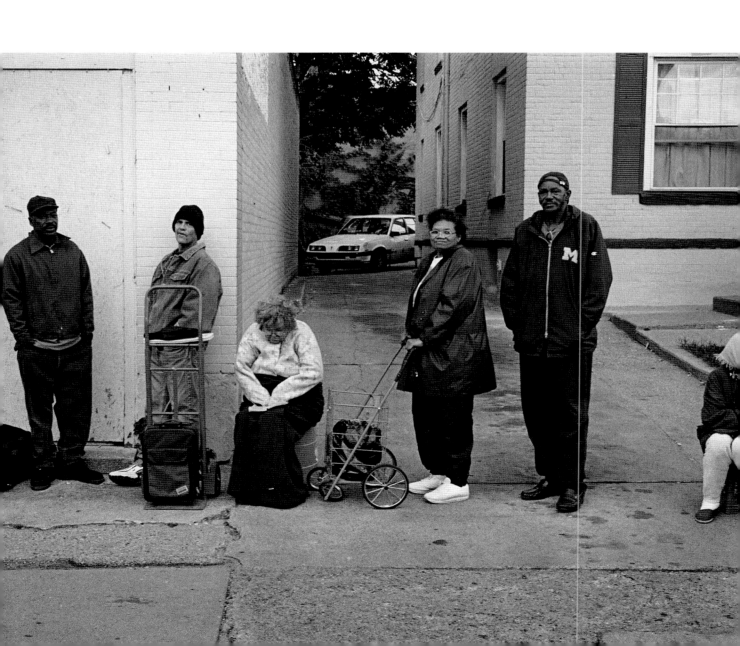

A GROUP OF YOUNG MEXICANS
in the anteroom of a local portrait
photographer, who is to take a photo
to commemorate the day. The families
are celebrating the *Quinceañera* – the
fifteenth birthday of the girls who,
according to tradition, now become
eligible for marriage.
El Paso, Texas, USA. 2002.

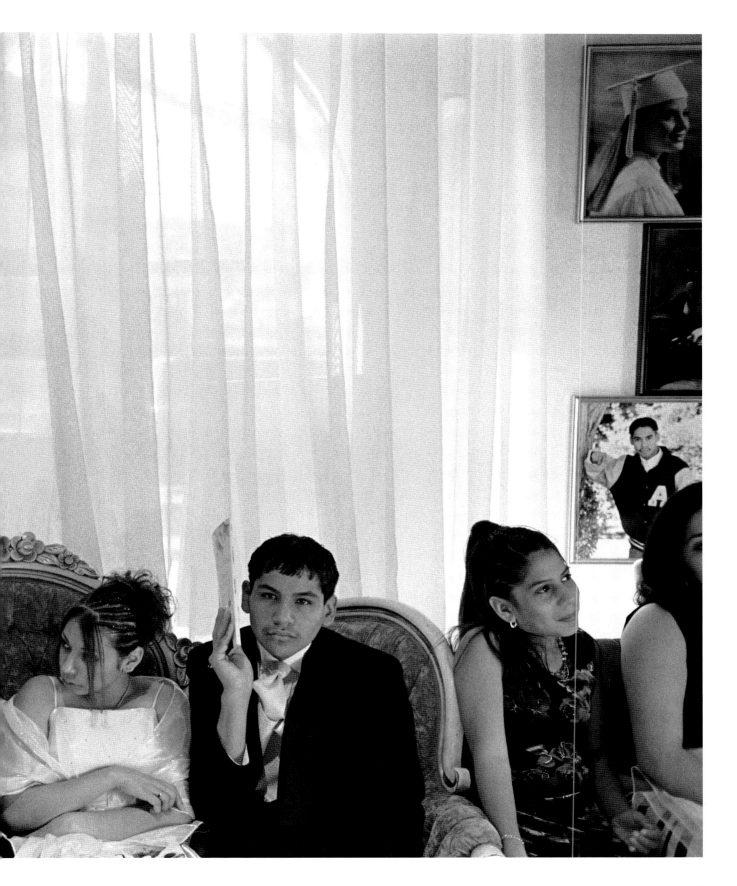

CRISTINA NUÑEZ MADE IN ITALY

From the superpower of the 20th century to the new elite of the 21st and the paradoxes of the resultant global consumer society. Although Italian fashion has long been created by a transnational elite and distributed worldwide, its image remains bound to its national roots and to the concept of Italianness. The members of the new elite define themselves through a unified, multicultural lifestyle, and they take their cue from their counterparts in the other major cities of the world.

Fashion is a creative business and highly glamorous, but it is also a global industry, the sixth largest worldwide. It is a globalizing force not only in terms of financial turnover but also as a huge hybridizing force that fosters social and cultural crossovers and multiculturalism.

Excavating the industry at all levels is particularly revealing in Italy, the quintessential centre of fashion and all its subsidiaries. The international and multiethnic workers and clients in the Milan fashion world cluster like bees around a beehive. The social contrast inside and outside the fashion world are investigated in these photographs, which were mostly taken at prêt-à-porter collections in Milan and in the workshops of the clothing industry in the Naples area.

The photographs show the emergence of a transnational elite, which identifies itself with similar people in other centres of the postmodern world – in fine arts, music, cinema, for example. The highly desirable but often unattainable glamour and luxury of the high fashion houses, thanks to the fashion myths distilled in their logos has naturally given birth to a huge market of legal and illegal copies. The Milan designers are trailed by many 'layers' of transnational people who are workers in the system, a growing number of a transnational class of illegals and a grey zone of 'legalized illegals' – those companies who started producing false brands and are now launching their own collections. In Italy there are also several hundred smaller fashion companies that follow the trend decided by Milan fashion. These companies are called *pronto moda* because they launch their collections just after the Milan shows, following the same trends but with cheaper materials – to keep prices very low some of them delegate their production to factories in Third World countries, which generally results in social exploitation.

Models are now recruited from eastern Europe and Brazil as well as western Europe, the United States and Australia. The buyers – shop owners or international distributors – are now mostly Japanese and Korean, but there are also many Russian and eastern European clients, and Arabs. The Kuwaiti Sheik Majed Al Sabah has recently opened one of the most luxurious fashion malls in the world in Kuwait City, with Prada, Gucci, Etro and Fendi boutiques. The wives of the princes of petrol arrive in black limos with their husbands, and inside the mall remove the veil to reveal perfect Prada and Gucci outfits. The backstage dressers are frequently students of fashion design schools in Milan, and they come mostly from Asia, many from India and Korea. Young talented designers, hair stylists and make-up artists come from all over the world and work for the big fashion companies in Milan.

On the margins of the legitimate fashion business in Italy are the street traders of Milan and Naples. Senegalese sellers usually sell perfect copies of Prada, Gucci, Versace and Armani. They are made for southern Italian producers by Chinese workers in Naples and Prato. These producers work so fast that their false collection is on the street even before the authentic one is out. Some have 'friends' in the laundries where the designers send the clothes to be washed before the shows, and they have many other ways of finding out details of the collection. Some make minor changes to the design, and spell the logo slightly differently, so that the designers are unable to take legal action. The illegal market has grown so much and the copies are so perfect that when we see fashion worn by people on the street, we often can't tell if the garments are originals or copies.

Though it is obvious that the illegal fashion industry is a threat to the legal one – illegal industries in general, including software and pharmaceuticals, have caused a loss of tens of billions of dollars to legitimate industries – some designers have been delighted to discover perfect copies of their garments or accessories around the world, because it confirms their global success, gives them free advertising and adds to the creation of their myth.

ITALIAN FASHION is becoming global. In California's Mojave Desert I photographed a fashion shoot by Peter Lindbergh for Italian *Vogue* (overleaf). Asia Argento and the American actor Adrien Brody presented their outfits in a diner that had been artificially covered in dust. The team consisted of fifteen people and the photographer. California, USA. November 2002.

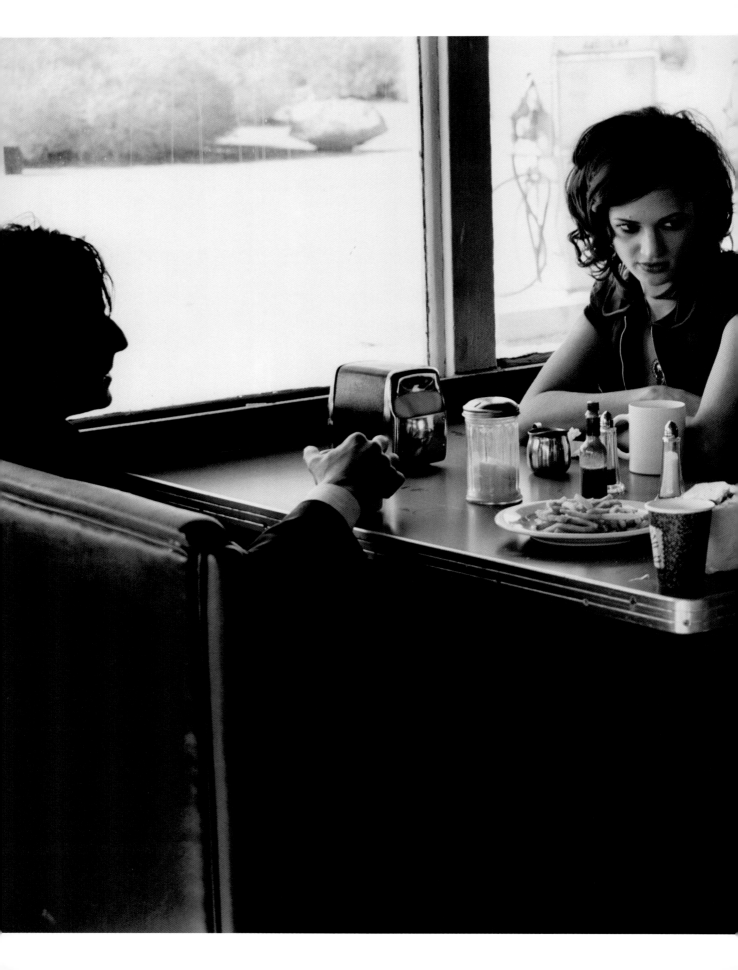

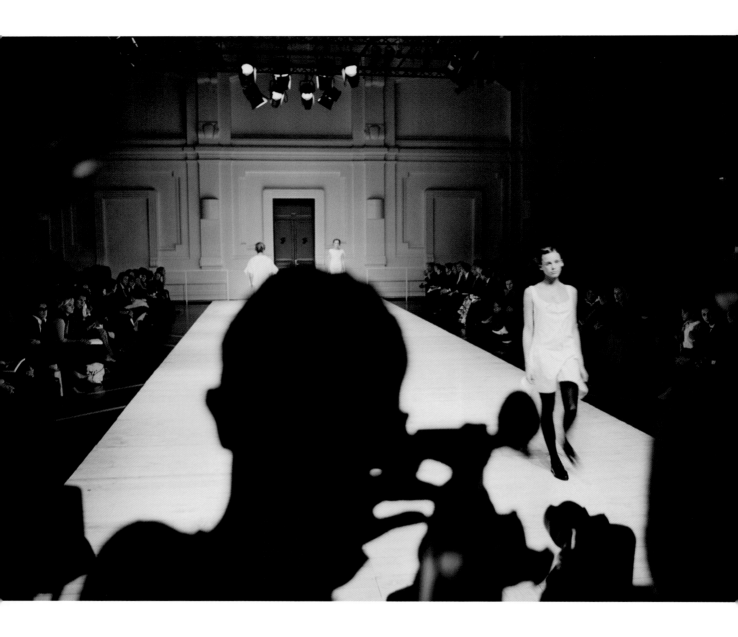

MILAN CHANGES INTO A MULTILINGUAL BEEHIVE
every spring and autumn. People fly in from all the
major European cities, from Los Angeles, New York,
Tokyo, Seoul and Sydney, and in more recent years
even from Moscow and Riad, in order to cast an eye
over the latest creations of Italy's fashion designers.
Most of these people represent international business
and distribution chains. Gianfranco Ferrè's 2003
Spring/Summer collection was one of extreme
simplicity and classical elegance. The clothes paraded
on the catwalk were rather reminiscent of Japanese
styles in their severity. I sat hemmed in by about
thirty cameramen and photographers, many
of whom were from Japan. Milan, Italy. September 2002.

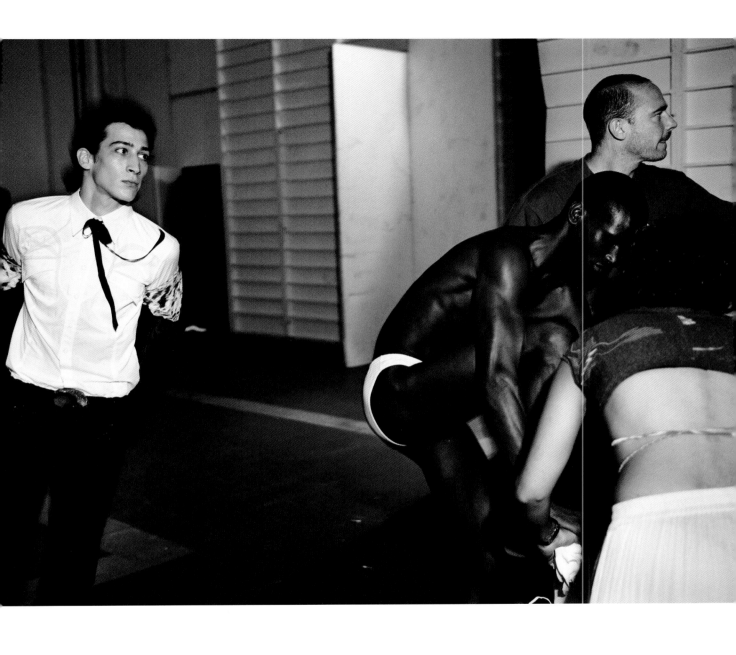

BACKSTAGE AT A ROBERTO CAVALLI FASHION SHOW.
Milan, Italy. June 2002.

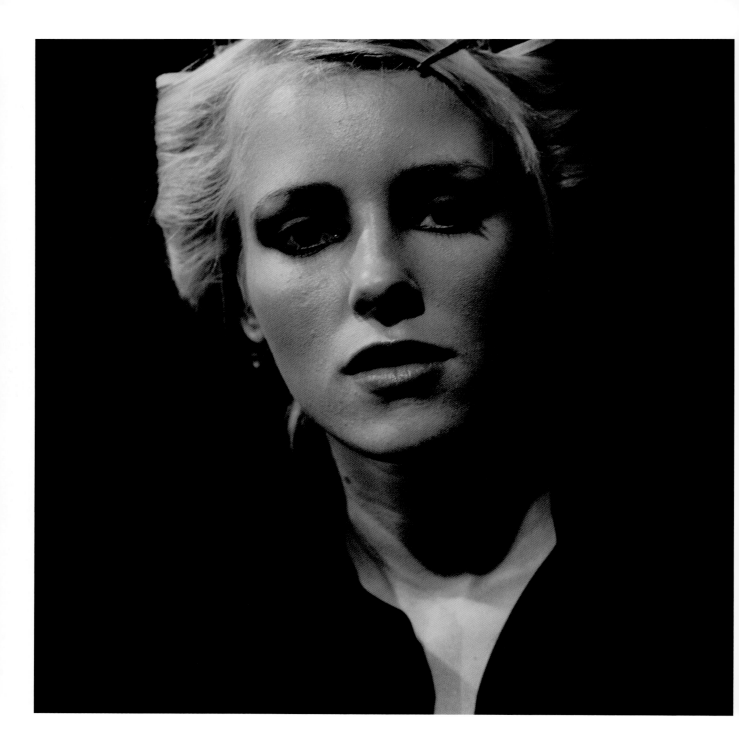

THE FIRST TWO YEARS OF HER CAREER were tough;
she was 16 then, she says, and it was hard. Today Diana
is twenty and commuting between Milan, New York
and London. No, she wouldn't mind making her
headquarters in Budapest, where she grew up, but the
city is too remote, and her boyfriend, who works in
the art trade, lives in Milan. In 2001 she paraded on
the catwalk in ninety different fashion shows.
Milan, Italy. September 2002.

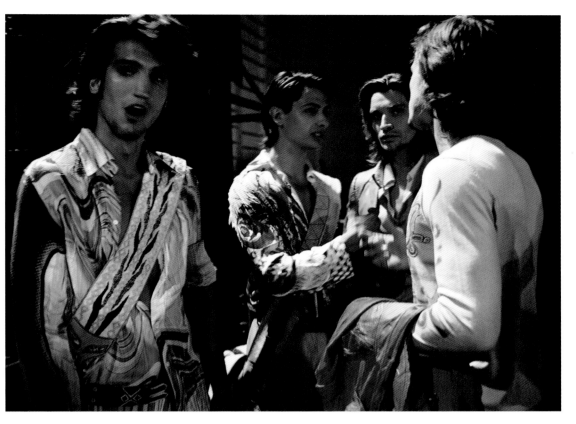

THEY'RE LAUGHING, cheerful and having fun. For a long time, men were the poor relations in the fashion industry, but since trendy lifestyle magazines discovered 'man, the fashion victim', male models have conquered the catwalk. None of them has yet attained the degree of popularity enjoyed by the top female models, but that can change. And unlike some of their female colleagues, who often pursue their careers with serious determination, they are as relaxed as real stars. You never see them looking bored with life. Mariano, Sandro, Alvaro and Marcelo (from left to right) wait to go on the catwalk during Roberto Cavalli's Spring/Summer show. Milan, Italy. June 2002.

INSPIRATION COMES from the working-class fashions of the 1920s, from French rococo, from the hippies of the 1960s, and even from Bavarian lederhosen. Designers take up textile patterns from central Africa, from old carpets, from abstract paintings and from Kufic script. During the last few years, the global trend in fashion has increasingly turned away from the ideal of classic elegance. Important new sources of ideas are the subcultures, the ghettos and video clips. Rap stars are among the top customers of the fashion industry, and they are also among its top promoters. Etro's designs for the 2003 Spring/Summer show combine a military style with a 1980s cut and African colour and patterns.
Milan, Italy. September 2002.

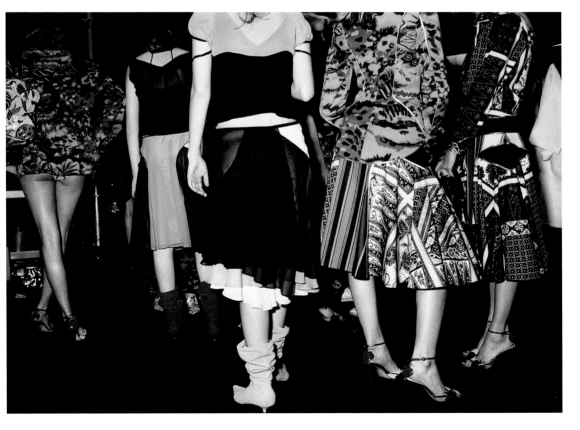

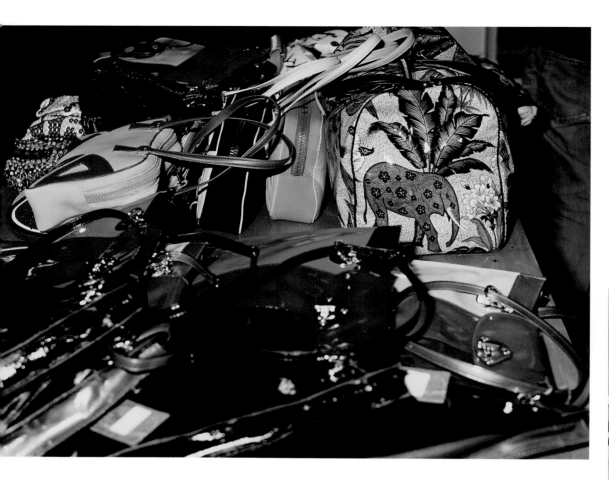

THE FACT THAT IT BREAKS ALL THE RULES
of everyday life is what gives luxury its prestige.
It's often hard to say what other purpose it serves:
'It cost me three million, and I enjoyed it for three
minutes,' said Charles II of Spain after he'd seen the
Diana fountain which he had commissioned in the
garden of La Granja. Nowadays luxury accessories like
handbags can fetch anything between $500 and $13,000.
Those who buy them have long since ceased to be
exclusively from the upper classes: in the last twenty
years the market has won over a new, middle-class
clientele. The democratization of luxury has presented
the fashion industry with record new turnovers, but it
has also had a lasting effect on the demands now made
on the fashion houses: today they are forced to bring
out new designs, trends and models at ever shorter
intervals in order to satisfy the constant need to be
individual, to be different. Nevertheless, the customers
still expect top quality. 'Luxury,' said Coco Chanel,
'is not the opposite of poverty, but of vulgarity.'
Milan, Italy. September 2002.

LOUD MUSIC FROM THE JUKEBOX, and the food from the buffet is cold: fittings generally take place some days before a fashion show. It can take up to two days for all the details to be settled, the order of showing the outfits and the accessories to go with each. Fashion designers bring their pets with them, to stop themselves from getting too bored. Pictured here is Lolita, Veronica Etro's fox terrier. Milan, Italy. September 2002.

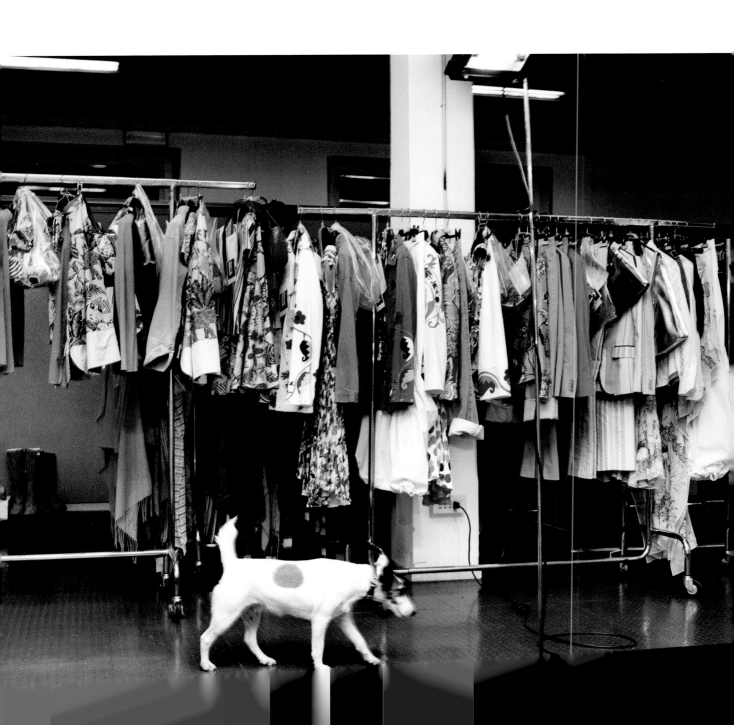

COLIN THOMPSON AND KIM YE YOUNG. He is
a designer for Moschino's menswear, she is fashion
editor for *Vogue Pelle* and *Vogue Gioiello*. Colin has an
English passport and Jamaican parents, and Kim comes
from South Korea. They make a handsome couple.
Milan, Italy. September 2002.

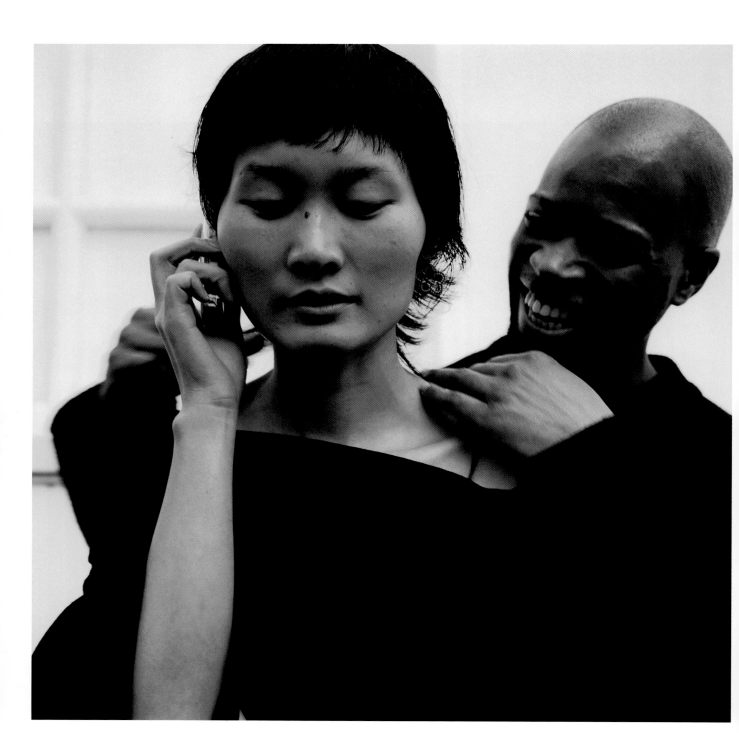

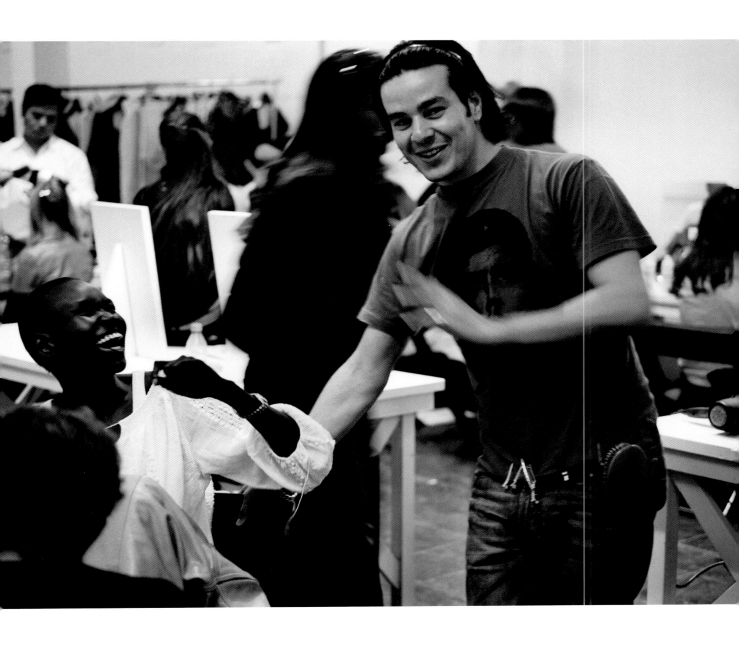

BACKSTAGE DURING MOSCHINO'S
Spring/Summer show. The Sudanese star
model Alek Wek with her hair stylist.
Milan, Italy. September 2002.

GUCCI SHOP IN RODEO DRIVE.
The biggest sales outlets for Italian
fashion are not in Italy at all. Italian
clothes have long been designed
and made by a transnational elite,
but the fashion lives – as it has
always done – on the Italian image.
The clothes are made for the world
market, but at the same time the
makers do everything they can to
prevent their image from being
absorbed by this market. The
industry's dependence on
global trends makes the future
unpredictable: after 11 September,
fashion houses had to reckon
with a drop of up to 20% in their
turnover. Recently the Italian
fashion industry has set out to
conquer the Chinese market, where
the majority of the clients are men.
Beverly Hills, USA. November 2002.

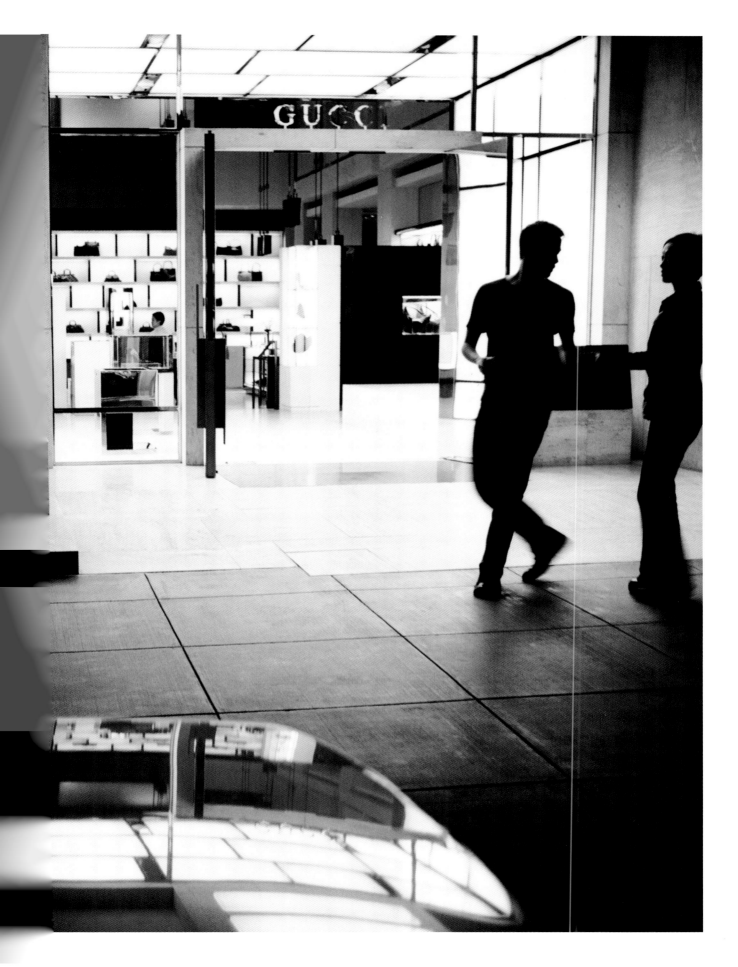

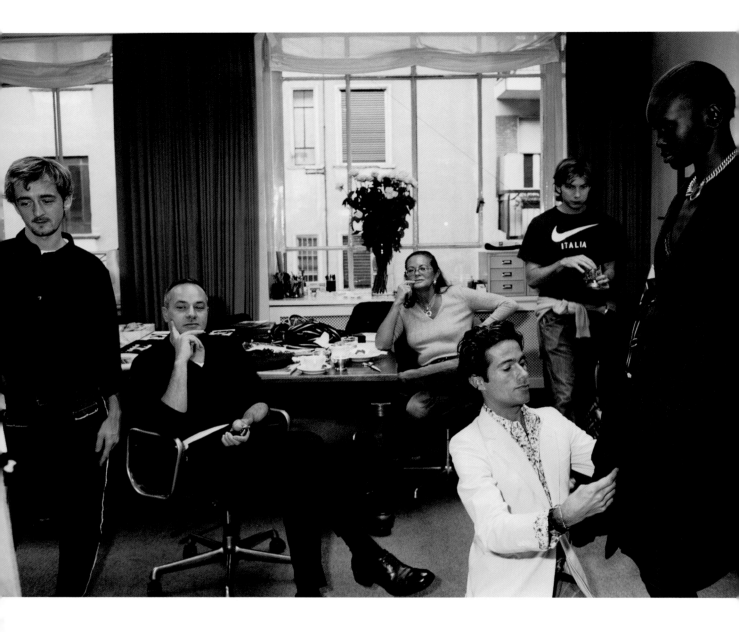

FASHION HOUSES RECRUIT THEIR PERSONNEL
from all over the world, but their success depends
ultimately on the personality of the designer. Moschino
was founded in the 1970s by Franco Moschino, and his
firm is one of the very few to have survived the death
of its creative head and its subsequent sale. The
collections continue to impress with their provocative
wit and irony. Pictured here is Franco Moschino's
successor, the creative director Rosella Jardini, with
her team: Sean McGowan from Britain (on the left),
the designer Vincent Darrè from France (foreground)
and the American Bill Saphiro, together with the
Sudanese star model Alek Wek and the fashion
editor Andrea Tenerani (seated).
Milan, Italy. September 2002.

IN 2000 JI SUNG HAM PACKED HER BAGS
and went to Milan. She comes from Korea, and studies
fashion design at the Domus Academy. Her main
interest lies in combining Far Eastern graphic design
with Western elegance. Once a week she meets her
Korean friends, with whom she is working on a
project for a fashion magazine. Her parents, says
the 27-year-old, were not happy when she left.
Milan, Italy. December 2002.

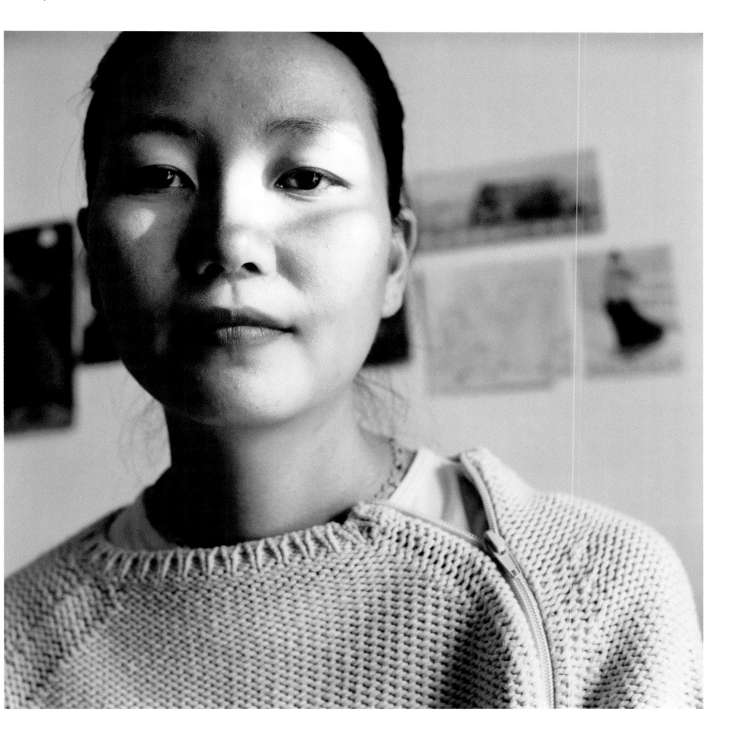

BELOW VESUVIUS, not far
from Naples, in a no-man's-land
of workshops and factories and
overdeveloped villages, record
turnovers are being achieved,
though they never make their
way into the statistics. The area
is renowned for its river, which is
polluted to a degree unparalleled
in the rest of Europe, and for
its fashion businesses, which
manufacture their clothes and
accessories within the walls of
ordinary-looking houses. Some
of the sunglasses, handbags, shoes
and clothes that are produced here
bear logos and names like 'Dolce
& Giuly', 'Emporio' and 'Burla'.
Other items are simply called
'Gucci', 'Armani' or 'Versace',
and they are so well made that
you often can't tell them from the
real thing. During the 1990s, this
business is estimated to have had
a growth rate of 1300%, and Italy
is now the biggest manufacturer
of fake brand names in Europe,
and third biggest in the world
after China and South Korea.
Paesi Vesuviani, Naples, Italy.
October 2002.

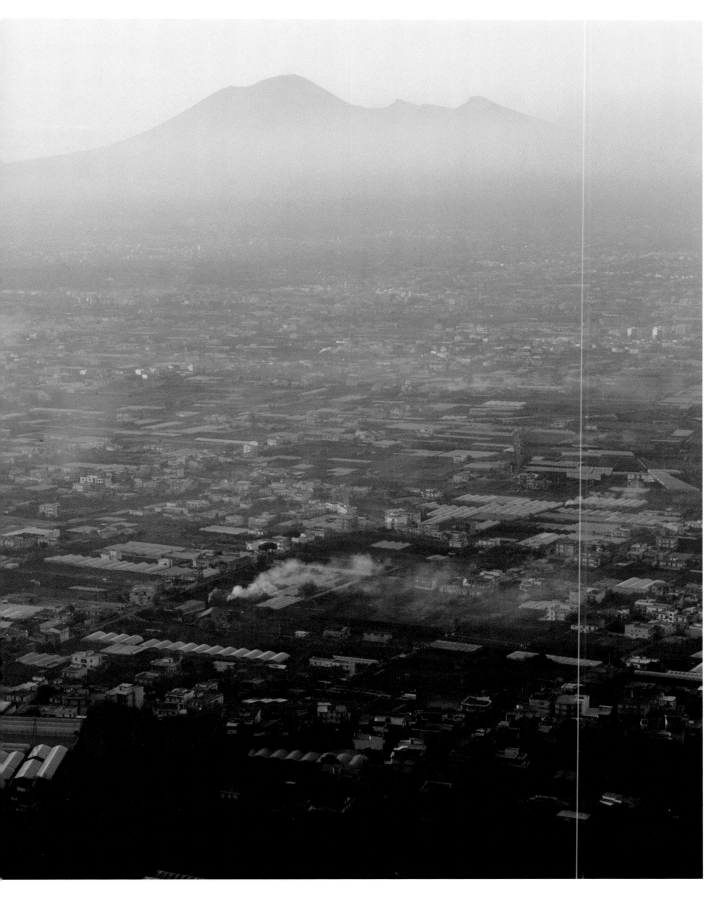

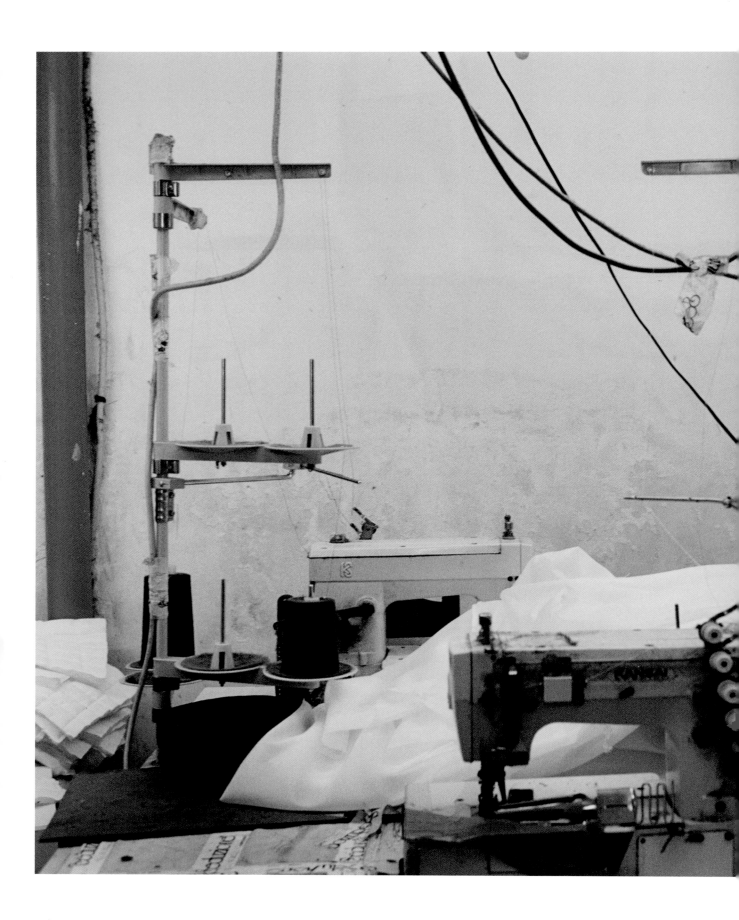

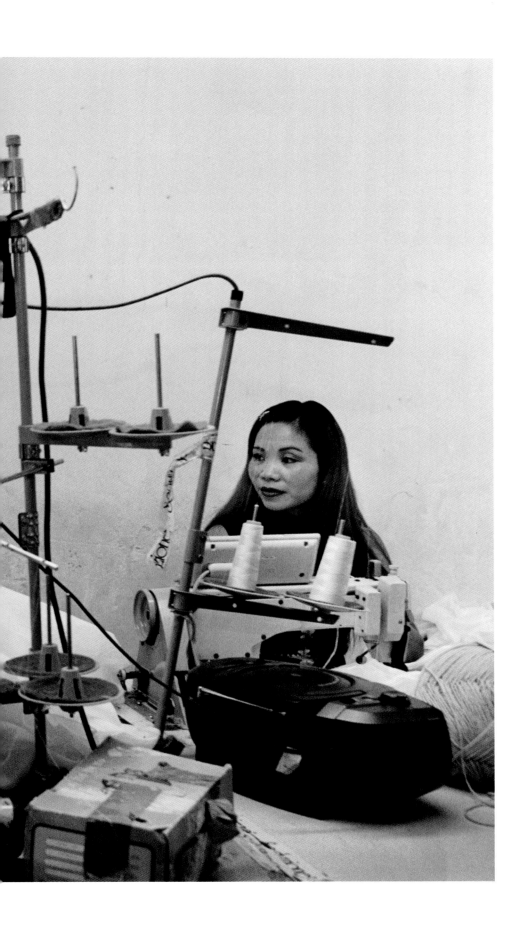

THIS 'FACTORY' is a private house with unplastered brick walls which make it look as if it's only half finished. Altogether it contains an area of about 100 square metres (over 1,000 square feet), and every centimetre is filled with sewing-machines and rolls of material. It's like a makeshift garage workshop. Eleven people work here, employed by a semi-legal company, sewing clothes. The factory is run by a Chinese 'entrepreneur', and almost all the workers here are his relatives. According to my informant, there are about 500 such factories in and around Naples, making fake clothes for the fake industry. Most of these little factories are run by Chinese, and, from the standpoint of hygiene and sanitation, working conditions are generally bad. The majority of the workers are illegal immigrants. Paesi Vesuviani, Naples, Italy. October 2002.

THE DIVISION OF LABOUR IN THE FAKE INDUSTRY
is very well organized. The illegal company takes care
of the pattern and cut of the materials, while the sewing
is done in the Chinese workshops. The finished articles
then find their way to the distribution centres, which
sell them to dealers in illegal goods. The industry
works so fast that its products often reach the market
before the authentic goods even get into the shop
windows. Some of these companies have informants
in the laundries where the fashion houses send their
clothes to be washed in preparation for their shows.
And there are apparently many other ways of finding
out details of a new collection. A Chinese worker
loads clothes into a VW Golf.
Paesi Vesuviani, Naples, Italy. October 2002.

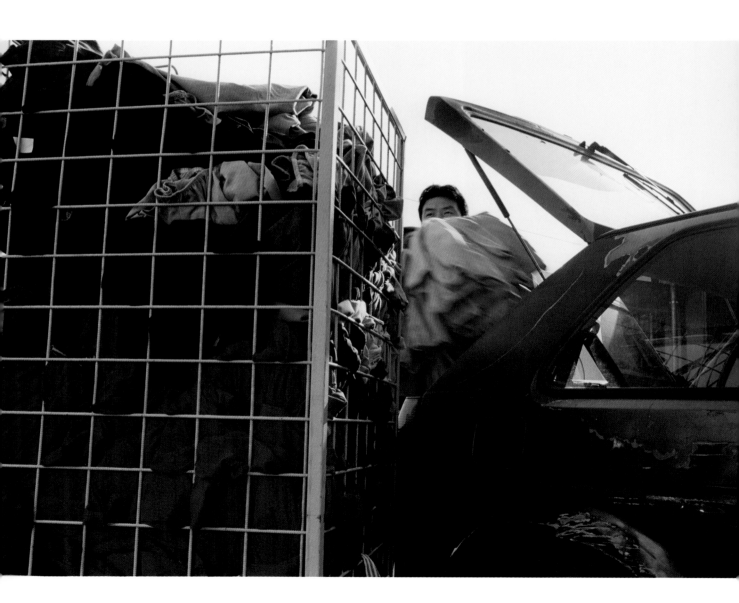

KATIA WORKS AS A FASHION DESIGNER for a
flourishing factory in the region at the foot of Vesuvius.
Her studio is a bare room with no windows. She gets
her patterns from the Milan fashion shows, and often
they are direct copies with a few details changed to get
round any legal problems. Katia designs the clothes on
a computer, then cuts out the paper patterns with the aid
of the plotter and sends them to the Chinese company.
She designs new items throughout the year and not just
during the season as the Milan designers do. She says
that she feels very lucky to have a job like this.
Paesi Vesuviani, Naples, Italy. October 2002.

THE SENEGALESE ARRIVE IN THE EVENING.
On the Via Brera they display handbags bearing the
Gucci, Hermes, Armani or Versace logos, and these
are indistinguishable from the originals. In Rodeo
Drive such bags can cost between $500 and $13,000.
Here they cost between $50 and $150.
Milan, Italy. November 2002.

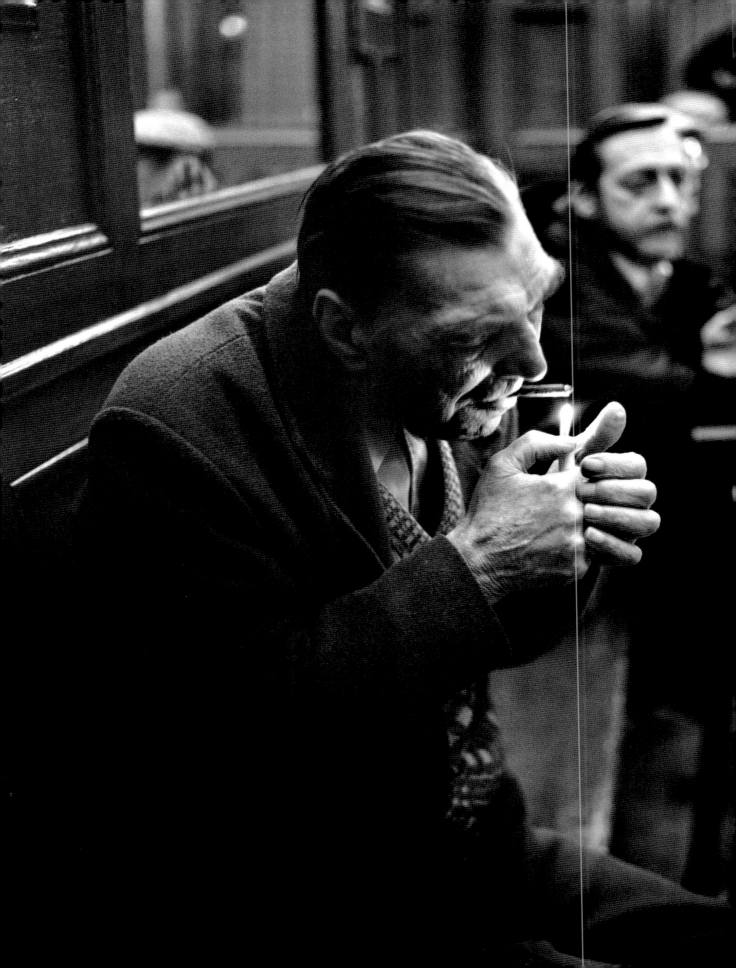

driver to take him to his hometown for free, and arrived at the church just in time, his neat pink ski-suit shining among the black mourning-clothes of his family.

Luca is also a man who is very near my heart. A lovely man, he has four children from three different women. He walked away from his past and swore that he would never work again. The leather jacket and the mouth-organ are his new family. Freedom is his motto, but he is dependent on his welfare payments and the booze. He plays the mouth-organ until his lungs squeak and the alcohol floods his blood.

I met Nancy for the first time on the street, trying desperately to score drugs. She didn't have a permanent address, and was then sleeping in a cheap room in a lousy hotel. She was thirty-one, looked fifty and felt eighty. She was sick, addicted and exhausted. She once fell through a window on the second floor, breaking almost everything you can break, from her leg to her chin. Behind that damaged exterior and the lacklustre eyes was a soft gentle voice, which in her innocent youth probably set fire to the hearts of her male classmates. A month later I saw her again in a bar after a tiring night without sleep. 'I am fed up,' and she put her head on the table.

Roger was an old man with a beard. He lived in an apartment full of books, old gramophone records, paintings and newspapers. He had moments of confusion and moments of clear and brilliant thought. He had a past in the art-world as an artist and in psychiatry as a patient. Months after I took his portrait and gave him a photoprint of it, I saw him walking from bar to bar with it always under his arm.

Johnny was also one of my warm encounters. Johnny was an Elvis imitator for more than thirty years. No expensive costumes or a big record collection. Drama, simplicity and a little brilliantine. The costumes were sold a long time ago, his hips are now arthritic and his voice has been washed away with alcohol. Johnny never recovered from the loss of his beautiful young wife in car accident. From pure despair he parked his life and his liver in alcohol, and only Elvis gave him some consolation.

I met Marcelle Joséphine in a sandwich bar. I guess she is in her nineties (you never ask a lady her age, do you?). The bad weather meant that she stayed there the whole afternoon. Little chats with the customers and the owner to pass the hours. On sunny days she goes to the park close by to watch the pigeons, and before sunset she goes back to her apartment. A few times I give her my arm in gentlemanly fashion for her walks around the block to stretch her legs. She is a flower of a woman. May she live a long life!

Astrid is from Marseille. When she was young she had a transsexual operation in Morocco. Now she is sick. If she goes for a walk, the ghost of Greta Garbo follows her shadow. Depilation, clouds of hairspray and make-up are daily morning rituals.

Albert and his wife have had a difficult time financially. He only sleeps for a couple of hours in the morning, does the domestic work in the afternoon, and at night sits behind his computers and electronic equipment. He is an autodidact and an electronic genius. He repairs all the electronic appliances that he finds on the street and gives them away to friends.

One of his proudest inventions is a coffee-machine with a giant filter and a month's supply of coffee. Everything works automatically. His favourite prototypes include curtains that open electronically and which adjust according to the incoming light. And all this time the cold wind has been blowing through a broken window for over two months. Long live cutting-edge technology!

I can't write about some of the life stories that go with these portraits, partly because of the express wishes of the sitters, and partly because a few are too tragic. It was also sometimes difficult, even after several visits, to find out where the truth ended and the lie started. There are always many gradations of truth.

My sincere thanks to and deepest respect for all the people who let me into their homes and into their lives. Thanks for facing your stories.

STEPHAN VANFLETEREN FACING STORIES

From the hybridizations of the global economy to those that affect the losers in the reorganization of the world's economic structure. In First World countries, the new forms of poverty are caused less by material need than by an absence of human contact, by loneliness and isolation. Those who are most at risk are people who are unable to adapt to the constraints of an ever more rationalized working world.

Belgium, fourth place.

In the Olympics, fourth place is a disaster. No gold, no silver, no bronze. Nothing but the shadow of the podium. But fourth place in the UN report on global prosperity – this is every president's wet dream.

Geographical destiny has been good to me. Belgium is my country, a neat toytown kingdom in the heart of Europe, lost between history and the future, always invaded. Our underdog mentality is legendary and our distrust proportional. And now it is officially the fourth most prosperous nation of the world.

Of course Belgium is a wealthy country. There is compulsory education and the right to vote. Most people have a job, a house, a car. People seldom die of cold and hunger here.

But before we start to celebrate, poverty is not just a lack of cash, tiles over our head or a full stomach. In my search for poverty I came across another kind of poverty: loneliness. I met people in warm living-rooms, where TV commercials were promising miracles; where there was a mobile phone in the pocket, cigarettes on the table and a glass of beer in the hand. The only venture outside the house was for the dog's daily walk. But there was loneliness, even with the electronic 'window on the world', or with a mobile phone to call all over the globe – to say what? 'Is anybody out there?' When I had finished with the polite questions, the silences were sometimes painful.

Luckily there are still the bars. There are conversations, and music, movement, liquor and sometimes quarrels. At least something happens. But the number of bars is constantly shrinking. People stay at home. Some don't have the money and others are too exhausted from a hard day's work. Men, women, families are hidden behind clean bricks and tight curtains. They fear the world, which apparently turns faster and faster until it sweeps them out by centrifugal force.

But there are people who keep fighting, dreaming and drinking in search of a better life. I made friendships, embraced 'hard men', kept off the booze, calmed quarrels, tried to console, acted as taximan and took photos. Looking for people who would open their doors and their lives for me with my old Rolleiflex. The bottle of wine is put on the table, music plays, hair is checked in the mirror and the camera is loaded.

While I focus on the eyes, the lips open and speak. Their life-stories are often courageous, sometimes hilarious and sadly mostly unhappy. Everybody has his own drama, his pride, his guilt, his scapegoat and sometimes his little falsehood to camouflage the harsh truth. 'Let him who is without sin throw the first stone.'

Ivo is a beautiful, slender young man with a great love of gin and a perfect sense of humour. He had been a dancer in an important dance company. I met him one morning in his apartment. He was sitting in his chair, with his dog at the point of death. Ivo had slept the whole night there, waking for his faithful beast. A Hawaiian LP was playing in the background. There was a melancholy atmosphere, in spite of the cheerful tune. The dog's hips didn't want to move any more. Ivo lived on the street for a couple of years, but now he has an apartment through social services. He told me of the time when he was still homeless, and heard that his grandpa had passed away two days before. He wanted to be at the funeral at any price. The only clean clothing he could find was a pink ski-suit. He took the bus from the city, persuading the

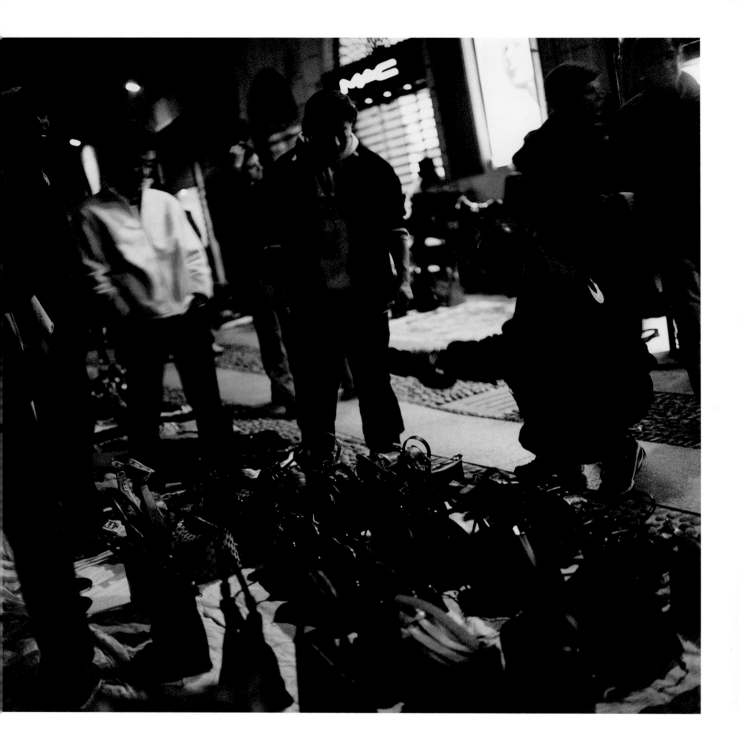

MOST OF THESE SENEGALESE are in Italy without a residence permit, and selling fake articles is a crime. Generally they work in little groups of two or four, and when things get too hot they grab as many bags as they can carry and make a bolt for it. They often live together in one room or in a dilapidated apartment. Milan, Italy. November 2002.

RENÉ

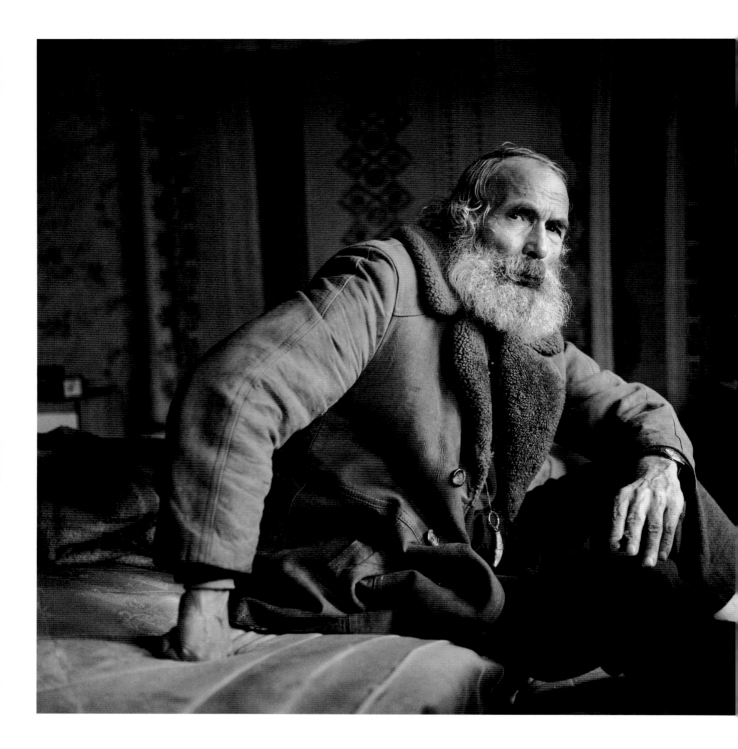

ROGER

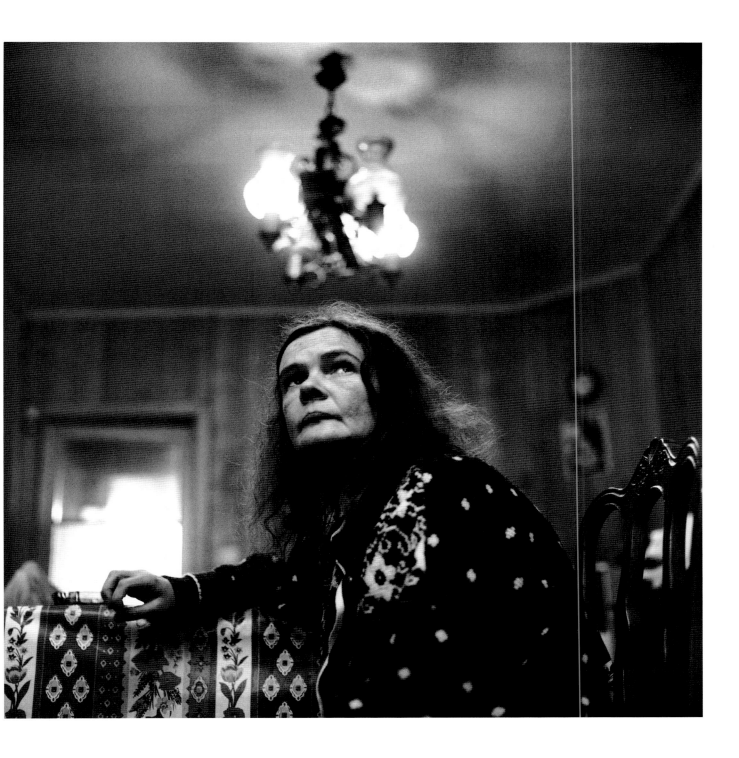

ANITA

GINO

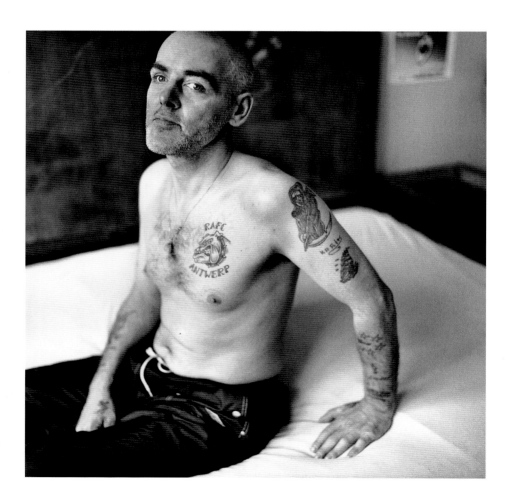

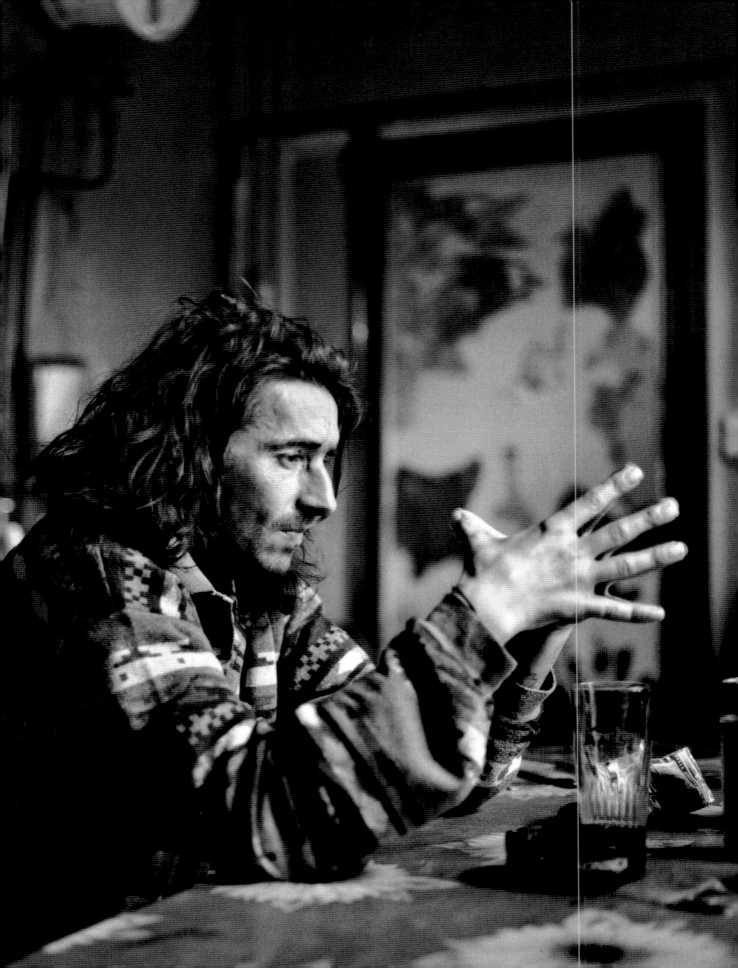

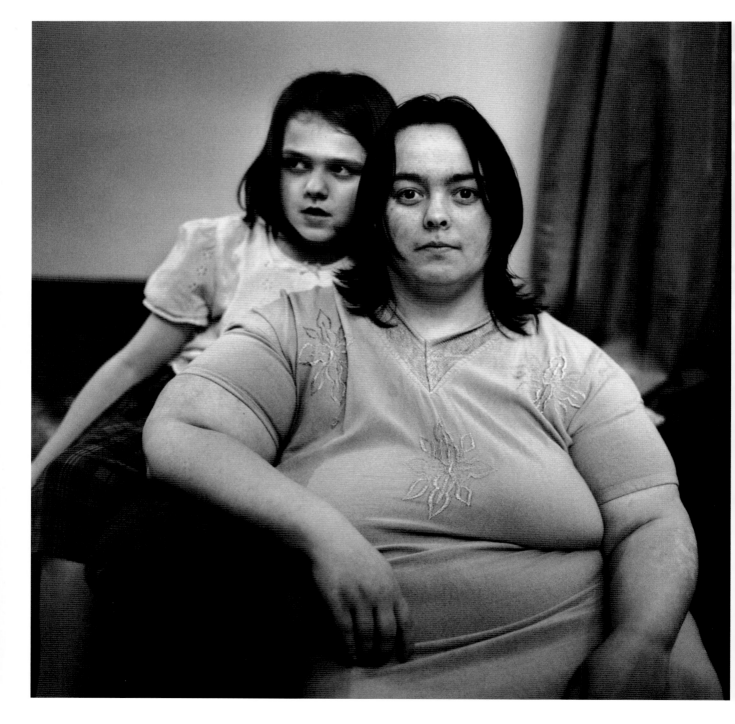

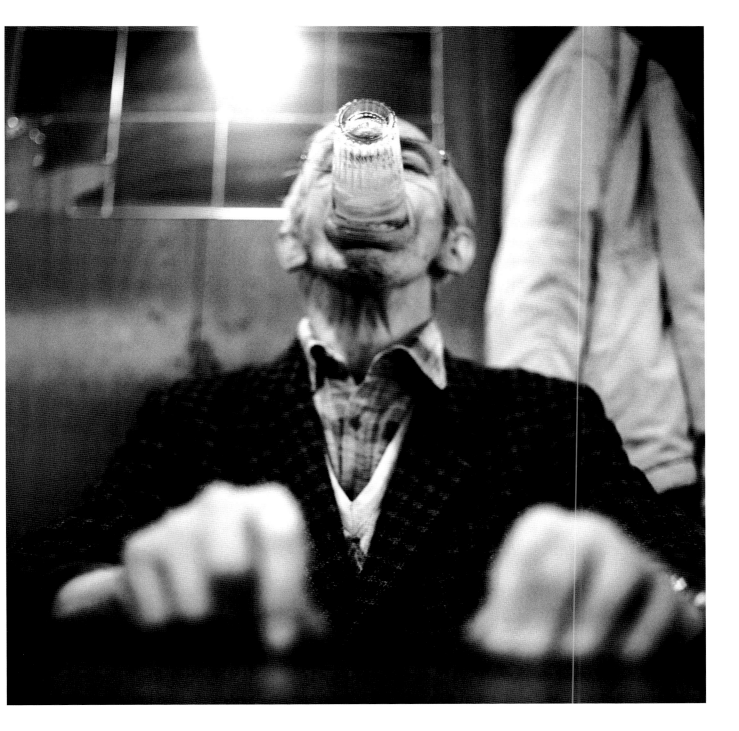

DÉSIRÉE

ASTRID

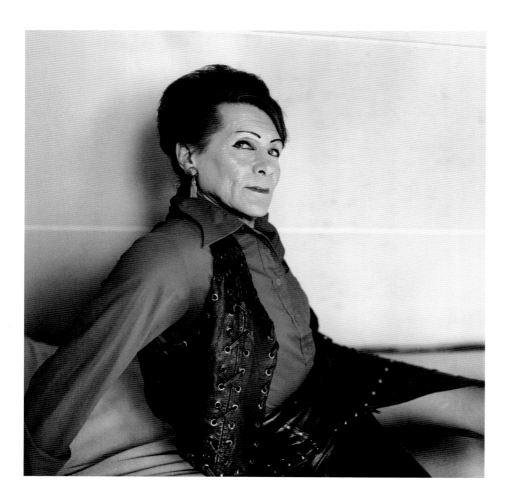

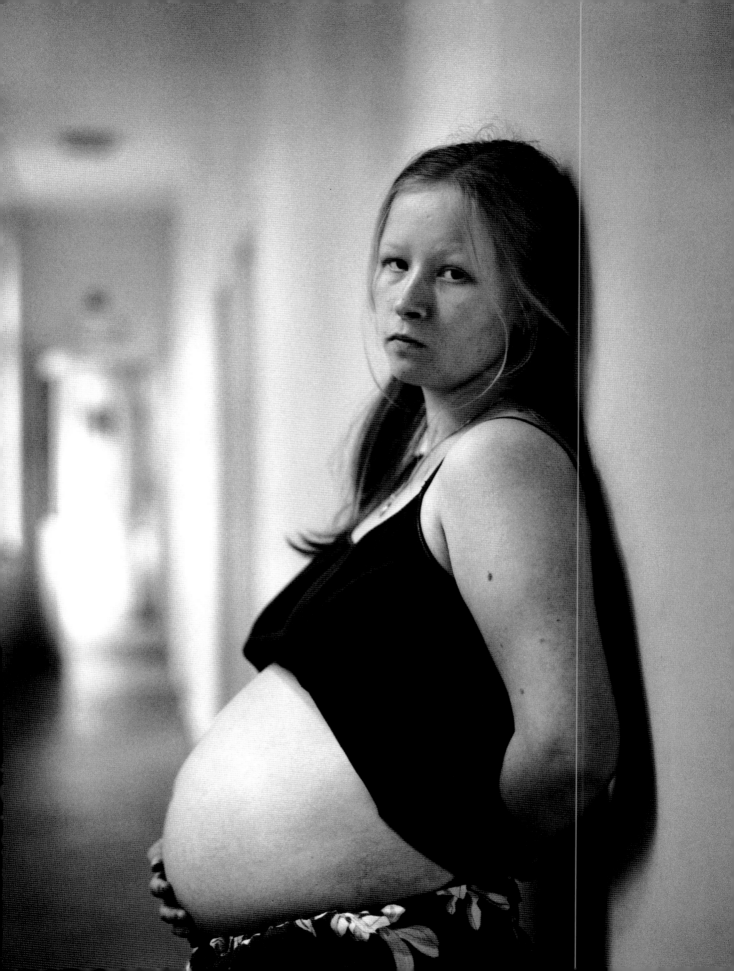

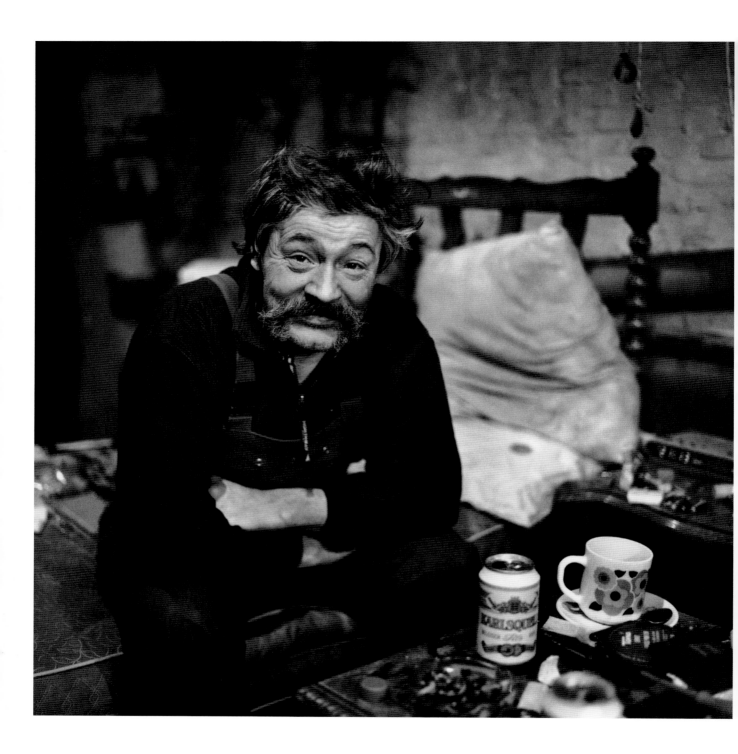

GASTON

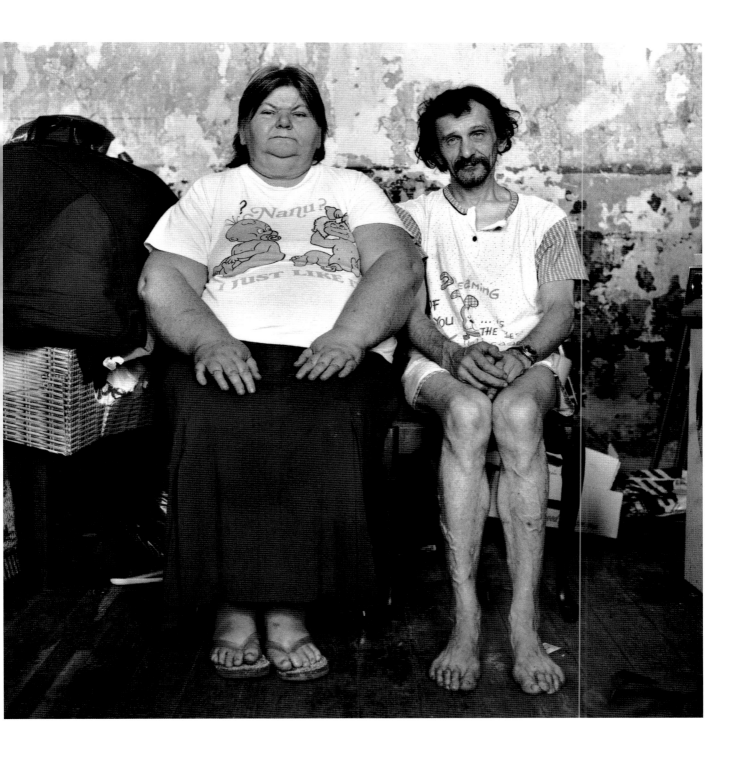

JUANITA AND ALBERT

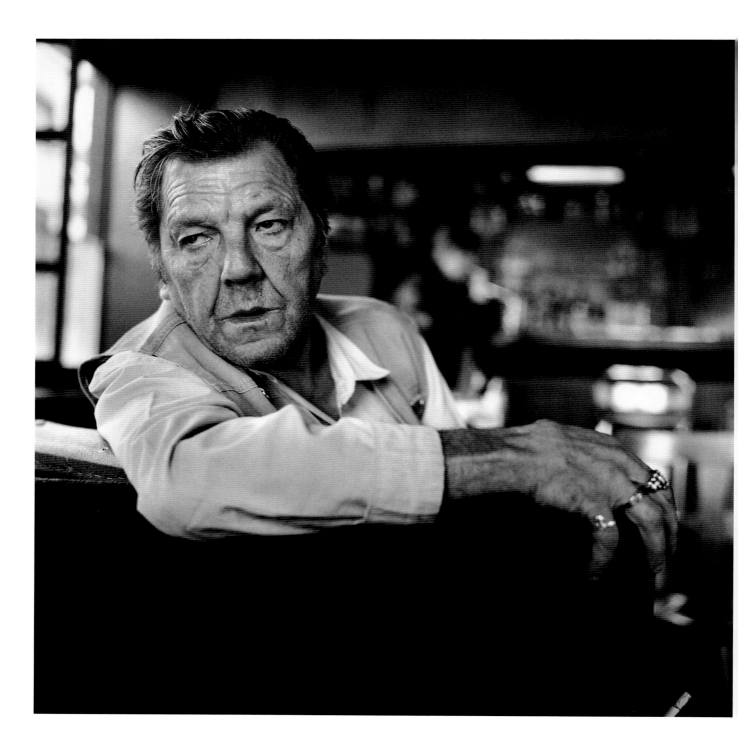

JOHNNY

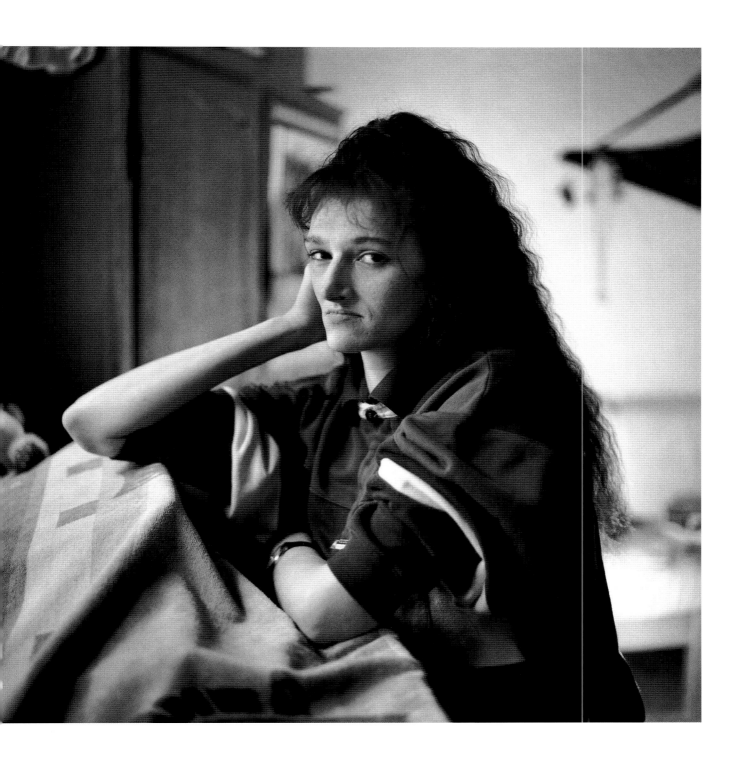

KRISTEL

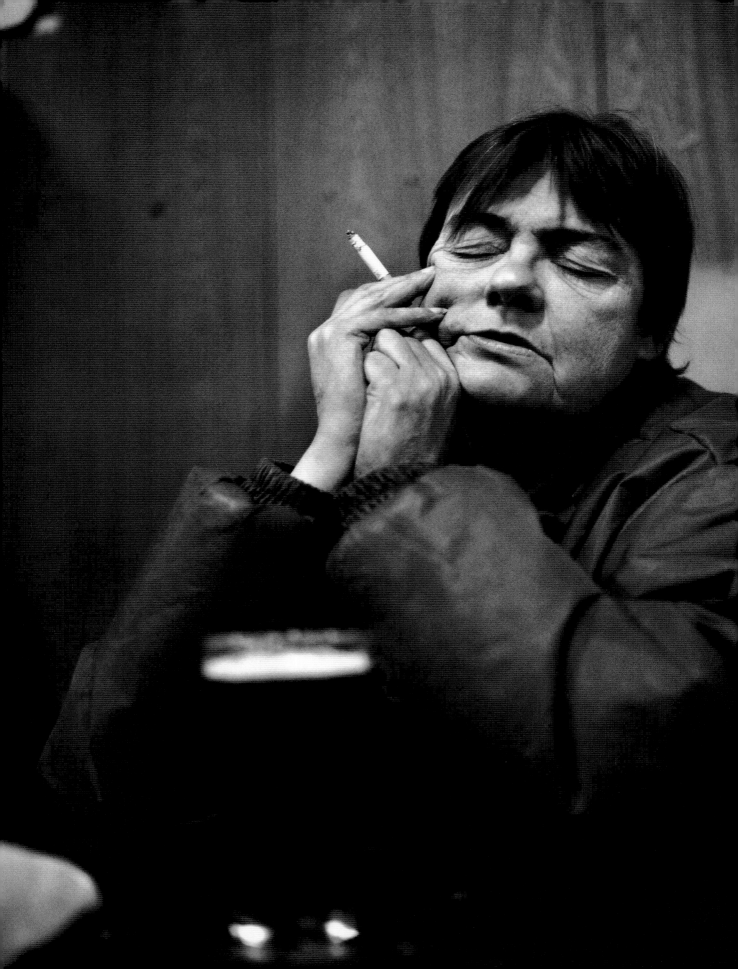

MARTINE

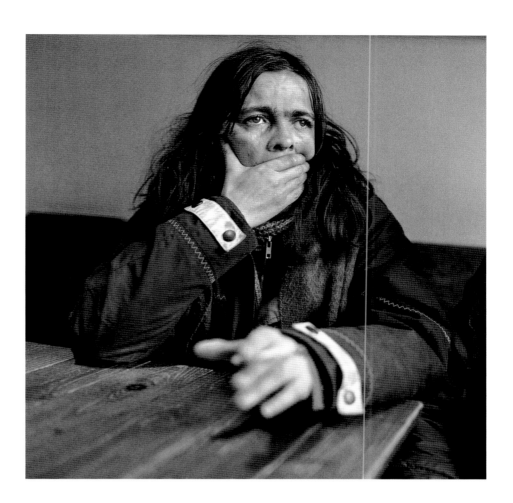

REGINA

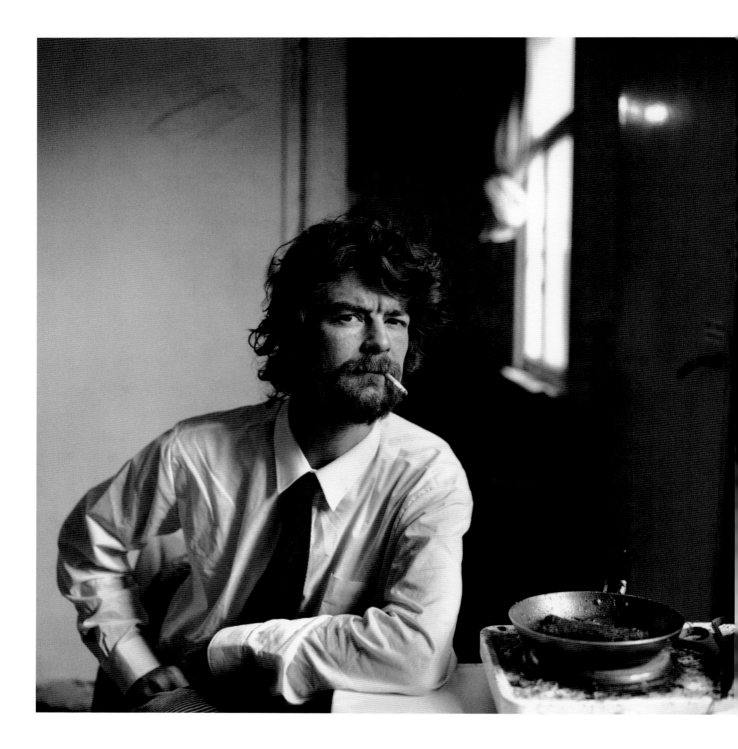

IVO

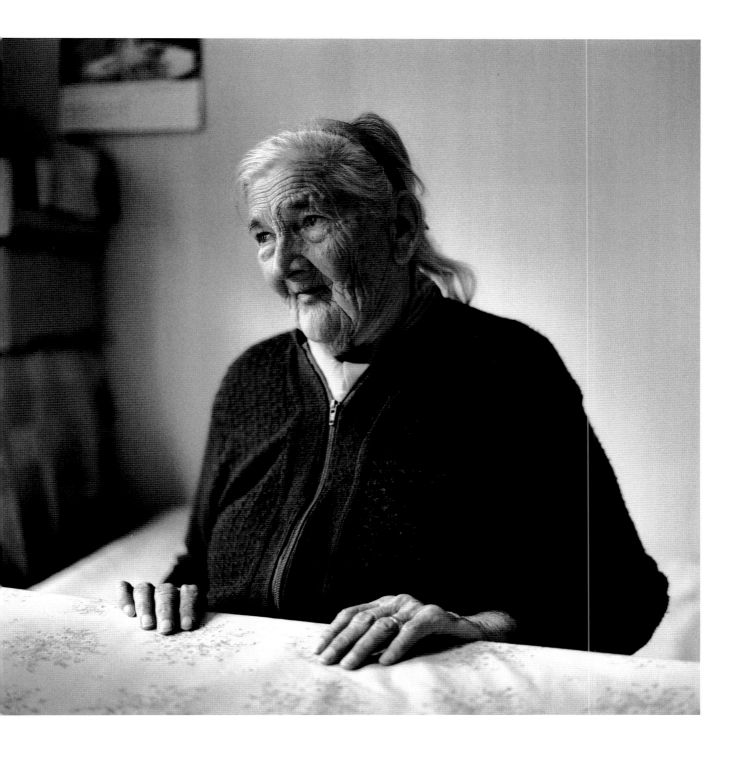

MARCELLE JOSÉPHINE

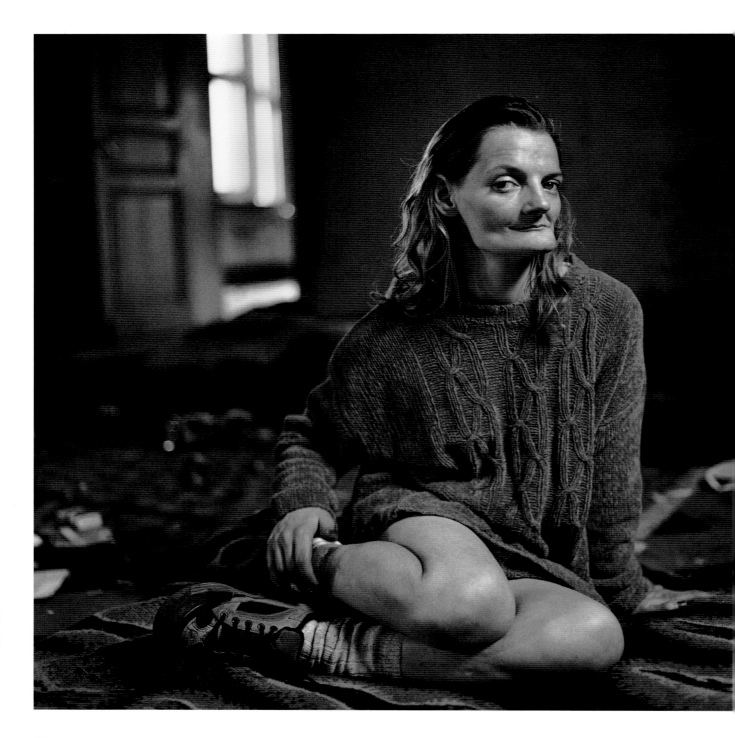

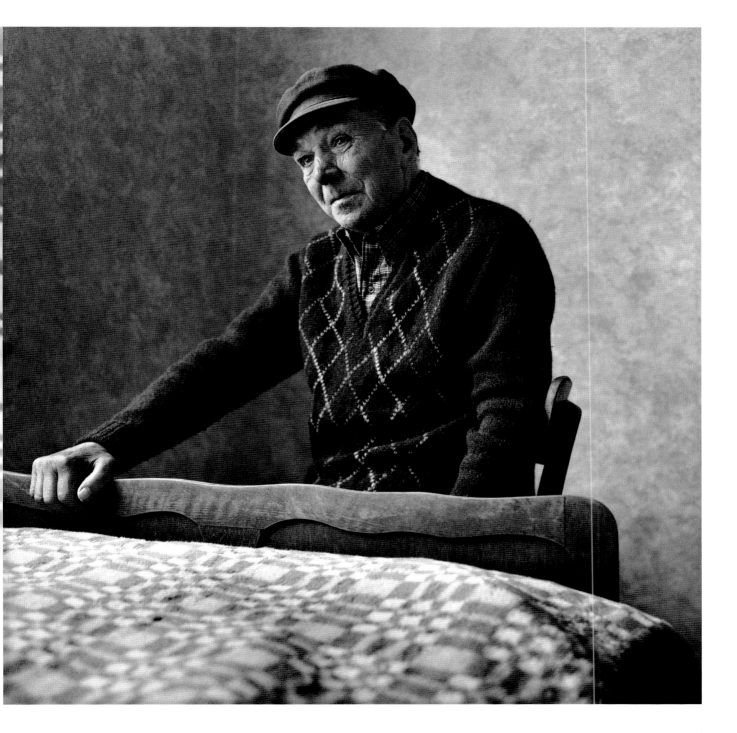

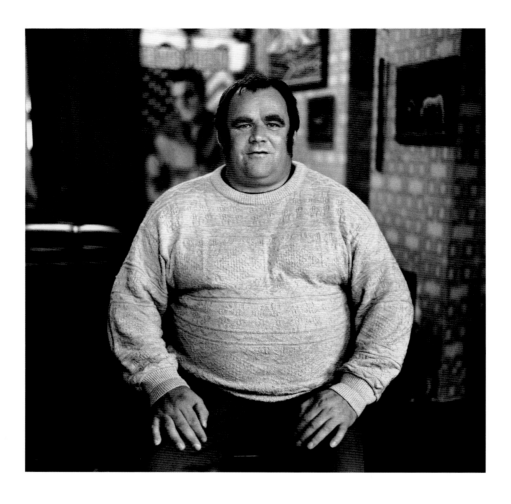

ROGER

LIZZY

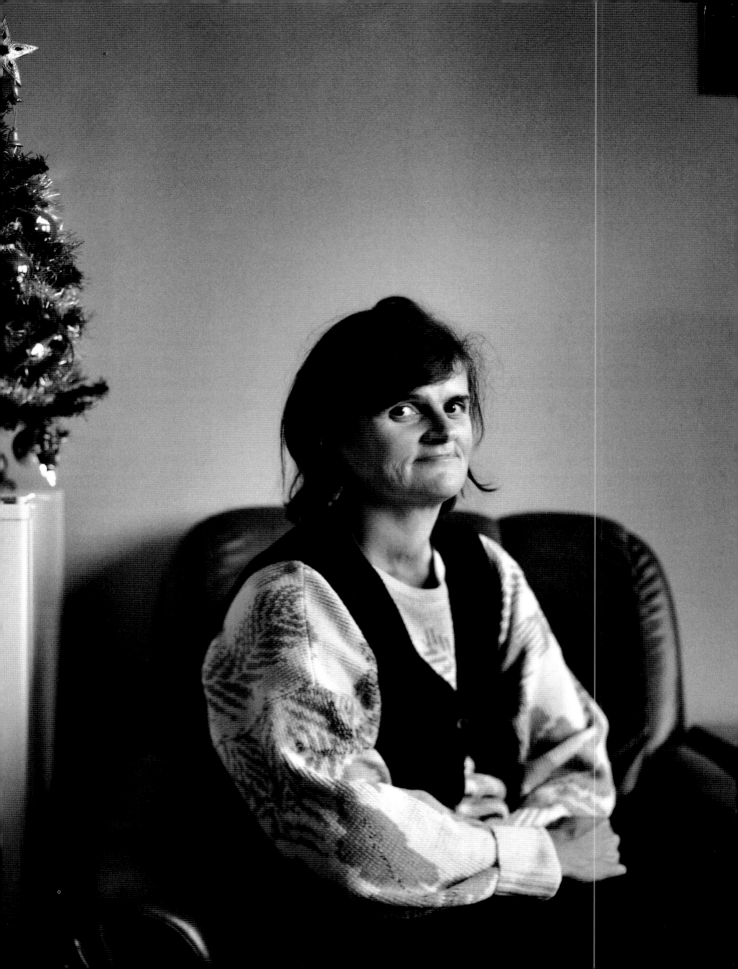

SHEHZAD NOORANI CHILDHOOD DENIED

From the relative poverty of the First World to the absolute poverty of the Fourth World. Ecological disasters, such as floods or soil erosion, and the decline of traditional areas of economic activity have subjected South Asia to an uprooting process of unparalleled dimensions. Nationwide criminal networks profit from the fragmentation and destruction of traditional communities, and their main victims are children.

The flickering images of Bollywood stars on the Indian Zee TV channel appear unreal and dreamlike compared to the lives of people on the overcrowded streets of Bombay. Over a quarter of Bombay's population sleeps on the streets, often in rain or chilly winds, next to open sewers or in cramped shanty towns. In the city of Dhaka parents abandon their children at railway stations because they cannot afford to feed them. Women give their daughters away to 'uncles' because they cannot pay a marriage dowry.

In a remote village to the north-east of Kathmandu Sangeeta Sani, a poor Tamang woman, encouraged Seema, one of her two daughters, to go to the city to find work. Seema ended up in a Bombay brothel where she contracted HIV. When she could no longer work, she returned home, dying of AIDS two years later. Her mother feels responsible for her death. Unfortunately, this story is not an isolated case among the Tamangs, the largest Tibeto-Burman ethnic group in Nepal. Little is known of their history except that they have been exploited by higher castes, especially since the unification of Nepal under the Shahs. In the nineteenth century, their legally defined status was the lowest of any hill people, and much of their land was distributed to higher castes. The Tamangs were prevented from joining the government or the military, and they remain mostly extremely poor, working as porters, cart-pushers, or rickshaw-pullers. Many Tamang women have been forced into prostitution.

In rural Nepal, thousands of women are caught in a vicious circle, perpetuated by lack of education and opportunities. From a young age, girls must help their mothers at home or work on the farms to support their family – the common attitude is that education for girls is a wasted investment. A seven-year-old Tamang girl in Taluka village, balancing a heavy basket tied on her head, said, 'No, we don't go to school. We have no money, and mother says we must all work.'

Nepalese women are targeted for recruitment into the sex trade because they are poor and lack alternatives. Every year, according to an ILO study, it is estimated that 12,000 children are sold to brothels in India; over half the girls are under sixteen, a quarter under fourteen. Hong Kong is said to be the second biggest market for Nepalese children after India. A woman or a child is most vulnerable when she leaves home for the first time, looking for an alternative to poverty. Both in Nepal and in Bangladesh there are brokers who roam from village to village, selling dreams of life-changing jobs. Some women, believing that they have been hired as carpet-weavers or garment-workers in the city, find that they have been sold into prostitution. Some consciously choose the sex industry because other work is either unavailable or does not pay enough to send money home.

Salma Begum, a woman who works in a rice mill in a village in the northern parts of Bangladesh said, 'We have no land, no cattle. My daughter Mumtaz is growing and we have already started to receive marriage proposals for her. She is fifteen now, and we will marry her as soon as we can find a suitable person. We will have one less mouth to feed.'

Desperation drives poor people to sell their children, especially girls. Usually, these are soft sales in the form of marriage, or a verbal labour contract when a person offers to look after the child in exchange for domestic help. Marriage can provide the

perfect cover for parents to get rid of their children, often without a dowry. At the same time it provides an excellent medium for a procurer to obtain girls for prostitution. Parents generally get nothing in return, only a promise that the person marrying or hiring the child, will look after her. They may know what the fate of their child is going to be, but, having no other option, choose to keep quiet.

Prostitution, poverty and economic policies are inseparable. Whether the motive is profit or survival, it does not seem to matter that human beings are converted into merchandise. People who are already at the bottom of the economic ladder are forced to trade anything they have. For international organized crime, the traffic in people is as important and lucrative as the traffic in drugs and arms. India is a major hub of the trade in human misery, and about two million women are involved in commercial sex work there – one in four below the age of eighteen.

Processes leading to what is now called 'globalization' have been taking place since ancient times. The urge to transcend boundaries was driven in large part by trade, and recently it has been further powered by big technological advances. The costs of transport, travel and communication have fallen dramatically, almost entirely because of technological progress. Unfortunately, this has brought wealth and technology only to a select few living in the urban centres in the developing world. It has brought indescribable suffering and humiliation to much larger numbers of people living in rural areas, or worse – in the slums of the megacities.

Dashing youths outside a private college in Bombay or in a trendy internet cafe in Dhaka have very little in common with those who struggle on the same cities' streets, just trying to survive. These two extremes live in two completely disconnected worlds that have very little to do with each other. If globalization has worked at all, it certainly has not been able to penetrate through the caste and class system into the deep-rooted poverty all over southern Asia. The cost of living has rocketed, and those who could comfortably afford three meals a day now have difficulty in earning enough even for two. This disparity has the worst effect on the households headed by women and those who have dependent children. These families are often uprooted from their communities and driven to live on the streets. As a consequence, there has been an enormous increase in rural-to-urban migration, contributing to an astonishing number of women and unprotected children in urban centres. The resulting dilemmas can vary depending on the social structure, culture and religion of different societies. In most cases, however, it takes its highest toll from the most vulnerable.

The United Nations estimates that over a million children are subject to sexual exploitation in Asia alone. In his distressingly frank book *The Child and the Tourist*, Ron O'Grady writes: 'When you encounter some of the young boys and girls who have become the victims of this trade, you begin to realize why the prostitution of children is now being seen as a crime against humanity.'

Some names of people and places have been changed.

A NEPALI WOMAN in the foothills of the Himalayas to the north-east of Kathmandu (overleaf). Chisapani, Nepal. August 2002.

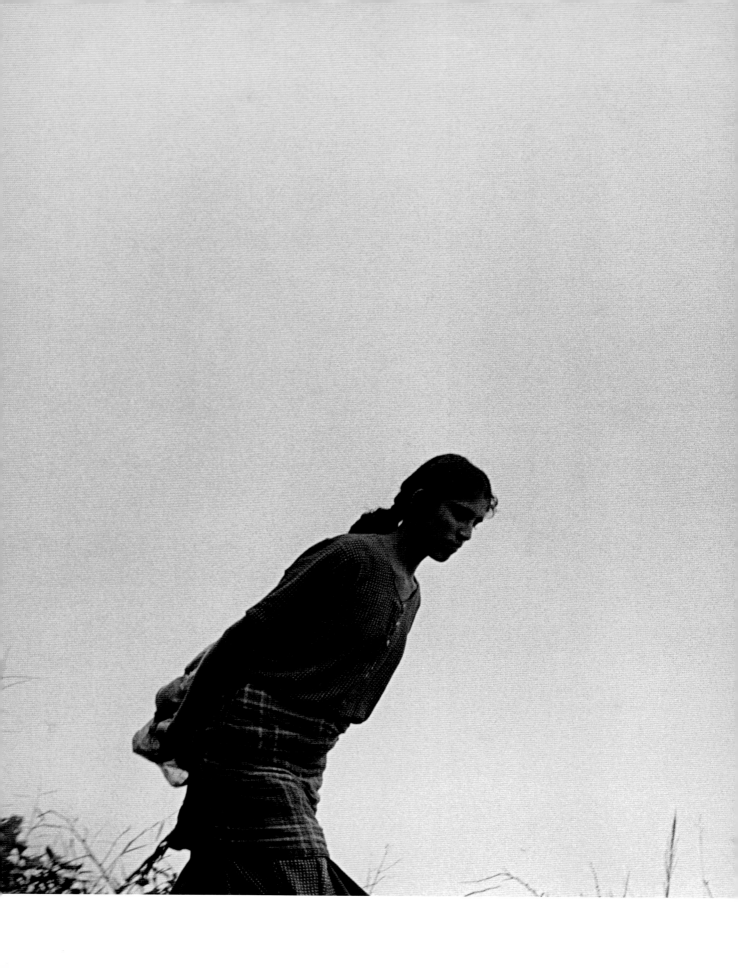

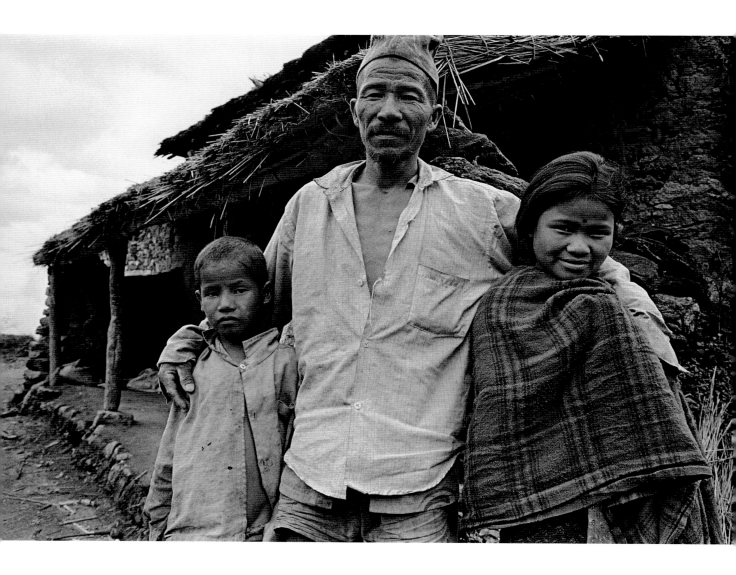

SRI RAM WITH RAJENDRA AND KANCHI MAYA,
two of his four children. His wife died of 'swelling'
during childbirth. He belongs to the ethnic group of
Tamang, a low caste in Nepal, and he earns a living by
working on other people's land as a labourer. He gets
about 25 Rupees per day (about 33 US cents).
Taluka, Nepal. August 2002.

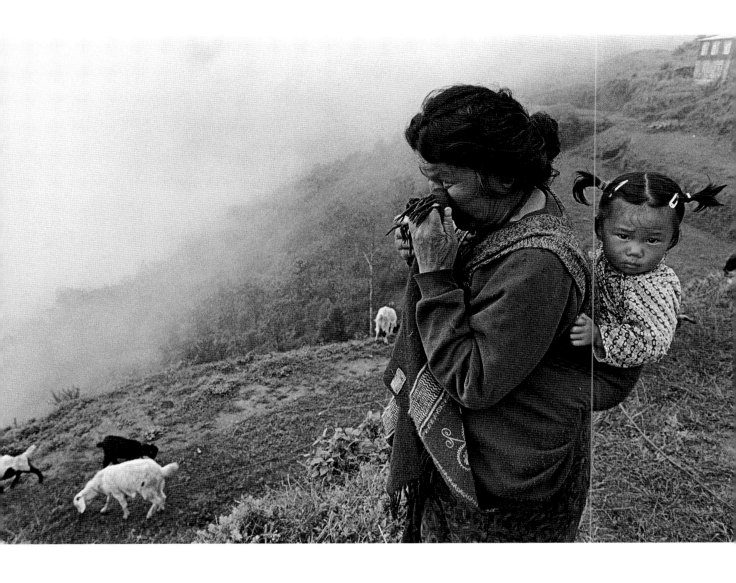

LIFE IN THE VILLAGES IN THE FOOTHILLS
of the Himalayas is as isolated as it could be.
A day's hike from Kathmandu, there are no paved
roads and no electricity. Agriculture and the passing
trekkers are the main source of income.
Chisapani, Nepal. August 2002.

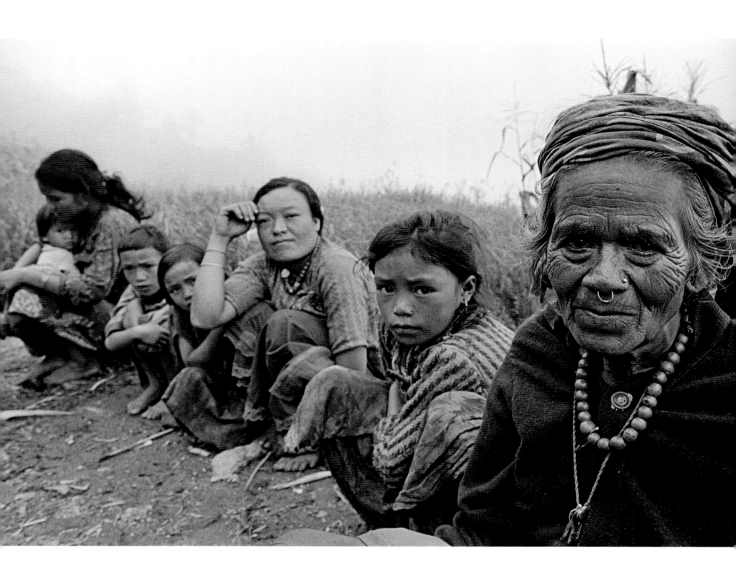

SANGEETA SANI, A VERY POOR TAMANG WOMAN,
encouraged Seema, one of her two daughters to go to
Kathmandu to find work. The search for work eventually
took Seema to a brothel in Bombay where she contracted
HIV. When she became too sick to work any more, she
came back to Taluka. She died of AIDS at home. Sangeeta
Sani considers herself responsible for her death and said:
'I am so sorry. I ate her.' The women in the background
are Sangeeta Sani's daughters-in-law. Their husbands
have gone to Kathmandu to work as a day labourers.
The children work in the farm nearby and do not go to
school. There is every possibility that history will repeat
itself again with the children of this poor Nepali family.
Taluka, Nepal. August 2002.

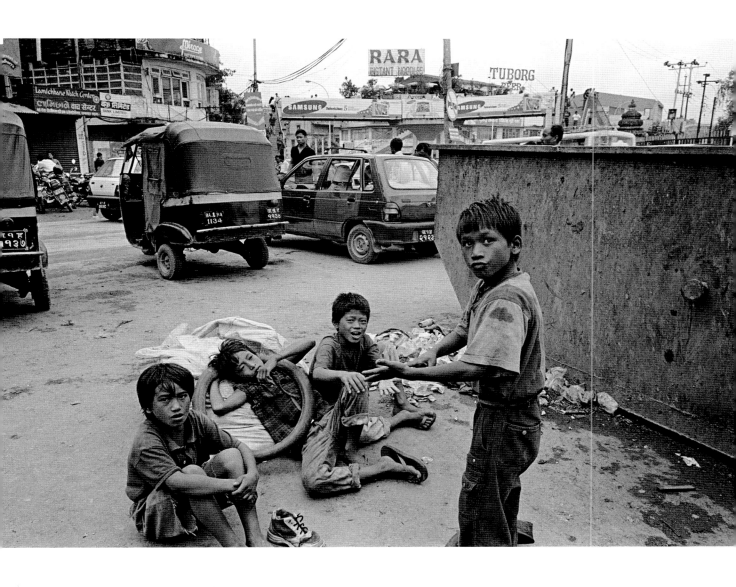

A GROUP OF STREET CHILDREN on one of
the busiest streets of Kathmandu near New Road,
full of electronic and fashion apparel stores. They
scavenge on the streets for recyclable materials.
Kathmandu, Nepal. August 2002.

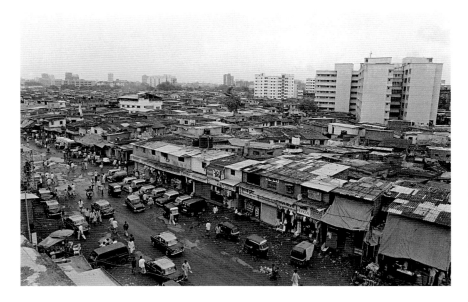

ONE DAY RENU DISAPPEARED FROM SCHOOL.
She was twelve, and she was going to be married.
It was a big ceremony attended by special guests,
and she married her grandmother. The following
day, she was divorced by her grandmother. As a
divorcee, she was considered spoiled. A man paid
10,000 Taka (the equivalent of about US$180) to
spend the first few nights with her. Now Renu
is fourteen (above, at the back). She looks older,
probably because of the steroids and other
hormones she was given to make her body develop
faster. She has a six-month-old child, and anyone
can sleep with her for 20 Taka (about 36 US cents).
Kandhapara Brothel, Tangail, Bangladesh.
November 2001.

KURLA, ONE OF THE LARGEST SLUMS OF ASIA.
Because of population pressure in Bombay, high-
rise buildings are rapidly springing up, replacing
slums one by one (top). Today an estimated twelve
to fifteen million people live in the megalopolis.
Bombay, India. August 2002.

IN THE SONARGACHI NEIGHBOURHOOD
of Calcutta, some sex workers sit by and
others try to solicit clients. Calcutta, India. August 2002.

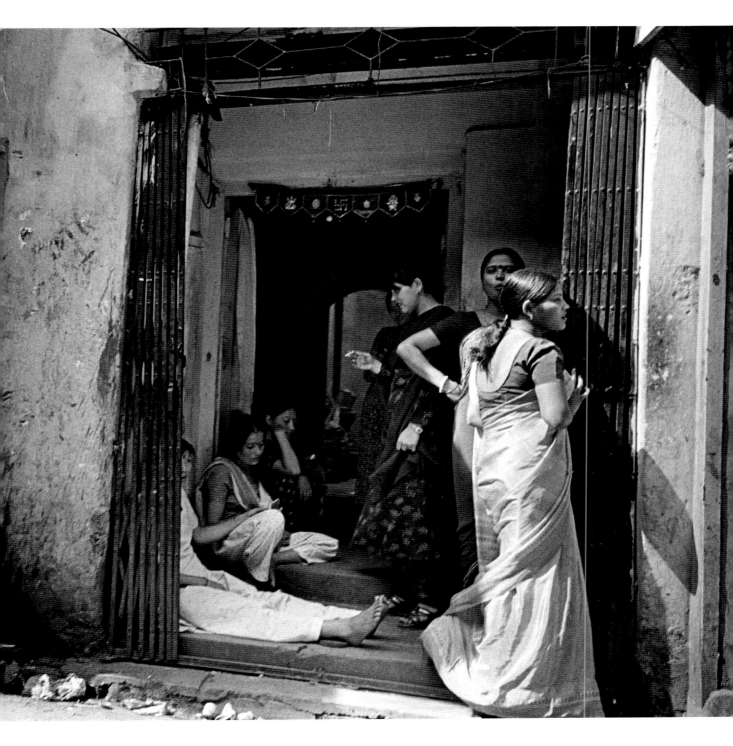

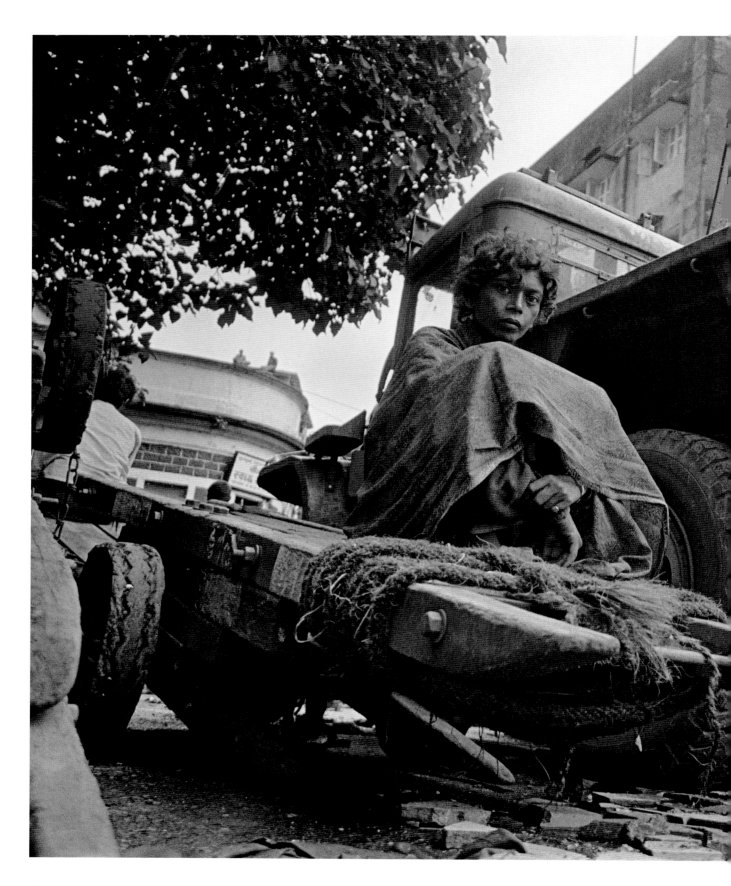

A WOMAN WITH HIV outside a well known brothel in Bombay. 'I am no one you want to know. I have no name any more. I have been thrown out of the brothel. I am too sick and people are afraid of me. I am useless now. I just sleep here awaiting my death.' Bombay, India. August 2002.

115

SITTING BETWEEN SCOOTERS
at the Kamlapur Railway Station,
a young street child is crying of hunger
in the early hours of morning. He had
nothing to eat the night before, and
his hunger has become unbearable.
Dhaka, Bangladesh. July 2002.

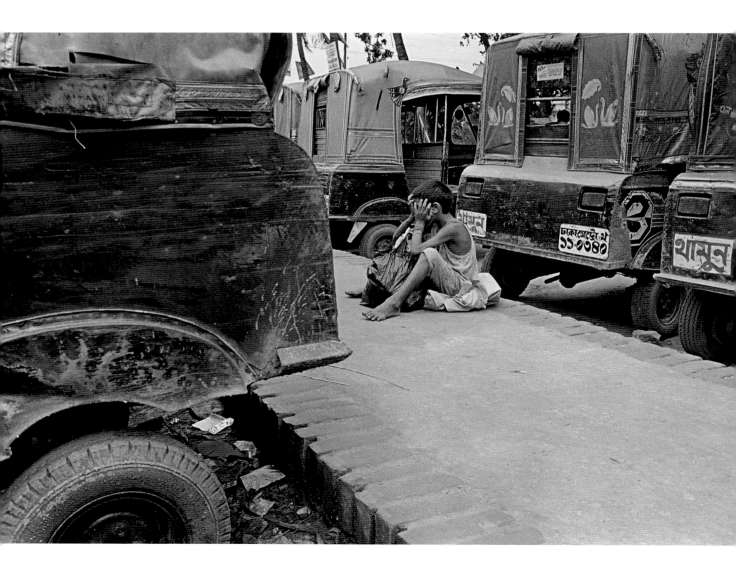

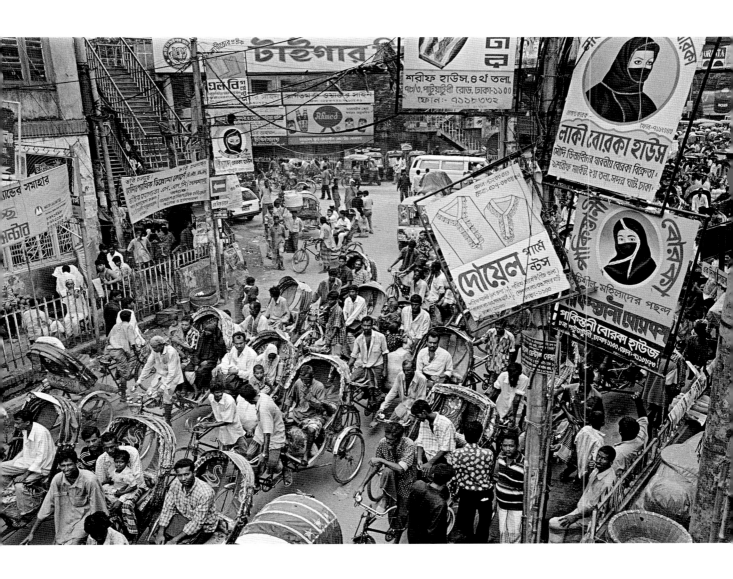

A STREET THAT LEADS to Sadarghat Ferry Terminal in Dhaka (above). Every inch of available space is taken over by people, rickshaws or advertisement hoardings. Dhaka, Bangladesh. July 2002.

FAISAL AND HIS YOUNGER FRIEND (right) pull a rope attached to a boat carrying drums that once held diesel oil. They search through the empty drums for any drops of diesel they can find. They use a long metal rod with a piece of small sponge attached to it to collect leftover oil, which they filter with an ordinary piece of cloth. By selling this oil, each manages to earn between 40 and 60 Taka per day (from 72 US cents to just over US$1). But there is a price to pay for earning so much money: diesel burns their hands and causes painful infections. Dhaka, Bangladesh. July 2002.

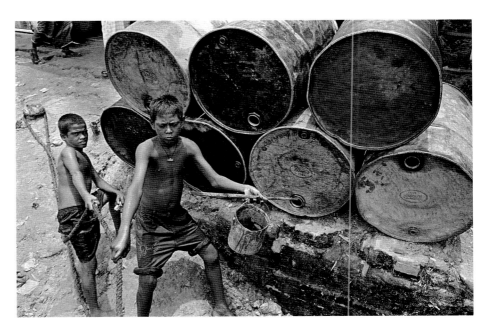

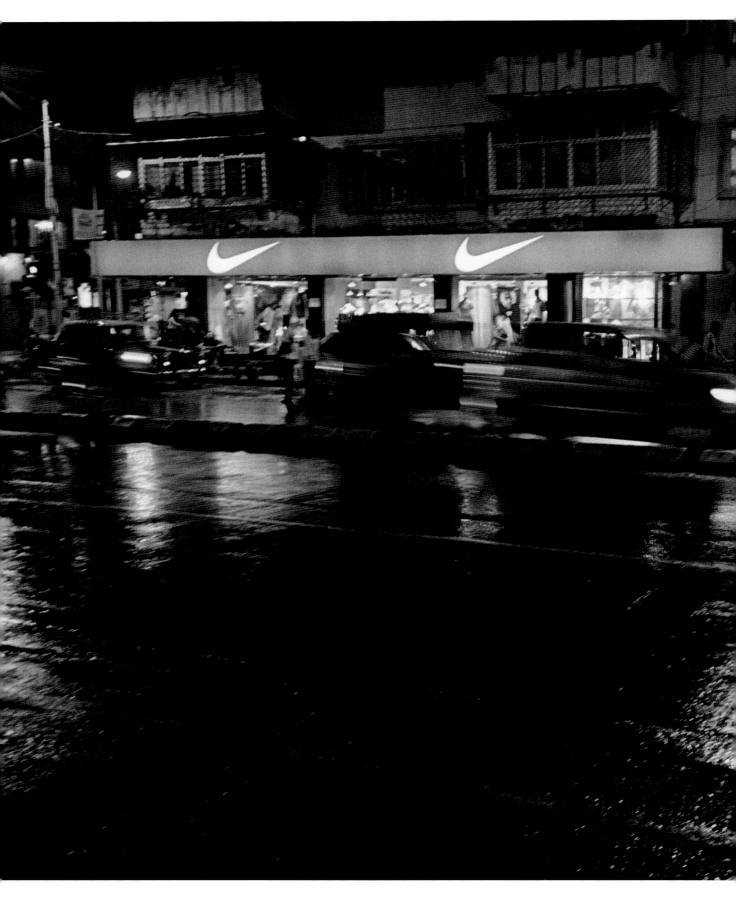

LOGOS SHINING through a rainy night in a suburb. It is the promised participation in a better world that brings people to the illuminated cities. Bombay, India. August 2002.

TRAUMATIZED NUSRAT with her younger brother Narjol sleeping beside her. 'My mother left us here two days ago. She probably went to Comilla. She did not come back. I ate a piece of bread yesterday morning. I am very hungry and cold. I don't know when my mother will come back. If she doesn't come back, I will just keep sleeping.' Dhaka, Bangladesh. November 2001.

TWO MEN TRY TO PERSUADE SAIFUL, a street child who lives at the Kamlapur Railway Station, to come to Chittagong (opposite above). They promised to find him a well paid job. 'My father married four times. My mother is the fourth. She works at a local cigarette factory in Rangpur. She gets 10 to 15 Taka [18 to 27 US cents] per day and cannot feed us. I always used to be hungry, so I left with a friend. We both used to work at the railway station, but he suddenly disappeared two weeks ago. I don't know where he has gone. He is lost. Those men? They want me to go to Chittagong. They said that I could earn a lot of money. I didn't go because I was afraid.' Dhaka, Bangladesh. November 2002.

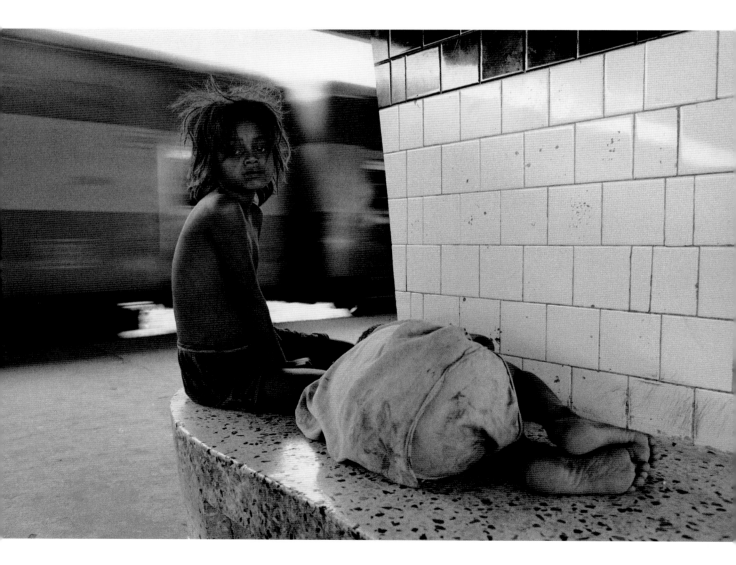

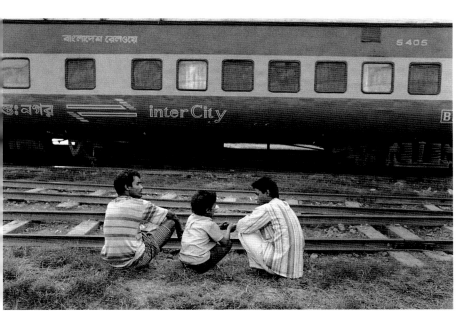

THERE ARE HUNDREDS OF CHILDREN who take refuge in the big buildings of Kamlapur Railway Station and Sadarghat Ferry Terminal (below). They try to earn a living by helping passengers carry their luggage to and from their trains and boats, or by selling cigarettes and fruit on the ferries. They sleep in a group, almost on top of each other, in order to protect themselves. Men, older street children, drug addicts, even policemen, often try to use them sexually. Sometimes these children serve a purpose for the politicians and policemen. When the police cannot find enough trouble-makers for the required quota, they come here and pick up street children instead.
Dhaka, Bangladesh. November 2001.

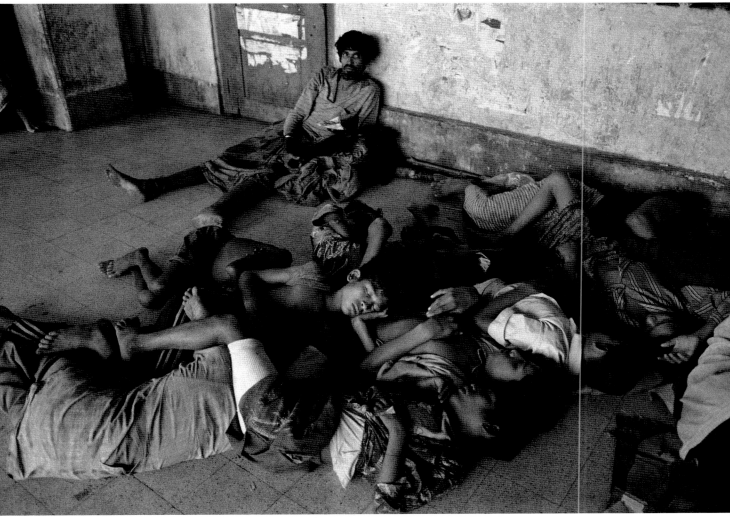

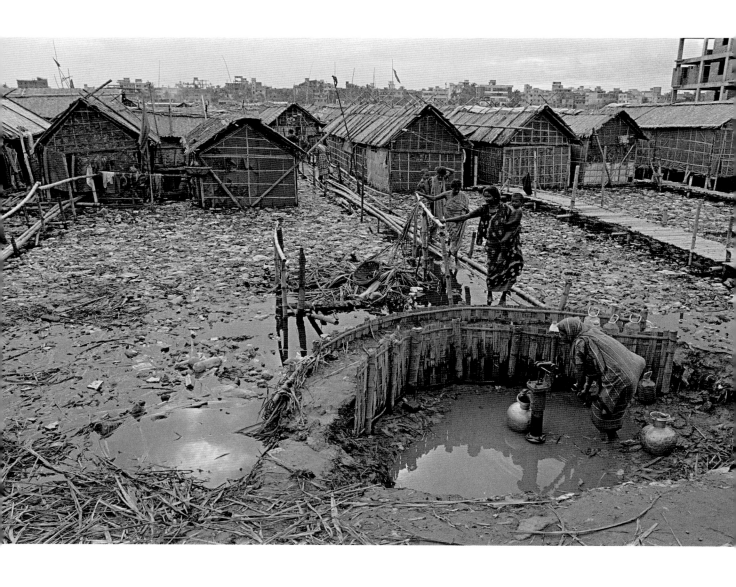

ON THE OUTSKIRTS OF DHAKA, a bamboo slum has
been built directly over a pool of chemical waste from
nearby tannery plants processing hide and leather.
Using a hand pump installed over this pool, in
an area secured by a mud wall, women are drawing
contaminated water for drinking and cooking.
Dhaka, Bangladesh. July 2002.

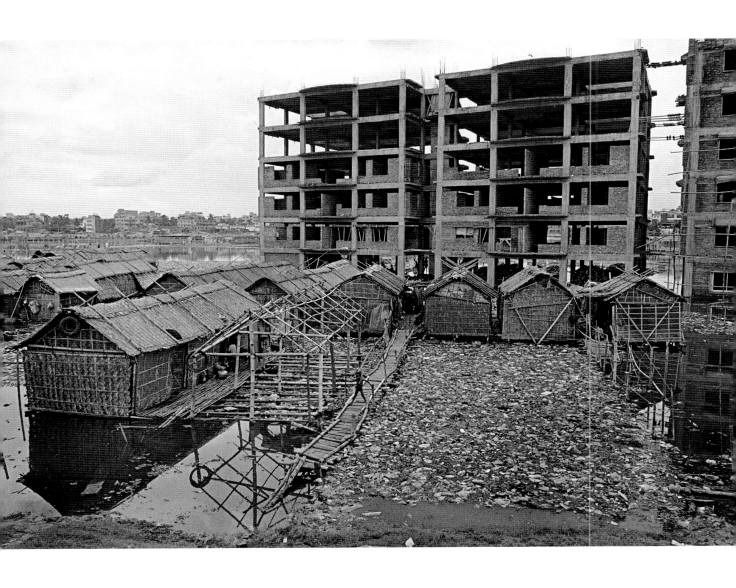

NEXT TO THE BAMBOO SLUM, a high-rise building goes up. Like any other megacity with a high population density, Dhaka makes property investment very lucrative. The city is growing at a tremendous speed, and property developers are taking over every available space. As soon as the construction is completed, the slum dwellers will be forced out of their homes. They will have to find somewhere else to live. Dhaka, Bangladesh. July 2002.

SAFDAR RAN AWAY FROM HOME. He was tired of beatings and abuse from his father, who wants him to work. Safdar is originally from Faridpur, but his family moved some time ago to Dhaka. He is waiting for a boat to take him away, anywhere where his father cannot reach him. He doesn't have the money for the fare. He is a likely target for child traffickers, who are plentiful in any bus-, train- or boat-terminal. Dhaka, Bangladesh. November 2001.

ABDUL HOSSAIN, cutting his immature jute crop
before the land is eroded by the river. Riverbank erosion
is a silent and insidious disaster for tens of millions of
people who live in the villages along the country's major
rivers, constantly endangering their habitat. Every year,
over two-thirds of the people living in the flood plains
of the Ganges-Brahmaputra delta are subjected to
floods, tidal surges, erosion and cyclones.
Sariakandi, Bogra District, Bangladesh. July 2002.

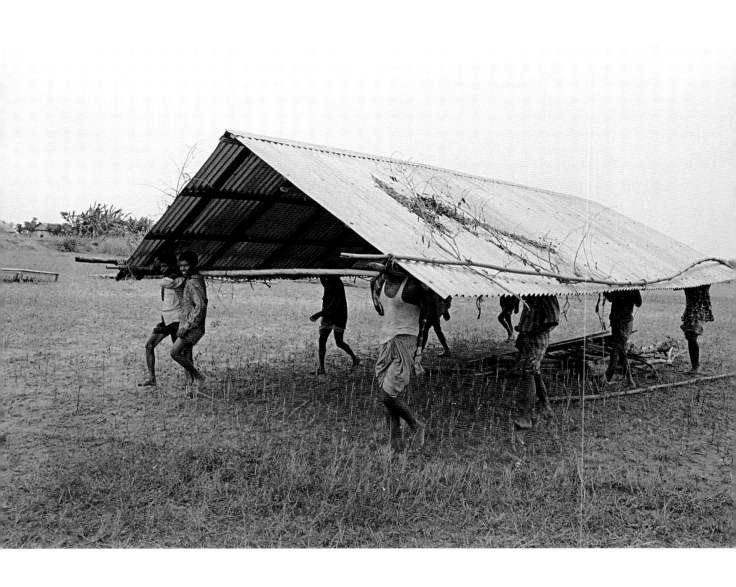

THE ROOF OF A HOUSE is being moved to a safer place just before the land that the house was built on is eroded by the river. 'In few months the rain will stop and the river will calm down. Some of the flooded land will reappear and we will move the house back to where it belongs.' Sariakandi, Bogra District, Bangladesh. July 2002.

ZIYO GAFIC QUEST FOR IDENTITY

From ecological catastrophe to that of war. The war in Bosnia has been described as a throwback to the nationalism of the 19th century, but without the influence of trans- and supranational resources it could never have happened. The international community, the media, and sympathetic states had as much to do with this conflict as diasporas and religious communities.

i When the war was over, a foreign journalist came to interview my professor of poetry, Marko Vesovic. Entering his apartment, the journalist noticed my professor's dog who was lying in a corner.

'What remarkable blue eyes he has,' the journalist said. 'Well, you see,' explained my professor, 'the dog used to eat the same food that we ate during the war. Now he is blind. Dogs age seven times faster than we do, so with us it is different. We still have to wait for the effects.'

ii I never witnessed a mortar shell exploding in front of the people in the market place or a sniper shooting someone in front of my high school. I was always a couple of seconds or minutes late, or I would pass by the market place just before the shell exploded and killed more than sixty people waiting to buy groceries, or I would be running in a dark street with broken glass falling on me. But I've seen people cleaning the streets after shelling, I've seen what was left of a young man after a thirty-kilo shell

exploded near him, and I've also seen the face of a woman who survived this unhurt.

iii Lately, when I was in Jerusalem for the first time, I wanted to visit the Al-Aksa mosque. At the entrance I was stopped by an Israeli soldier, a native Russian, and an Arab guard of the mosque. 'You are not allowed to enter,' said the soldier. 'You are not Muslim.' 'But I am!' I insisted. They wouldn't believe me. In Italy, I told an acquaintance of mine that I was a Muslim. He was irritated. 'But then,' he said, 'you cannot be a European.' 'But I am!' I replied.

iv The Turks have left us with an unsolved national question. Religion and culture have always been strongly intermingled in our country. When the Ottoman Empire conquered Bosnia in 1453, the strategy it used to establish its rule was Roman: *Divide et impera*. Religion was the vehicle. Favouring the Muslims helped the Turks run the country, but it divided the Bosnians. In the nineteenth century,

during the era of Romanticism, when Central Europeans began to build up their ideas of nationhood based on concepts of cultural uniqueness, Bosnians developed their own cultural identities out of religious affiliations. But these cultural identities failed to develop into the idea of a Bosnian nation: Bosnian Catholics and the Bosnian Orthodox were seduced by the ideas of a Great Serbia or a Great Croatia.

Today Bosnia is a resort of moderate, autonomous European Islam. Actually most of the population are Christians: Orthodox and Catholic. The Arab countries were not too impressed by the Bosnian version of Islam, and their help wasn't sufficient to help us defend ourselves against the former Yugoslav Army, one of the strongest armies in Europe. The body count in the recent war was almost all Bosnian Muslim, but for the first time in the last two hundred years we have a state of Bosnia-Herzegovina, a language that is recognized.... We've never been closer to being a nation.

I'm afraid that the fact that Bosnians are white helped us a lot. Probably that's why it took only four years for NATO to intervene in Bosnia. Before the fall of Srebrenica, the UN safe haven zone, foreign involvement was on the level of bringing humanitarian aid, mostly only where the Serbian Army allowed, and counting the shells and bombs falling on Bosnian cities. Then, after the fall of Srebrenica and the massacre of Bosnian Muslims that followed it, NATO bombed the Serbian positions and brought peace. The first shelling of their positions around Sarajevo came at night. I remember our windows, covered by humanitarian nylon sheeting with UN signs instead of glass, flying open because of the detonations, this time on the Serbian side. My mother cooked a pie to celebrate.

vi Our lives during the war were reduced to the basics. Having a bath with five-litre cansters and then using the water for the toilet. Making meat pie without meat. We became experts at peeing in the dark. The path to happiness was very short, and the learning curve was steep. Once we all adopted these vital skills, and even got used to our little limbo and for a moment stopped talking about peace, our politicians signed the peace agreement.

We have a new anthem now. We also have a new flag. It has a dark blue ground on which is displayed a golden triangle, a row of golden stars on one side. The triangle is meant to represent Bosnia and the row of stars, I guess, implies the European Union.

Today we have to stand in a queue to get a visa for every European country.

vii The writer Ivo Andric, one of two Bosnian Nobel Prize winners, described Bosnia in one of his novels as a 'valley of darkness'. The valley is surely dark; it is dark with Bosnian blood, it is darkened by American ignorance and European impotence, it is dark because of the clouds above. Yet it is our valley.

BOSNIA IS A COUNTRY AT THE BORDERLINE and always has been. In former times, the river Drina separated the Eastern from the Western Roman Empire; later it became the front line between Ottoman and Habsburg Empire, Christianity and Islam. The bridge at Visegrad (overleaf) was built in the 15th century, at a time when the Ottomans were ruling the country. It was the only solid construction over the river, and it allowed an exchange between cultures. But this exchange has never been an easy one; the country has always been exposed to fanaticism and the nationalist aspirations of neighbours. In 1992, two thousand Bosnian Muslims were executed on this bridge that was supposed to connect the river banks. Visegrad, Bosnia-Herzegovina. July 2002.

TWO MEN WERE CARRYING BAGS DOWN A HILL.
Inside the bags were the remains of neighbours
from their village. The two men had not been there
when the Serbian army occupied their village during
the war; they had joined the Bosnian army. Now they
had come back to find their missing family members
who lay unburied somewhere in the mountains
where they had gone to hide. Thousands of these
thick nylon white bags have been used in Bosnia
in the past seven years.
Trosanj, Bosnia-Herzegovina. July 2001.

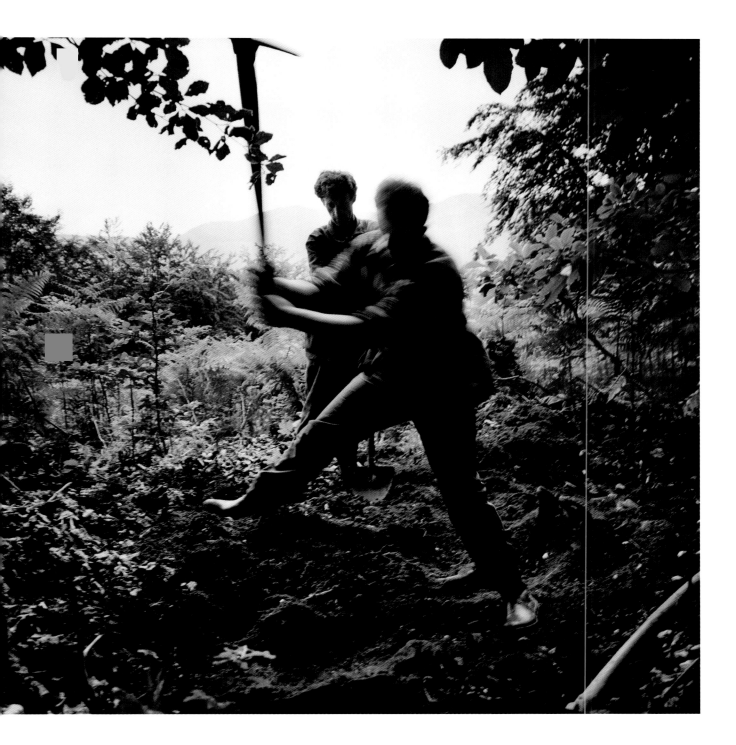

INDIVIDUAL GRAVES ARE EASY TO DIG UP.
You need two workers, one shovel and a pickaxe.
Forensics and anthropologists then collect the
bones and pack them into white plastic bags.
With mass graves, things are more complicated.
They're often situated in natural caves, and, after
people or corpses had been thrown in, the Serbian
army would drop in grenades, mortar shells,
explosives to destroy the evidence.
Trosanj, Bosnia-Herzegovina. July 2001.

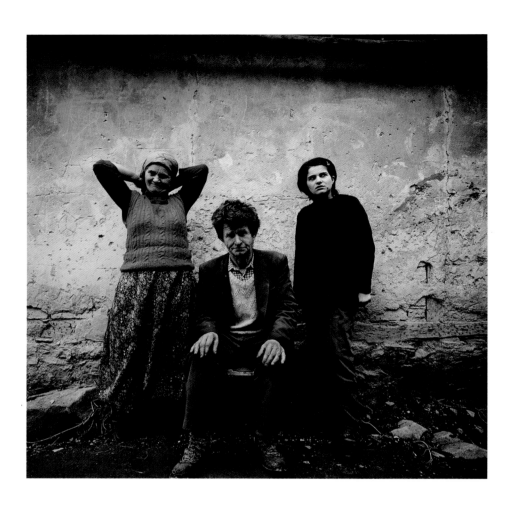

I NEVER MET MY COUSIN AGO BEFORE

I came to photograph him and his family.
He was once the richest man in his village.
He had a farm, animals, a family. In 1992 his
Orthodox neighbours joined the 'Cetnici' and
knocked on his doors. He had to give all he
had to save his family; he was severely beaten
up. Others weren't so lucky when neighbours
knocked on their doors. His daughter started
to cry when she saw me. She thought my tripod
was a gun. They live in an abandoned house
on the outskirts of Gorazde.
Gorazde, Bosnia-Herzegovina. September 2001.

APPROXIMATELY TWO MILLION BOSNIANS

were displaced during the war. Some of them
sought shelter in third countries, most were
internal refugees. Cities were strongholds
of resistance, and many people coming from
the rural areas took refuge there. They lived
in apartments abandoned by people who had
joined the enemy army or had left Bosnia; as
the war ended they had to give way to those
returning. As a result, there are many people
now living in tents or in burnt-out houses. This
Orthodox family from the outskirts of Gorazde
was quite happy. When the war began, the men
joined the Serbian army and took part in the
siege of Gorazde which lasted four years and
killed thousands of civilians. Their house was
on the front line and it was burnt down, but they
reconstructed it. Now they were moving back.
Gorazde, Bosnia-Herzegovina. April 2000.

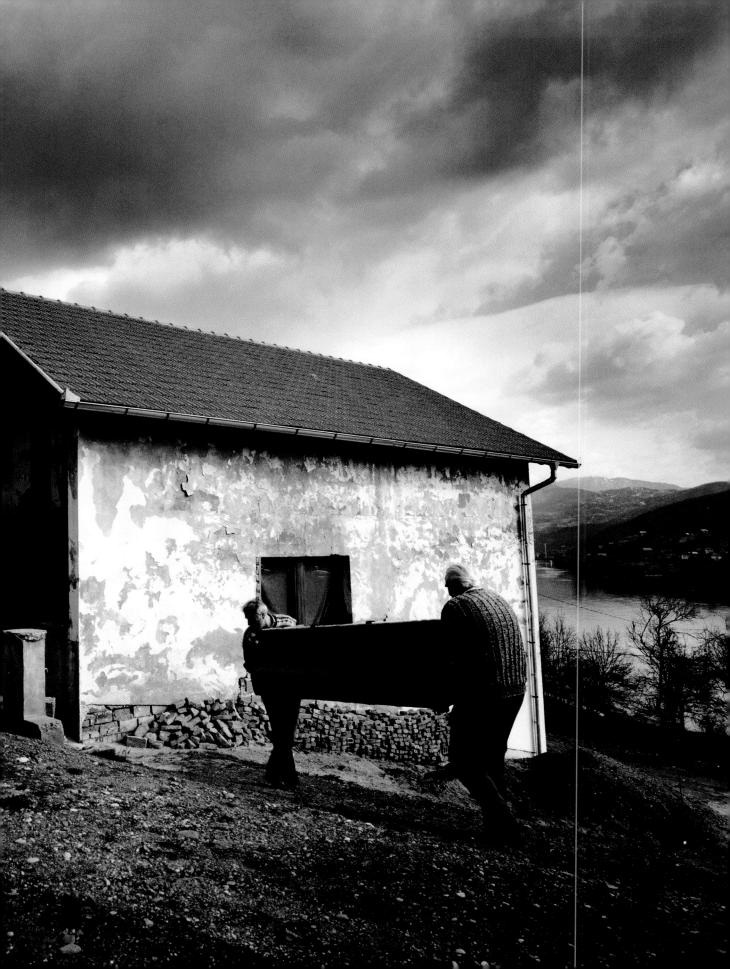

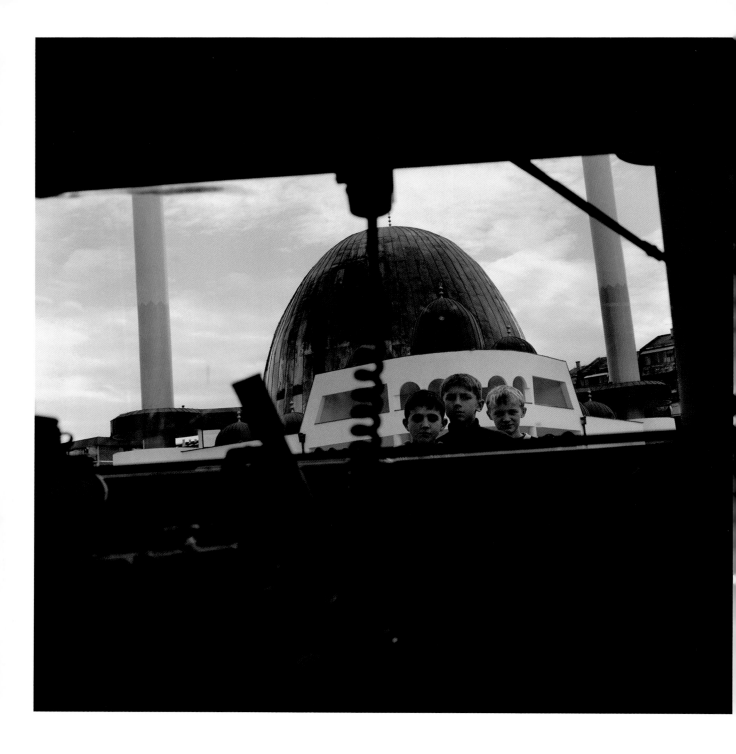

ABOUT A THOUSAND RELIGIOUS OBJECTS have been destroyed during the war. It is difficult to say when the equalization of religion and nationality began. Perhaps it started in the 19th century when Bosnia was annexed by the Habsburg Empire, and the rising nationalism in Croatia and Serbia began to use religion as a vehicle to fulfil their territorial aspirations. The Catholics became Croats and the Orthodox became Serbs. The idea of a Bosnian nation was weakened. Today there are too many people in Bosnia who don't consider Bosnia as their homeland. On a regular patrol with SFOR we parked for a lunch break in front of a recently constructed mosque. After the war, Islamic countries started to finance the building of hundreds of mosques. Yet there are still more destroyed than built. Tuzla, Bosnia-Herzegovina. September 2002.

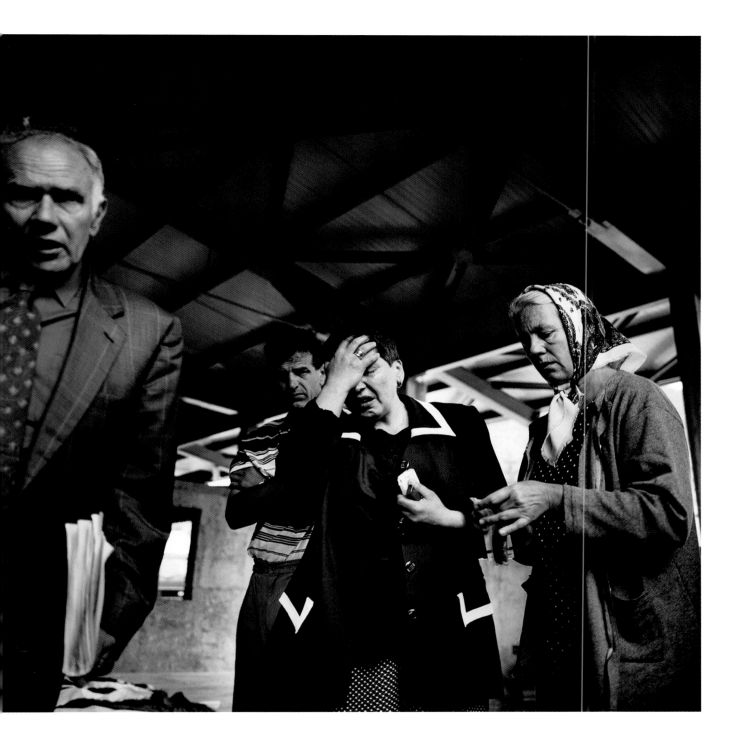

ENTERING THE MORGUE is like leaving this world and going into a sort of in-between world. It is not the world of the dead because they were not buried; yet it is far away from the world of living. They lie on the ground in those thick white plastic bags with their belongings, their families walking among them, whispering between themselves, trying to compare their memories of the beloved. It was between five and ten years ago that they lost their brothers, sisters, sons, daughters, parents; since then they haven't heard anything of them. Then one day the telephone rings to tell them to come to the morgue to identify some remains. This family is from Visegrad, eastern Bosnia. Visoko, Bosnia-Herzegovina. August 2001.

MOST OF THE PERSONAL BELONGINGS
are kept in the Commemorative Centre in Tuzla.
They are kept in small transparent plastic bags
and are marked with numbers that connect
them with the white plastic bags and the human
remains inside. Often these items are crucial for
identification. Someone's identity is reduced to
these small, ordinary objects; and yet the context
makes them extraordinary. They become a kind
of last resort of identity. I felt like a forensic
scientist and jeweler at the same time while
I was photographing them. I had to wear surgical
gloves and it was cold in the room because of
refrigerators in which samples of DNA were
stored. All the time I was trying to imagine
the faces of the owners.
Tuzla, Bosnia-Herzegovina. August 2002.

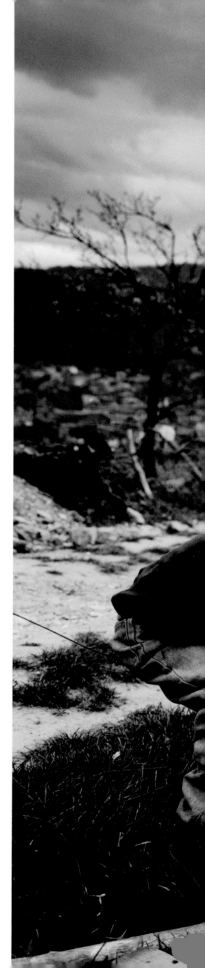

CHILDREN OF RETURNEES play in the suburbs
of Gorazde. There is an essential difference in
the look of a refugee and a returnee.
Gorazde, Bosnia-Herzegovina. July 2001.

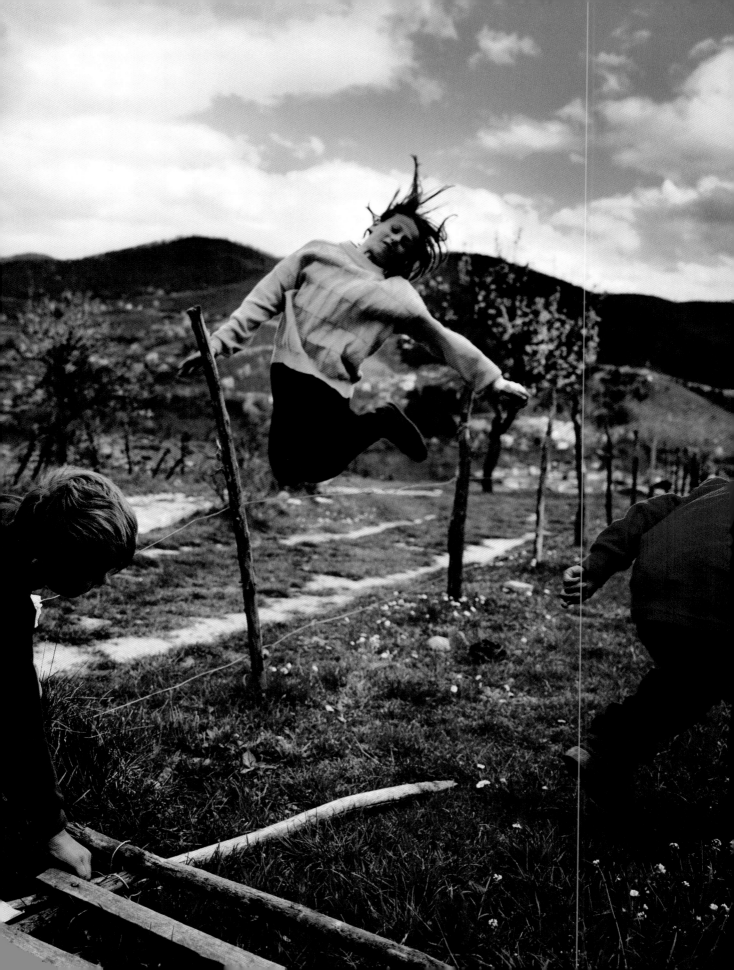

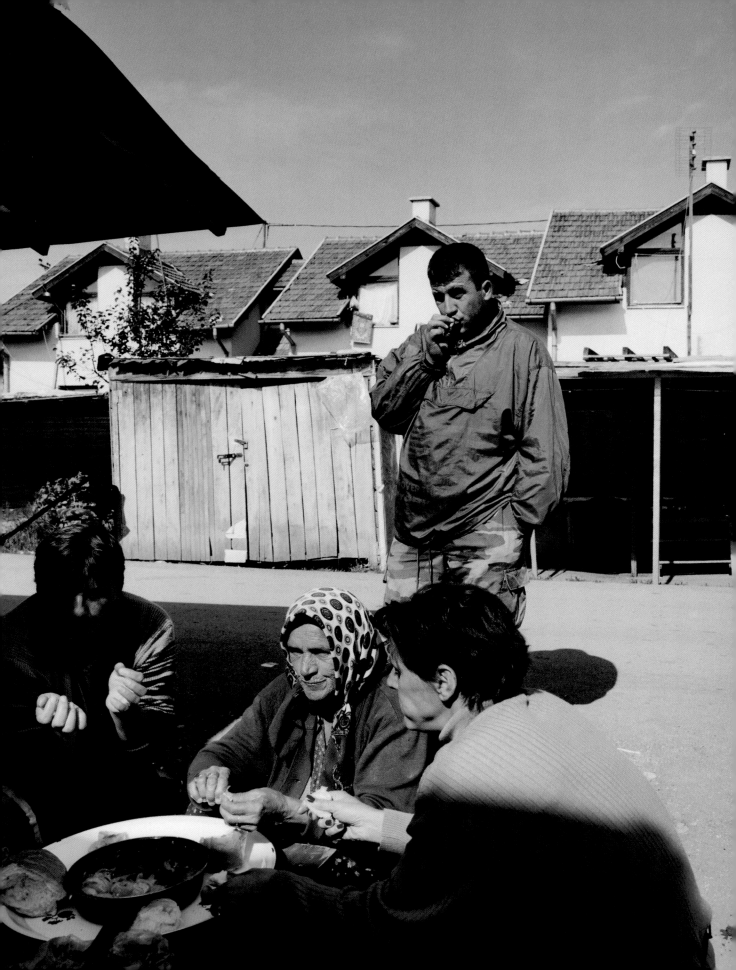

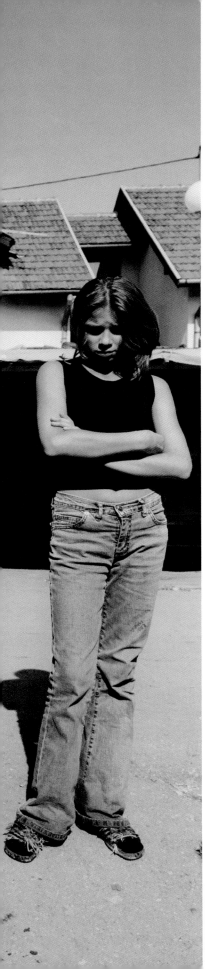

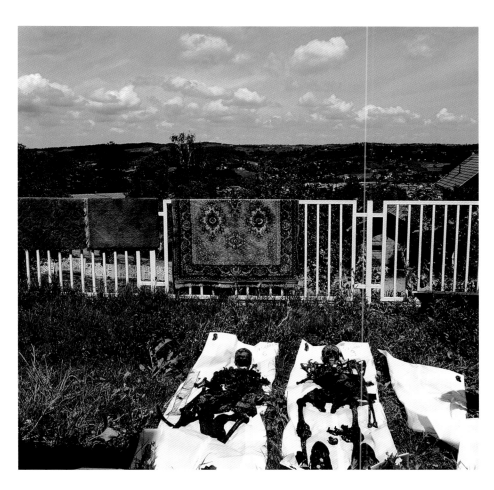

THAT HOT SUMMER NOON IN 2001, the Commission for Missing Persons organized the identification of a dozen bodies, killed when the Serbian army occupied the village of Matuzici. Bodies were displayed behind the mosque; they were simply laid down on uncut grass. Someone from the village was cleaning carpets and they were drying on the ground; later he hung them on the nearest fence to dry. Matuzici, Bosnia-Herzegovina. August 2001.

THE DUTCH GOVERNMENT has built a home for a couple of thousand of Srebrenica's refugees (left). It has been built behind a small hill so from the main road you can't see it. It's called Mihatovici because of the village nearby; actually, it looks like a sort of extension of the existing village. All the houses look the same. They're good quality houses except that you could find one family living in one room. It's been like that for five years. Almost no one wants to go back to his or her home, for understandable reasons. Mihatovici, Bosnia-Herzegovina. September 2002.

THERE IS A SORT OF RURAL PARTY IN BOSNIA; it is called *teferic* or *vasar*, and it is the same for all three religions. One of the things that differ, though, is the iconography. In the parts of Bosnia predominantly inhabited by Catholics and Muslims, you'll find posters of Mecca, the Vatican, animals, beaches. In the part predominantly inhabited by Orthodox people you'll find posters of beaches, animals, saints, Milosevic, Karadzic, Mladic. Derventa, Bosnia-Herzegovina. August 2002.

VASARS ARE USUALLY HELD somewhere in the mountains, in the open air. There is live music playing and people compete in stone-throwing. All over Bosnia drinks are the same; music is the same – something between traditional folk music and the sound of an old car engine, called *turbo folk*. In combination with roast meat and onions it makes any kind of communication almost impossible. The war brought so many people from the rural areas into the cities that you can now hear this kind of music in the centre of Sarajevo. Near Ilijas, Bosnia-Herzegovina. August 2002.

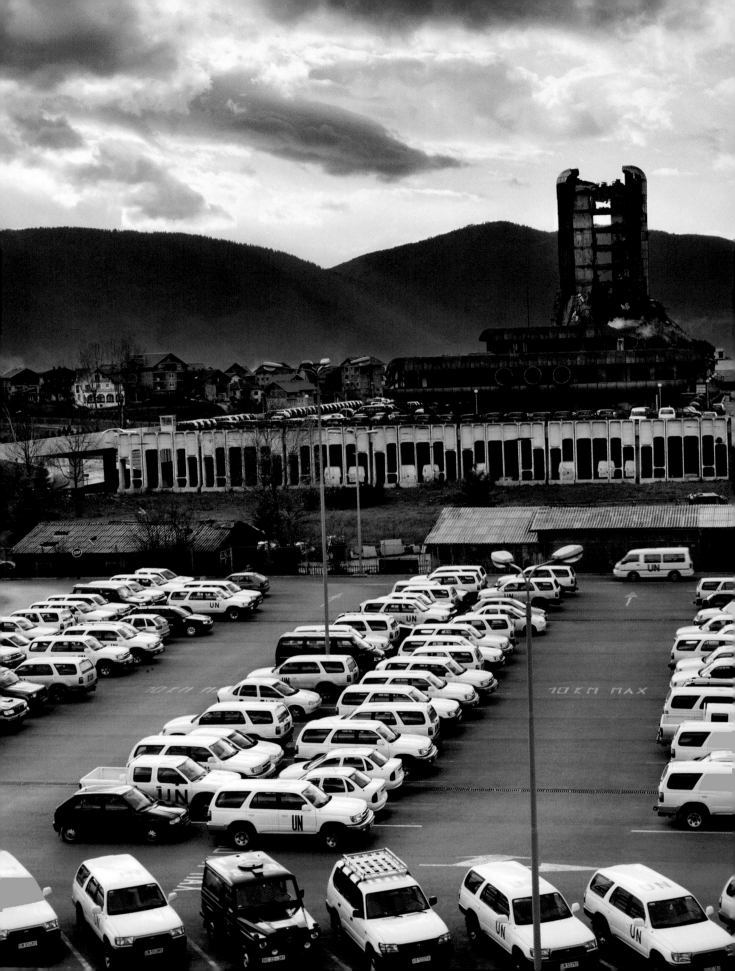

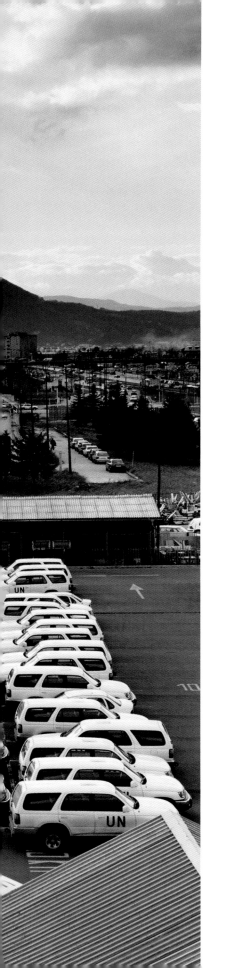

THE FIRST DAY OF THE TRIAL of Slobodan Milosevic for crimes against humanity committed in Bosnia-Herzegovina and Croatia. Sarajevo, Bosnia-Herzegovina. September 2002.

DURING THE SIEGE OF SARAJEVO a French humanitarian convoy brought us thousands of bottles of mineral water. We also received a pack of American biscuits dated 1975, probably left over from Vietnam. UN forces came to Bosnia in 1992, and it took the West four years to intervene. In the years in between, one could see many of these white cars all over Bosnia. Most of the time they were just standing around, counting the dead. The building behind the UN car park was bombed early on by the Serbian army because it belonged to *Oslobodjenje* ('Liberation'), the leading national daily newspaper, which was reporting atrocities in Croatia and Bosnia. This didn't stop *Oslobodjenje*, however, which continued to publish throughout the war. Sarajevo, Bosnia-Herzegovina. October 2002.

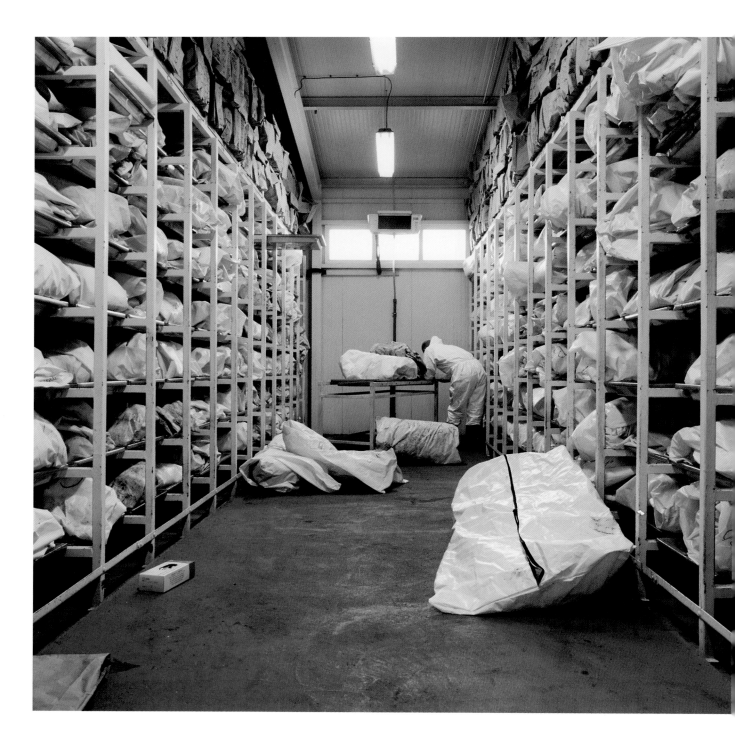

LIBRARIES ARE THE MEMORY OF A COUNTRY, and they were among the first targets. Destroying them was an attempt to erase Bosnian identity. Exhumed remains of missing people from Srebrenica are kept in the Commemorative Centre in Tuzla. They're packed into white plastic bags and placed on metal shelves in four corridors, four thousand of them. On top of the shelves are smaller, cardboard bags with personal items inside.

They're numbered, just as books are numbered in a library. The numbers do not correspond with names or titles but with a pile of bones, half-rotten clothes and perhaps a watch, a piece of jewelry, a lighter. What the bones tell us is not so clear. Perhaps one day the Centre will become a place around which Bosnians will build their modern identity, an identity that will keep them together. Tuzla, Bosnia-Herzegovina. October 2002.

WHEN THE REMAINS OF BODIES ARE EXCAVATED, the clothes are washed and dried in the sun in the same way as we, the survivors, dry our clothes. But when you look closely you notice small holes in these clothes. They're from bullets and from the roots of the plants that grew on the surface of mass graves. Sometimes the roots were so strong that people had to cut them to get the remains out of the graves. Now the clothes have been hung out to dry in front of the city morgue of Visoko. Survivors coming to try and recognize the remains of missing relatives had to pass by them. Visoko, Bosnia-Herzegovina. June 2001.

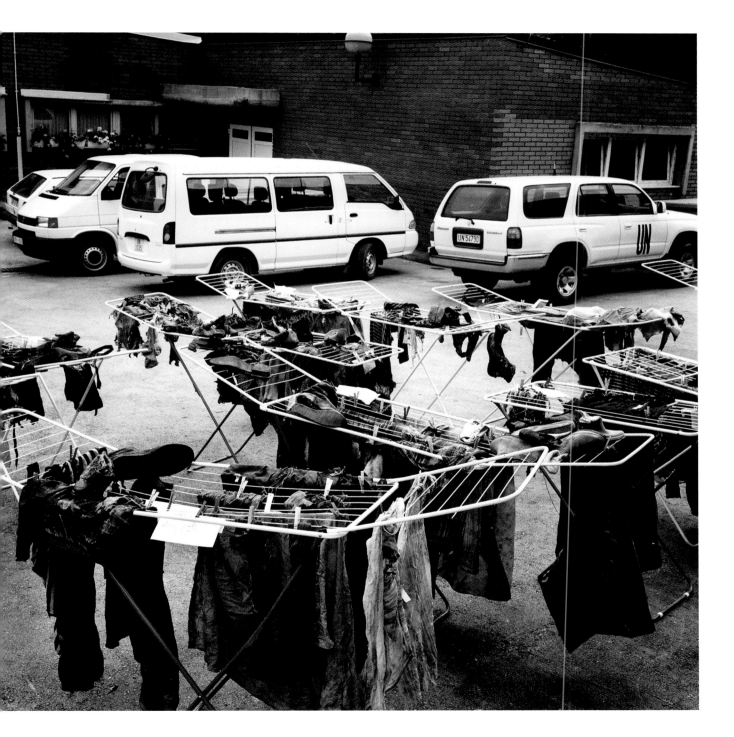

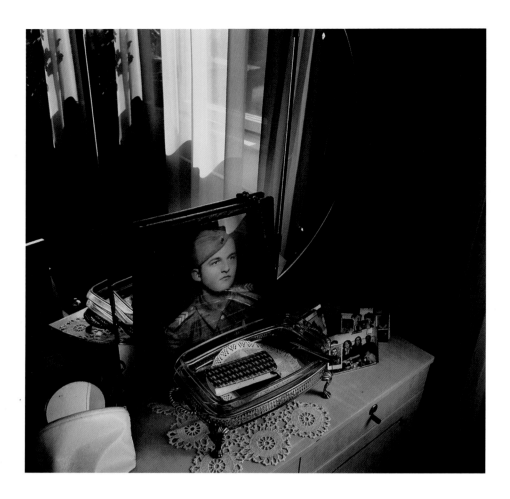

THIS IS MY GRANDMOTHER'S BEDSIDE TABLE.
I call it my family album. The big photo of the
young man in uniform is my grandfather. In 1942
he joined Tito's partisans to fight the Fascists.
In the years after the war he became an officer of
the OZNA, a special unit created to capture Cetnici
and Ustase who had collaborated with the Fascists.
In 1992 another war started. My grandfather was
very old then, and he recognized the names of
those who were joining the newly formed Cetnici.
After the first shelling of Gorazde he committed
suicide on the bank of the Drina. Hundreds of
bodies of Bosnians killed at the bridge in Visegrad
were floating at that time down the river.
Gorazde, Bosnia-Herzegovina. January 2001.

THERE WAS A TOWN IN EASTERN BOSNIA.
In 1993 the UN sent a Dutch battalion of a
hundred soldiers to protect the demilitarized
zone of 40,000 people. When the Serbian army
conquered the town in July 1995, 27,000 civilians
sought shelter in the Dutch compound inside
the factory. The gates were shut against them,
and the Serbian army separated men from
women and children. Then buses took 7,500
men off, destination unknown. Today there
are around 4,000 plastic bags with exhumed
remains from the mass graves. The contents
of 600 were identified, and they were laid in
the factory closed to them in 1995. There were
599 bags containing the remains of Bosnian
Muslim men, and one the remains of a girl
who didn't want to leave her brother. They
were buried in front of the factory 31 March 2003.
Srebrenica, Bosnia-Herzegovina. March 2003.

PLAYGROUND AFRICA.

For many African countries, the blight of colonialism
led to post-independence struggles and on to civil
wars that have become characterized as 'resource wars'.
These were waged by warlords and warring factions
that sought to dominate society through control
of a country's natural resources. Many of these
conflicts were initially fuelled by the larger political
manoeuvering of the cold war years. 'Resource wars'
developed these overtly political conflicts into self-
financing wars that depended upon the sales of such
commodities as diamonds and timber. As ideologies
fell apart, ethnic tensions were manipulated, and
greed for money and power led to widespread brutality
against civilians. In this respect, resource wars repeated
the cycles of history played out during colonial times,
and revealed most clearly the barbaric intent of war.
During the course of the Angolan civil war, towns and
cities were subject to terrible sieges. The bombardment
of civilian populations by mortar and artillery lasted
for months and years. This almost innocent scene is
set in a street where children have painted football
pitches on the pavement. They use wooden counters
or bottle tops to play the game of 'table football'. In
this instance, the pattern left by an exploded mortar
round reminds us that this scene is far from innocent.
Luena, Angola. September 2002.

While the minority world satisfies itself with a simplified media vision of our 'global village', the complex realities of the majority world become reduced to messages of exotic beauty or random chaos. This is partly owing to the reluctance to publish stories that portray the suffering and upheaval, that is associated with this part of the world. It is also due to photographers themselves reinforcing stereotypes through hackneyed imagery and surface-level coverage. By only reacting to 'events', such as the famines and civil wars that have identified recent African history, our perception of Africa has become skewed and distorted.

There can be no doubt that we are all connected in this world, but perhaps the truth is a far more complex and disturbing story than that afforded by the messages of 'our sound-bite' 'feel-good' era. Cycles of violence and resource wars are not random events. They have origins and stimuli that can be traced directly back to the financial appetite of the minority world. As this particular era of globalization threatens the world with a frightening pace of economic transformation, perhaps it would be foolish to ignore such lessons.

'Healing Sport' was born out of a desire to reach people. It uses the universal language of sport to keep certain countries and issues visible, despite the desire of media interests to airbrush them from view. It seeks to engage with subjects away from the 'news' spotlight, and to show that life continues to exist in Africa outside of CNN.

Sport is universally accepted as knowing no boundaries. Sport is common to all people of all nations. In Africa in particular, sport can be seen on every street corner, on every television screen, in every newspaper. The project 'Healing Sport' seeks to use the language of sport to explore the social and economic landscape of sub-Saharan Africa. Rather than cast people in roles of the needy, downtrodden, and oppressed, 'Healing Sport' provides a positive arena in which to identify the predicaments in which one-fifth of the world's population finds itself. Sports can highlight the many talents that people possess while not avoiding the difficulties that they face. It is a way of stimulating debate while reinforcing dignity and identifying strength.

Above all, I hope this project shows that the rich nations' version of the world is not the only version being lived today. Africans can and will take part in this world, not because they become economic migrants, but because they have as much a right to it as we all do.

TIM HETHERINGTON HEALING SPORT

From an ethnically motivated war to a war of resources. The end of the Cold War presented Fourth World countries with a new set of 'worst-case scenarios', in which the conflict was over who controlled the land and the valuable raw materials so essential to world trade. The civilian population suffered extreme brutality, and among the most affected were the young. For some of them, sport offers a way out.

In Huambo, Angola, I came across a derelict building where athletes had gathered to train every day. In the early 1990s, despite the fact that the town was surrounded and often endured month-long mortar and artillery sieges, they gathered at six each morning for a ritual that confirmed that they were alive. It was their form of resistance and healing.

This project was carried out in Liberia, Sierra Leone, Angola, Kenya, Korea and the United Kingdom between 1999 and 2002. It focuses on the countries and issues that are sliding off the map of international concern. Civil war in Sierra Leone, ex-combatants in Liberia, robbery in Kenya, and the ongoing tragedy of Angola. Can a young man who has had his leg blown off by a mine become whole again? Can children who were forced to maim and kill be reintegrated with other innocents? Can people who grow up on the streets learn to become part of society? Can a society fragmented by war find ways to become united?

George Orwell once wrote that football was war without bullets. For the Liberian child soldiers I travelled with, sport offered the possibility of a new family, a new beginning, a way to feel human again. I made this project as a means of resisting exclusion.

While globalization continues to have far-reaching implications for the world Africa's problems become our problems too. War, the breakdown of states and migration are the obvious examples. Less obvious, but equally insidious, is our increasing inability to look beyond our own borders. If we refuse to face up to what lies beyond our immediate interests, we will exclude ourselves from what is really happening in the world. This is a far more dangerous consequence of the divisive nature of globalization.

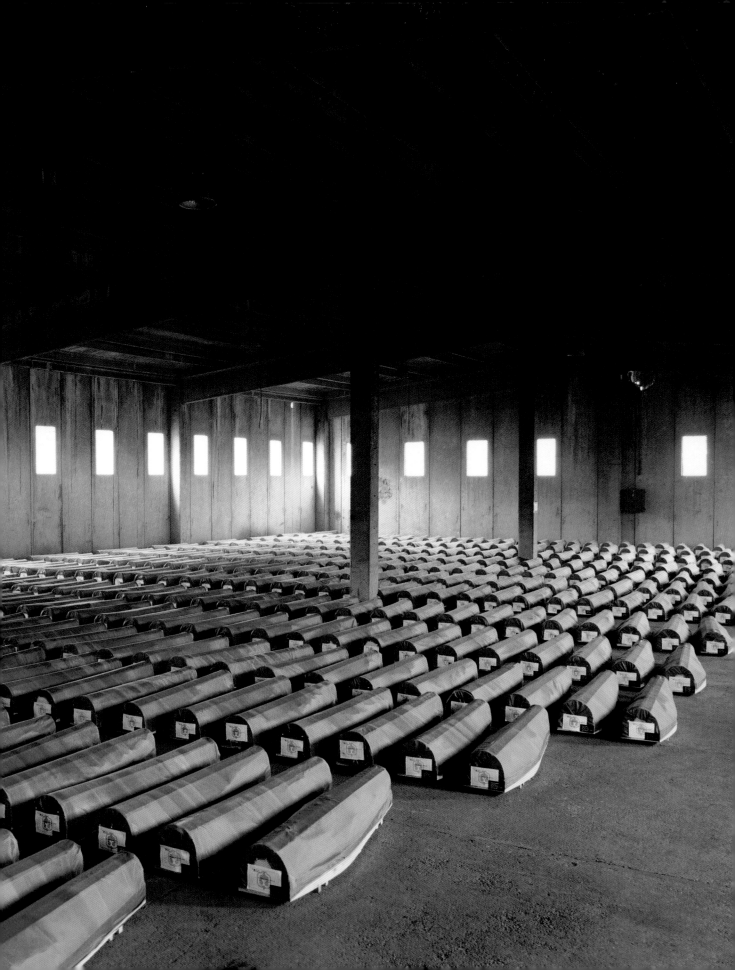

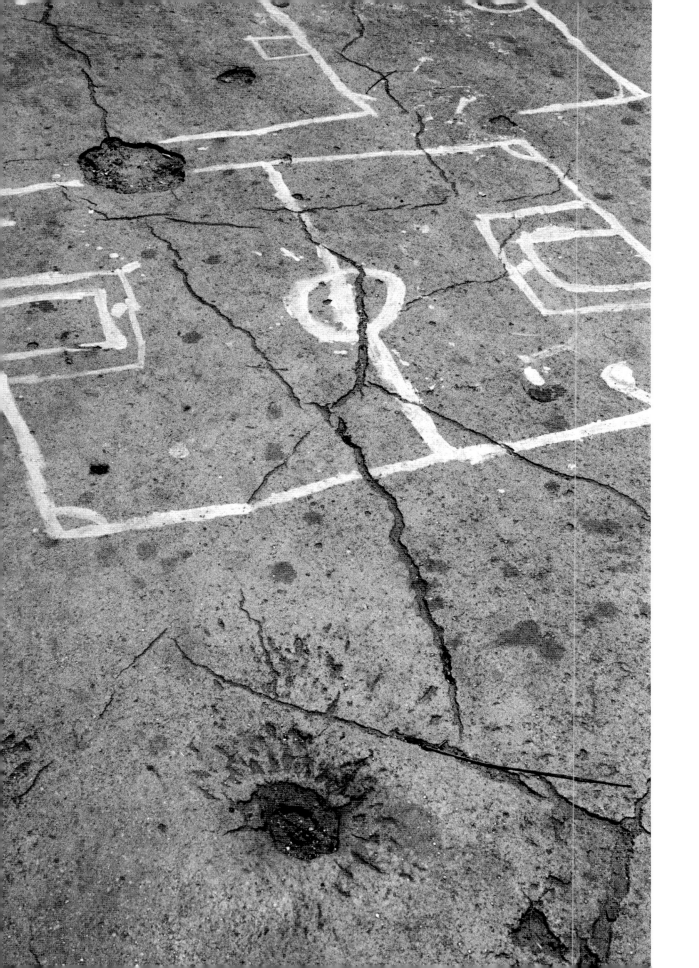

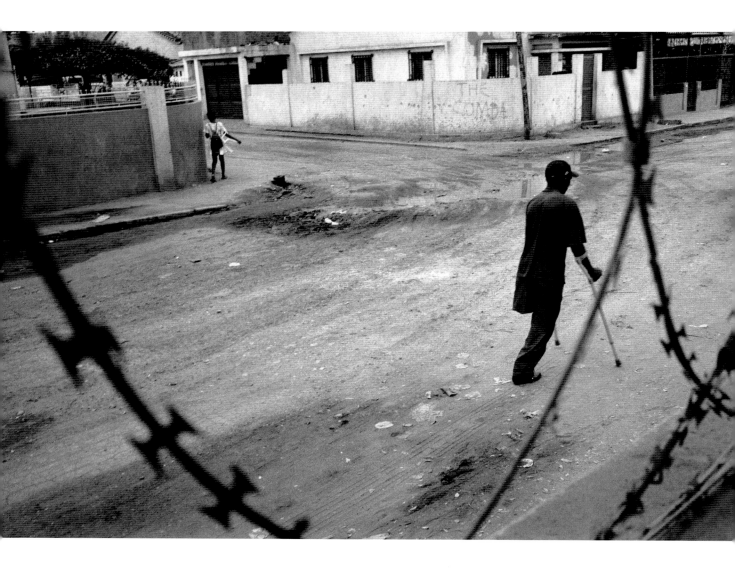

THE CIVIL WAR IN ANGOLA, post-independence, lasted for 27 years. During that time, towns and cities became battlefields, civic infrastructure was utterly destroyed, and it is estimated that nearly 2 million people lost their lives. Between 2 and 4 million mines are believed to have been laid, although an exact figure is nearly impossible to quantify. Often people braved minefields out of desperation for food and wood for fuel. Some even volunteered to cross the fields on behalf of their communities. Countless others died as a result of mine-related injuries, and many soldiers lost limbs to mines that their own side had planted. Today, with a population of 6 million, Angola is thought to have the highest mine-per-person ratio in the world. With people still losing limbs, this physical and psychological damage continues to ravage Angolan society. Luanda, Angola. August 2002.

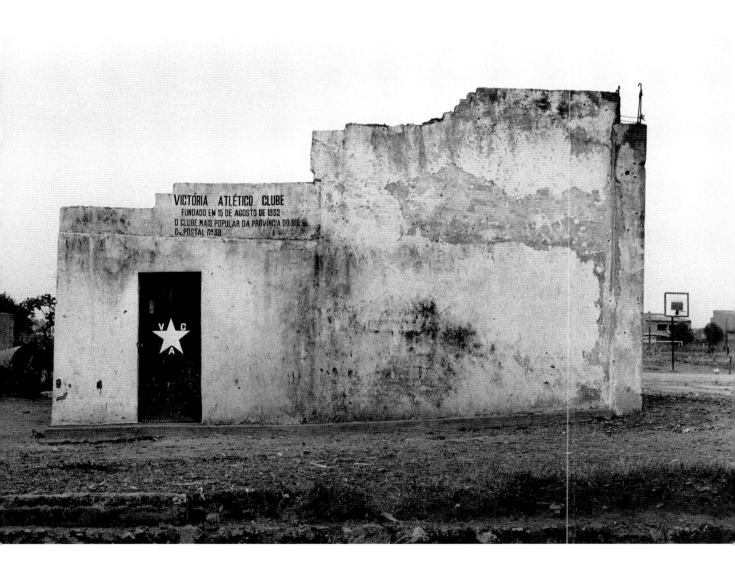

THE RUINS OF A FORMER SPORTS CLUB

n the Angolan town of Kuito. It is thought that
more than 70,000 people were killed in this little
own during the course of the war, and most
perished during a siege that lasted for over a year.
The inscription on the building reads: 'Victoria
Athletico Club. Founded on the 15th August 1932.
The most popular club in the province of Bie.'
Kuito, Angola. August 2002.

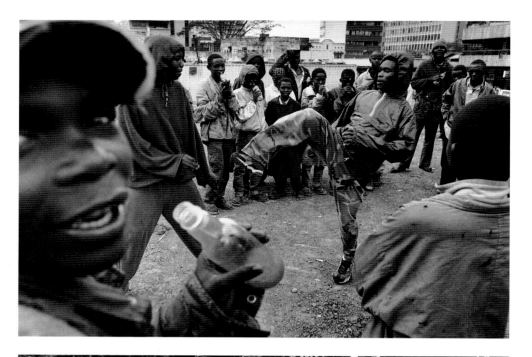

IN SUB-SAHARAN AFRICA there is, on average, the youngest population in the world. With war and poverty affecting the most vulnerable sections of society, children in particular are often at risk. The erosion of traditional society, mass migration to the cities and lack of basic structures to cope with this influx all lead to further fragmentation within a community. It is estimated that there are around 15,000 homeless children in Nairobi alone. The need to survive on the streets inevitably leads to exploitation, both of the children themselves as cheap labour, and of the actual victims of their criminal behaviour. While the trappings of a modern city like Nairobi offer them the sights of fast food outlets and shopping centres, their consumerism takes the form of inhaling glue as a means of 'escape'. Here ex-street children return to the streets to display their skills in the martial art taekwondo.
Nairobi, Kenya. June 2002.

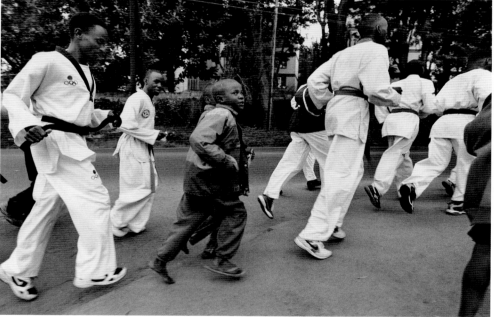

STREET CHILDREN follow the squad of taekwondo champion George Mureu as they run to the Nairobi city arboretum for morning training. Taekwondo originated in Korea's ancient feudal society more than 2,000 years go, not as a sport, but as a martial art and philosophy that organizes both mind and body to instil a strong moral code. Introduced into Kenya in 1978, it has become increasingly popular. For some, it has become a real means to move on. Mureu himself is a former street kid who later went on to become the Kenyan taekwondo champion and national coach. His squad is mainly drawn from street children who use taekwondo as a means of escaping the downward spirals of poverty and dislocation from society. Members of his taekwondo academy live and train together, and share money and opportunities. Nairobi, Kenya. June 2002.

EDUCATION IS A LUXURY

that few can afford. In Kenya, there are no state-funded schools, and most children struggle to receive the kind of guidance that will afford them a secure and reasonable future. Sport offers possibilities to those denied a formal education by providing an arena in which young people can develop themselves. It also allows children to interact with each other in a friendly and secure environment. It is this positive role that sport can provide in countries affected by war or poverty, that makes it indispensable to the younger generations. In the Kenyan Taekwondo Association headquarters, James Karuga looks around at the photos on the walls of a past generation of athletes (above right). Nairobi, Kenya. June 2002.

NAIROBI HAS OVERTAKEN

Johannesburg in the number of violent crimes committed. Taekwondo, the fastest growing martial art in the world, has become increasingly popular in Nairobi owing to this rise in violent crime that affects all sectors of society. Patroba Ojwang leads a taekwondo class in a clearing in the Mathare slum (right). Nairobi, Kenya. June 2002.

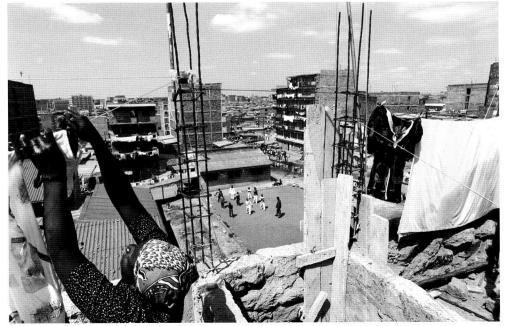

IN A PROSTHESIS CENTRE run by the
International Federation of the Red Cross, mine
victims are individually fitted with prosthetic limbs
that allow them to walk and play sport. Victims stay
at the centre while training to use their new limbs.
The process can last up to two weeks, and includes
exercises that involve ball control and use sport
as a means of improving co-ordination.
Luanda, Angola. August 2002.

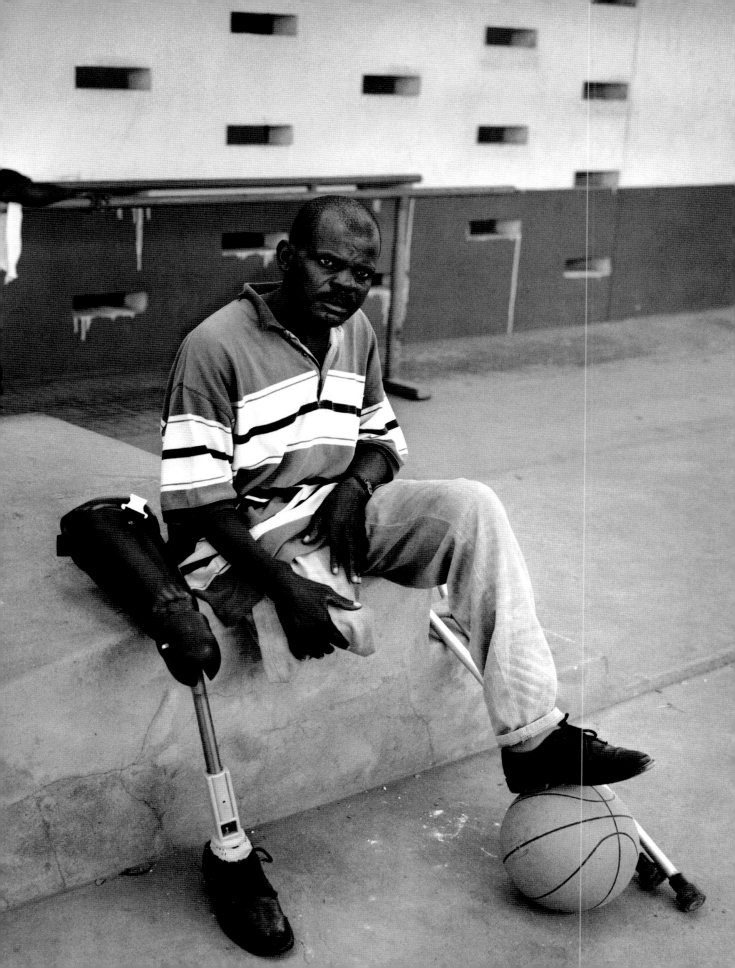

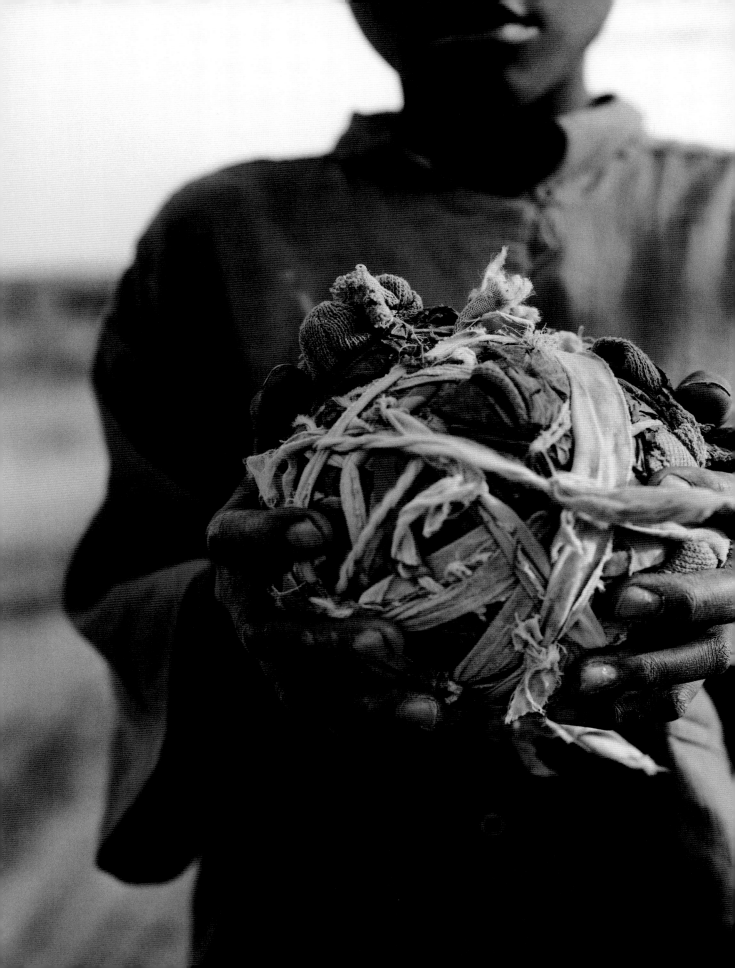

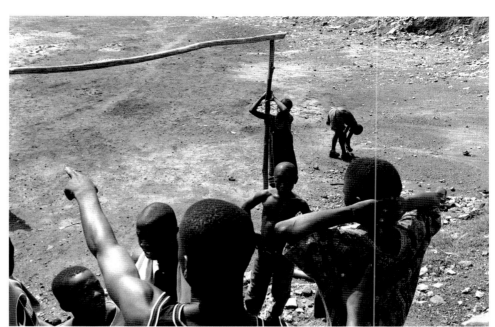

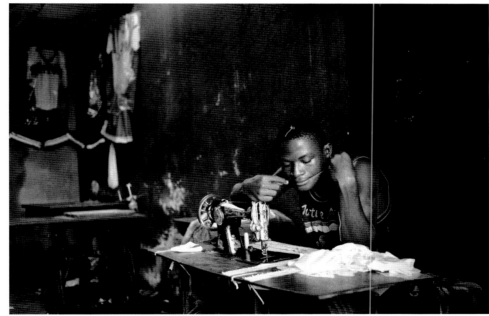

HOMEMADE FOOTBALL.
Kuito, Angola. August 2002.

ONCE A CLIENT STATE OF THE USA, Liberia has become increasingly isolated by the international community. This has led to widespread economic hardship and the need for self-reliance. A tailor at 'Happy Corner' in Monrovia (above) makes up a new football kit for the growing numbers of local teams. Owing to economic hardship, importing kit proves too expensive. Teams of local tailors make all football strips for the numerous teams. Monrovia, Liberia. May 1999.

FROM 1990 TO 1997 LIBERIA was the scene of one of the most violent and surreal civil wars. President Charles Taylor's personal bodyguard was comprised of the notorious Small Boys Unit (SBU), many of whom had seen their parents die in the conflict. By 1999, the Liberian capital Monrovia had become home to a large number of street children, many of them ex-combatants. They survive by collecting scrap metal from the ruins of Monrovia and selling it by the kilo. Many depend on charitable institutions for food and education, but the ritual of afternoon football was of their own making. Street children (top) gather for a football training session at a makeshift pitch in downtown Monrovia. Monrovia, Liberia. May 1999.

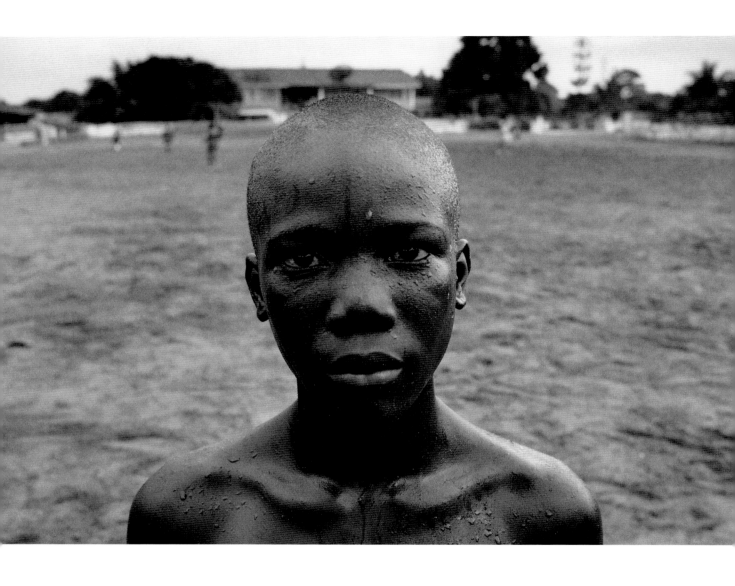

BOB KPWAILO, football player and member
of Millennium Stars football team. The team
was formerly known as Power from Heaven.
Monrovia, Liberia. May 1999.

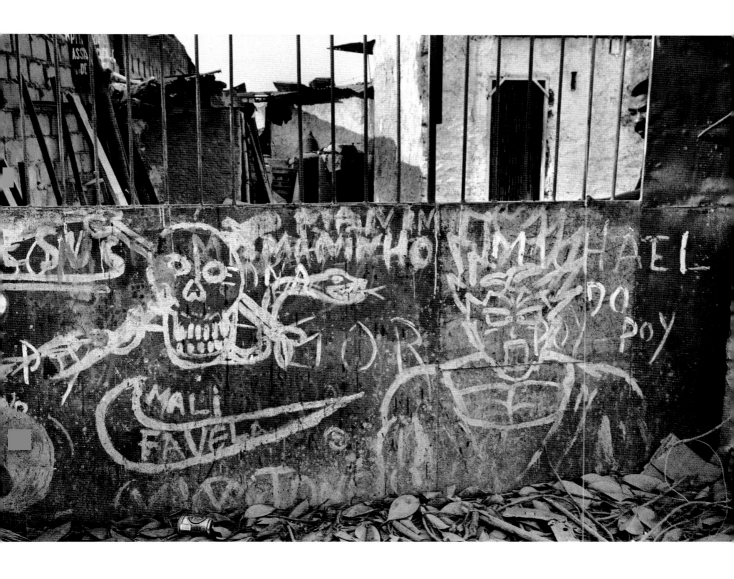

A NIKE LOGO is counterpointed by the skull-and-crossbones graffiti in a downtown barrio in the Angolan capital of Luanda. The symbol of the skull and crossbones has deeper connotations in Angola where it is used to warn of the presence of unexploded mines. Luanda, Angola. September 2002.

WARM-UP FOR FOKPA SUMO
of the Millennium Stars football
team. He fought for the National
Patriotic Front of Liberia (NPFL)
during the civil war. Some of the
child soldiers were as young as
ten years old.
Monrovia, Liberia. May 1999.

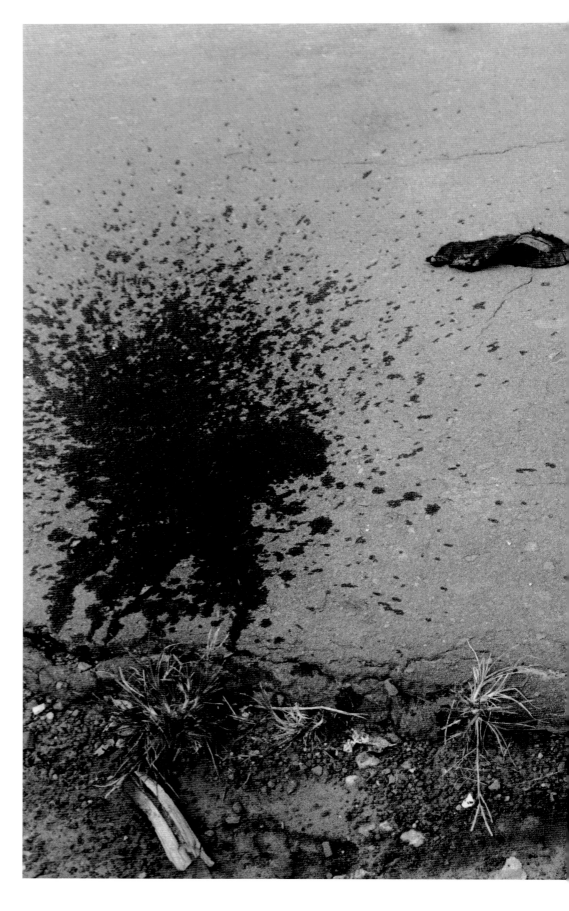

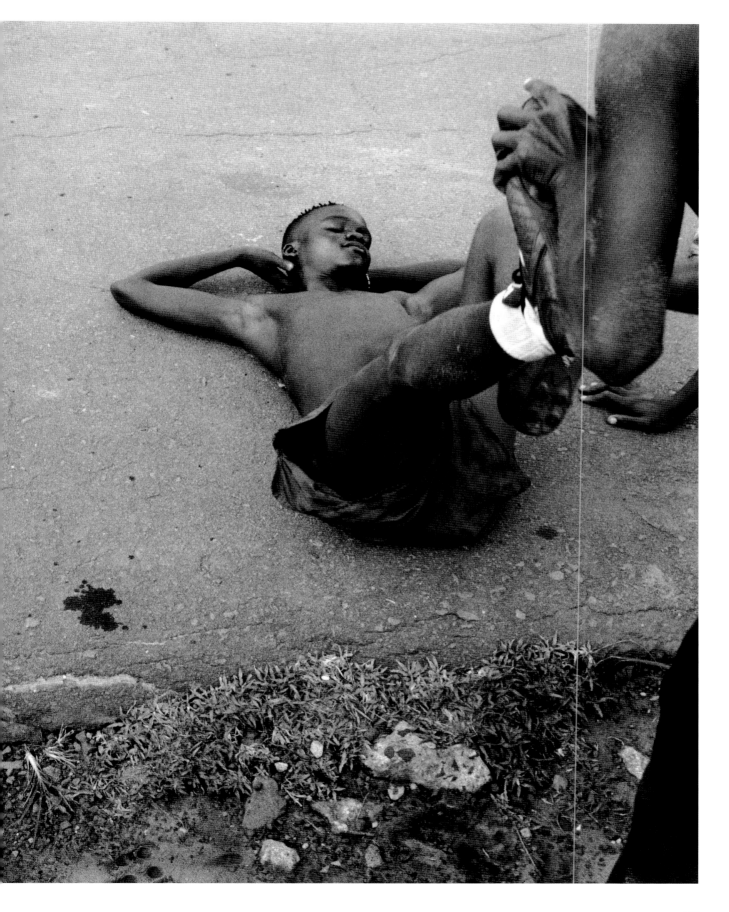

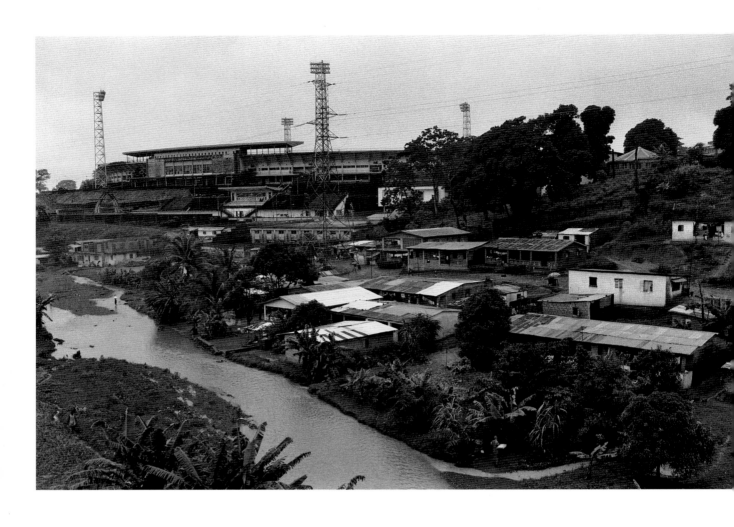

AFTER NEARLY TEN YEARS OF BUSH-WARFARE,
rebel forces of the Revolutionary United Front (RUF)
invaded Freetown, the capital of Sierra Leone, in 1999.
As in Angola and the Democratic Republic of Congo,
the violence of the Sierra Leone conflict stems from
the international world of commerce. Freetown was
the symbol of prosperity and corruption that had
excluded the people from the interior forests whose
resources it had plundered for international trade.
The capture of the east of Freetown by the RUF marked
a moment of revenge and hysteria. Rebel forces attacked
the city during the night, sending women and children
in front of them so that the defending forces of Nigerian
ECOMG soldiers were not easily able to return fire. The
attack resulted in the rebels occupying nearly half the
city, and around 40,000 people fled the fighting and
sought sanctuary at the stadium, which stood near
the front line at Congo Cross. Despite the fighting
that waged around them, sports training continued.
The National Stadium, Congo Cross. Freetown, Sierra
Leone. October 2000.

ROWDS RUN FROM THE POLICE
while trying to get into the National Stadium.
uanda, Angola. September 2002.

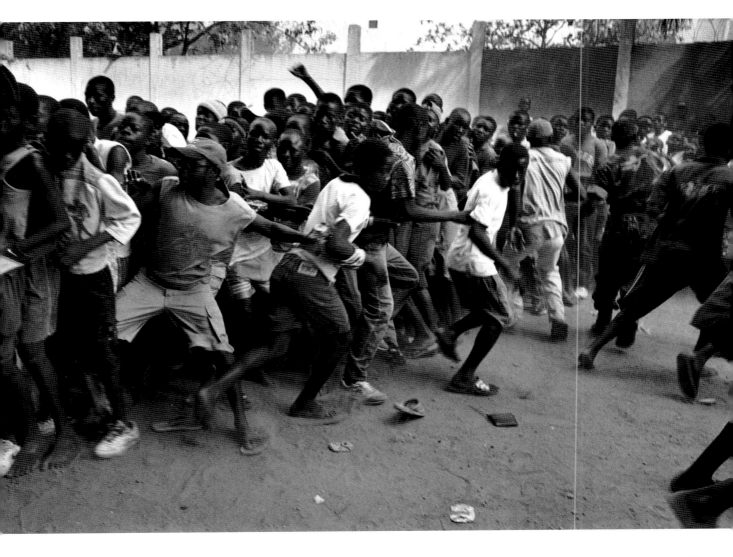

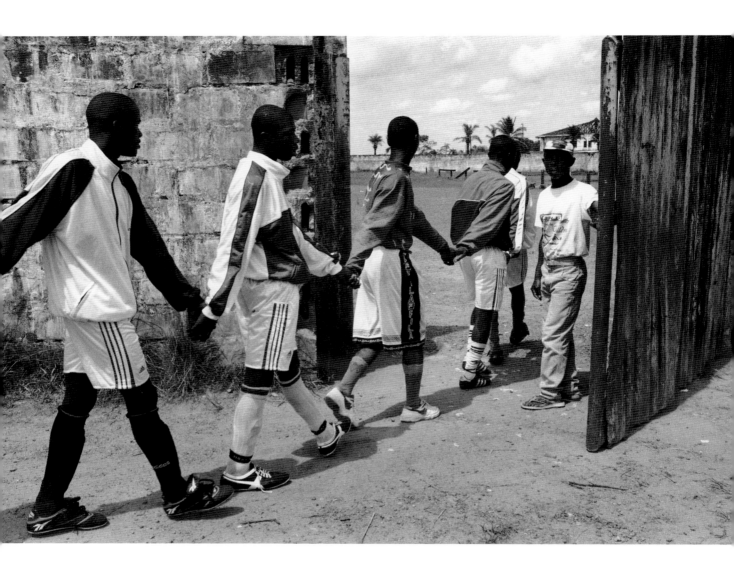

TEAM MEMBERS OF THE MILLENNIUM STARS
(formerly called Power from Heaven) file on to the
pitch hand-in-hand before the start of a match. Many
of them fought as child combatants in the ten-year
civil war. The capital of Monrovia was divided into
areas occupied by opposing factions. Young children
were frequently rounded up and conscripted into rival
militias. Many ended up fighting for at least two or
more of the factions during the course of the war.
Power from Heaven was originally formed as a way
of offering the young boys an alternative to military
camaraderie. The founder members lived together and
avoided conscription, even though some of them had
once fought against each other in rival factions.
Buchanan, Liberia. May 1999.

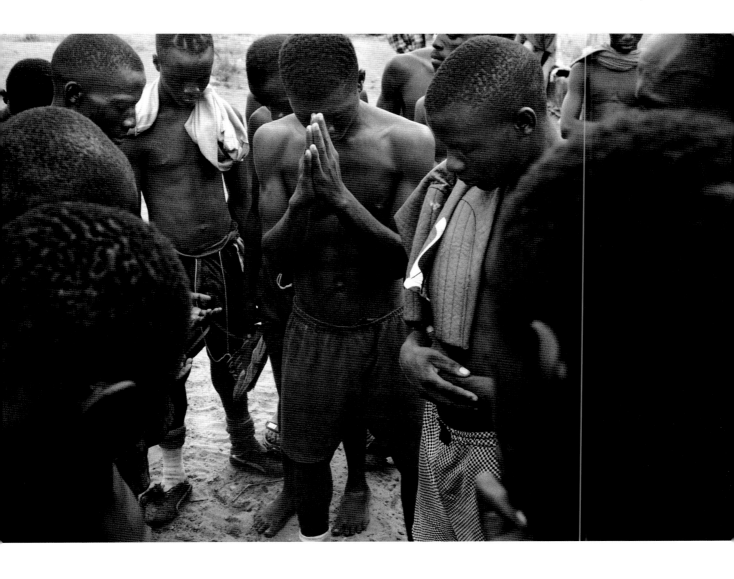

MEMBERS OF THE MILLENNIUM STARS PRAY
before training. Religion and football have
reintroduced some social cohesion into a fractured
society. Evangelical Christianity is particularly
prevalent with its violent symbolism and militaristic
language of the fight between good and evil.
Monrovia, Liberia. May 1999.

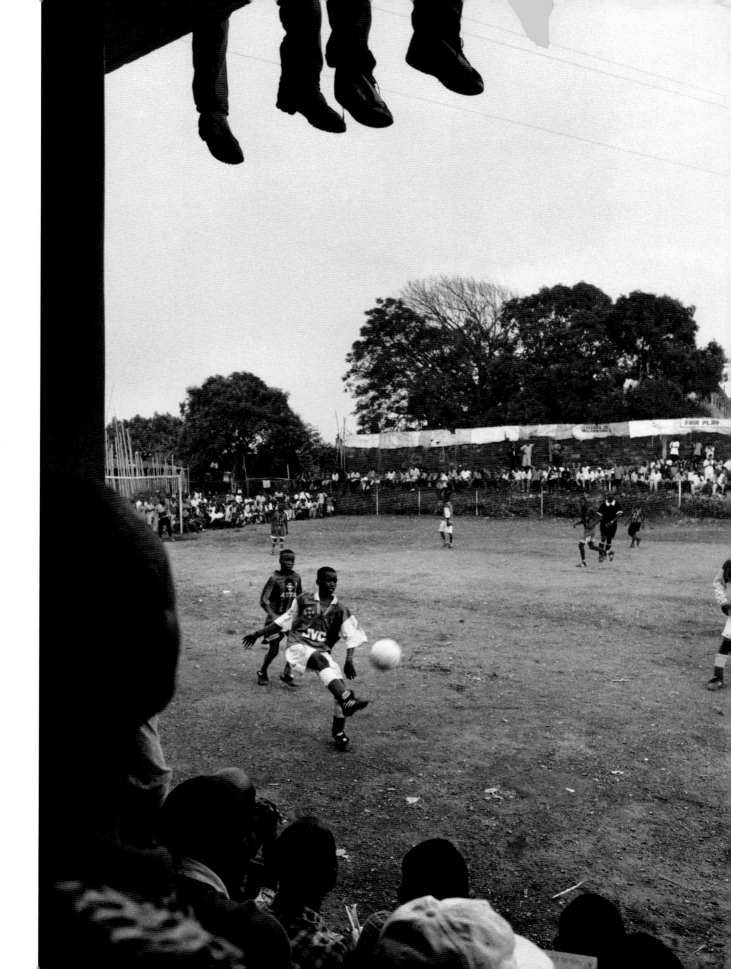

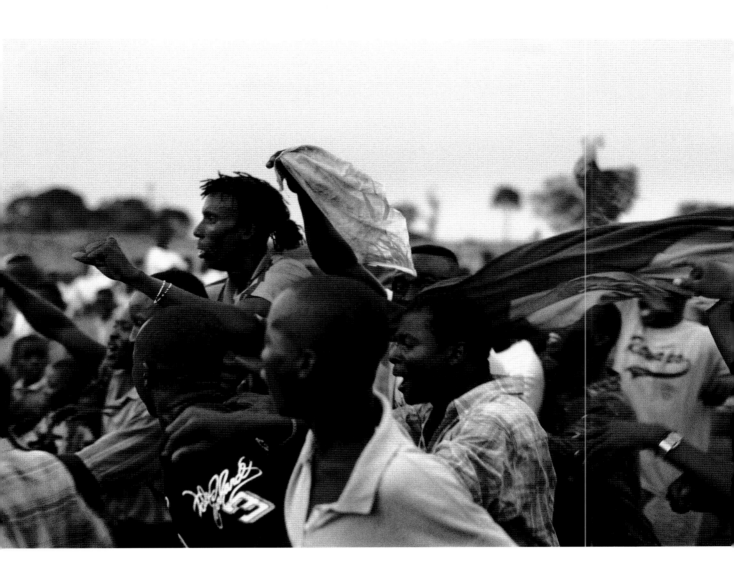

CROWDS WATCH UNDER-THIRTEENS PLAY
in a knockout football tournament in Monrovia.
Teams are named after the different African countries,
in this case Algeria versus Cameroon. Talent scouts
are always on the look-out for 'young blood' to play
for the many league teams, and even youth matches
like this one draw hundreds of people.
Monrovia, Liberia. May 1999.

THE 'MAN OF THE MATCH' is carried
around by a jubilant crowd. Two years after
the end of the notorious Liberian civil war, the
country remains in a deep crisis. There is little
basic infrastructure, and the towns lack running
water and electricity. Poverty is endemic, and
unemployment remains high. For many,
football offers the possibility of a way out.
Those Liberians who play football abroad,
like George Weah, are national heroes and role
models for almost all children. Weah maintains
a god-like position in the country, second only
to warlord and president Charles Taylor himself.
In the downtown district of Monrovia, stands a
bullet-riddled statue of Weah, one of the only
symbols of continuity for this country.
Buchanan, Liberia. May 1999.

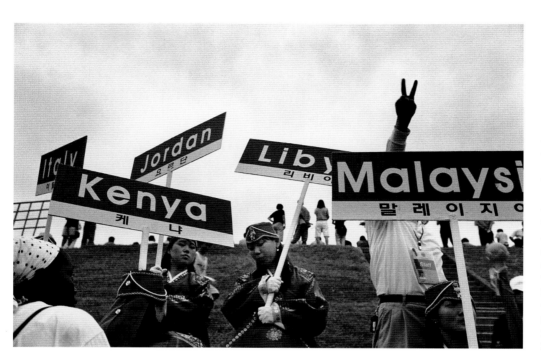

TAEKWONDO TEAMS GATHER
before their entrance to the main stadium for the official opening of the World Taekwondo Federation's Korean Open festival (above left). The Kenyan team comprised members of the George Taekwondo Academy (GTA), a squad of children drawn primarily from disadvantaged backgrounds. Only six members of the squad were able to make the trip to Korea to compete with players from over sixty countries. They returned with a host of awards including three gold medals, three silvers, and the trophy for the best team. Jincheon County, Korea. July 2002.

WAVING GOODBYE after a match against the Liverpool Youth team (below left). Members of the Millennium Stars ex-combatant football team travelled to the UK on a three-week tour. For nearly all, this was their first time outside Liberia. Liverpool, United Kingdom. September 1999.

WORLD CUP GRAFFITI
(opposite) at the National Stadium. Luanda, Angola. August 2002.

BERTIEN VAN MANEN PARADISE IN BOXES

From the ambitions of those who want to escape from their world to the existence of those who have arrived. While the continent of Europe is now in the process of creating a new 'European' culture and identity under the umbrella of an emergent supranational state, the satellite towns around the big cities are becoming focal points for the minorities flooding in from outside Europe and will change the continent in unforeseeable ways.

At 18:05 08.10.02:

Dear Andreas,

How are you? How cold is Berlin? I have been in Paris for nearly a week now, trying to get started on the assignment for Switzerland, but not with much success so far. I am waiting for the right contacts. Friends are trying to help, Valérie, Dominique, Klaudi, Lida, Rebecca....

At 19:08 17.10.02:

My dear Andreas,

Monsieur Fofana is my first contact. He tells me that he has many family pictures. I meet him in 'la Cité 4000 – la Courneuve', at the Association des travailleurs du Mali en France. He lives on the 22nd floor of one of the high towers. The room is gloomy. The curtains are drawn. Madame Fofana is sitting on the sofa, beautifully dressed, legs spread wide, a sleeping baby beside her. In a detached way she thanks me for the chocolate. In a corner I discover another woman, beautifully dressed, legs spread wide, a sleeping baby beside her. 'We have no photos,' Madame Fofana No. 1 says gruffly. 'No,' Monsieur Fofana now says, 'they didn't tell me that you needed photos....'

I decide to wait. The babies wake up and are put on the breast. Madame Fofana No. 1 eats the chocolate. After half an hour Monsieur Fofana fumbles in his inside pocket. He pulls out a small card: his working permit as a seasonal worker from 1964. 'Here's a photo for you,' he says. I put the card with the plastic flowers and take a picture. The faces of the two women light up. Monsieur Fofana goes to another room and comes back with a brown envelope. Slowly, he draws out several photos: different women, all beautifully dressed. We put each picture in turn with the flowers.

Out in the street again, Monsieur Fofana asks me: 'Do you want to see another flat? I have one more wife.' In the same building, on a different floor, we find Madame Fofana No. 3, vivid, big and happy. She has a lot of pictures.

At 21:27 18.10.02:

Dear Andreas,

Monsieur L. lives with his three wives and ten children in one flat. Five other children live in their village in Mali. Monsieur L. has to send large sums of money regularly. They are convinced that he is a millionaire.

In Mali the women are used to kicking the children out into the desert. The community looks after them. In Paris they send them down into the street. Nobody looks after them.

I had an appointment today at the Association des femmes du Franc-Moisin. During the alphabetization lessons I asked if anyone would like to show me their family pictures. After a painful silence a shy Algerian woman reacted, together with vivacious Mabrouka from Tunisia. Of course, they had to ask their husbands' permission first.

At 22:08 19.10.02:

Dear Andreas,

I called the Algerian woman. Her husband was not interested, she said. 'It is not me, Madame. I would very much have liked to. These men are so backward.' She was crying. Mabrouka's Tunisian husband, Monsieur Ouéfi, was less backward. I went there today. It was not easy to follow the directions they had given me. Often people do not know the exact name of the street or neigbourhood they live in. And anyway, if you're in the métro, for instance, if you

can't read, how are you supposed to tell the difference between Villejuif Léo Lagrange, Villejuif Paul Vaillant-Couturier or Villejuif Louis-Aragon, all on the same line No. 7? That is, if you have managed to take the train in the right direction and not the one going to Mairie d'Ivry. Lots of desperate women with headscarves and searching, anxious looks. So I, too, got off the bus at the wrong station and walked for about an hour to get to their house. Top floor, left floor. There was no answer. A neighbour told me, they were out. 'You never know with her,' the woman said. 'She lies on her bed all day and sends the children down to the courtyard.' I called Monsieur Ouéfi on his mobile: the whole family was waiting for me at the bus station. All five of them live together in one very small room. The furniture consists of two beds. But there was a brown cardboard box with plenty of photos. Monsieur Ouéfi came up with a small carpet that he stuck on the wall with some Sellotape. He leant the photos against the carpet. The whole thing kept falling down. When he heard I was returning to Amsterdam for a few days, Monsieur Ouéfi asked me to send a letter of invitation to one of his sons in Tunisia. They had not seen him for five years. Monsieur Ouéfi cannot organize this visa himself. After countless visits to the mairie, he has given up. He does not have a steady job.

At 21:32 15.11.02:
Dear Andreas,
Today I was in India. 25-year-old Dalida's marriage was arranged by her family. She lives with her husband in a small flat in a remote area in Paris. She does not know anyone besides two jealous sisters-in-law. She misses her family; she loves them more than her husband. Her wedding took place one week after she finished her English literature course in India. For her honeymoon they gave her a one-way flight to Paris. She has no computer. She watches TV and she buys lots of stuff: a Virgin Mary that lights up, red hearts inscribed with, 'Everything grows better with love.'

At 19:37 20.11.02:
Dearest Andreas,
In 1926 the Greek grandparents of Christina Mavropoulos fled from their house in Turkey. Christina lives surrounded by what is left of their possessions after their house was set on fire. Her grandfather took these things with him on the back of a donkey, rolled up in the rug that is on Christina's floor. She has some photographs. Beautiful studio-portraits of happy great-aunts and uncles and a photo of the house before it was burnt down.

At 09:29 27.11.02:
Dear Andreas,
Aziz shows me a picture of his wife Suhaila. 'I fell in love with her when I saw this picture,' Aziz says, 'this was back in Afghanistan.' 'And what about you?' I ask her. 'In the beginning, yes,' she answers, 'but not any more....'

Giving me a ride to the métro station, afterwards in his car, Aziz says: 'In general refugees are smart people, they are strong. I was not at all happy when I got my refugee status. Other people are excited. I want to go back to my country. But I am Ismaël, a minority, I can't. People become materialistic here. I work like hell. I am an electrotechnical engineer, but I work in a gas station. Suhaila wants a bigger car, a TV like a cinema, a bigger house. I can't sleep at night, we are fighting all the time. In Afghanistan these sort of quarrels do not exist.'

At 13:02 30.11.02:
Dear Andreas,
With their fragile eight-year-old daughter, Aslan and Zarema have been in Paris since September this year. They are moved from one hotel to another, from one room to another. They are not allowed to have visitors; nobody can enter the hotel. The extremely severe woman behind the desk refuses even to glance at my impressive letter of introduction from Zürich. We take the picture in the street: a photo of their two mothers in Chechnya, sitting together in the ruined house. There is no restaurant in this neighbourhood. Aslan, Zarema and the little girl have to take the métro to find one; eating in the room is forbidden. They apologize for not being able to be hospitable. I wanted to invite them for a meal, but they refused politely. It is Ramadan.

At 16:47 01.12.02:
Dear Andreas,
Back at home. With love, Bertien

VILLIERS-LE-BEL
Chez Monsieur Coly (Senegal).
They came to Paris in 1968.

LE PRÉ ST-GERVAIS
Chez Leila (Morocco).
They came to Paris in 1984.

ÉPINAY-SUR-SEINE

Chez Monsieur Maïga (Mali).
He came to Paris in 1968.

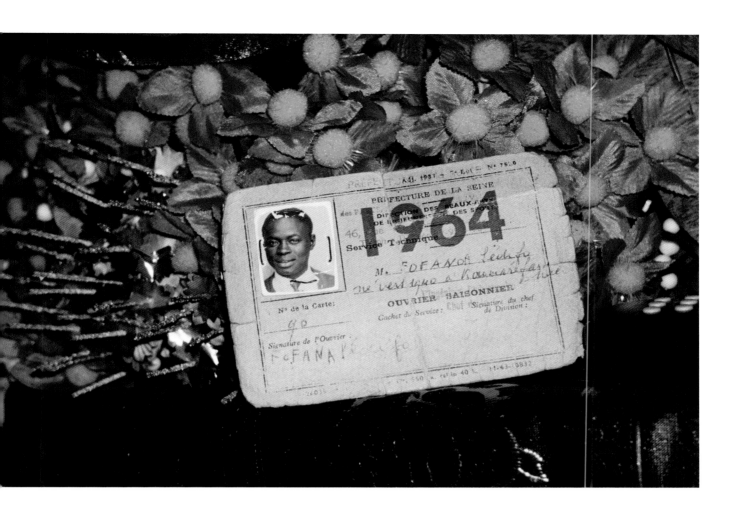

LA COURNEUVE
Chez Monsieur Fofana (Mali).
They came to Paris in 1963.

VILLEJUIF
Chez Ezidi Zarathustra Akdogan (Kurdistan).
They came to Paris in 1995.

ÉRAGNY-SUR-OISE

Chez Aziz (Afghanistan).
They came to Paris in 2000.

LA COURNEUVE

Chez Jamina Daf (Algeria/Morocco)
They came to Paris in 1967

ST-DENIS

Chez Amina Saïdi (Algeria/Tunisia).
They came to Paris in 1989.

189

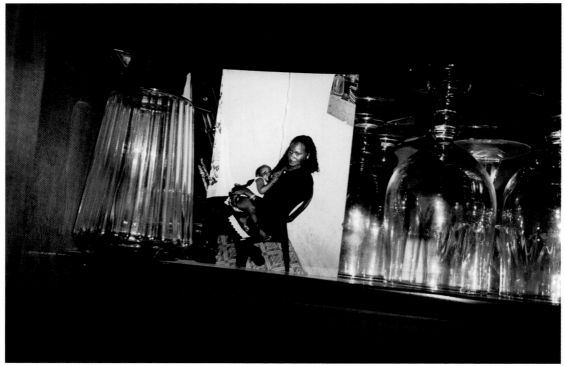

VILLIERS-LE-BEL

chez Monsieur Coly (Senegal).
(Above and below.)
They came to Paris in 1968.

LA COURNEUV

Chez Monsieur Fofana (Mali
They came to Paris in 196

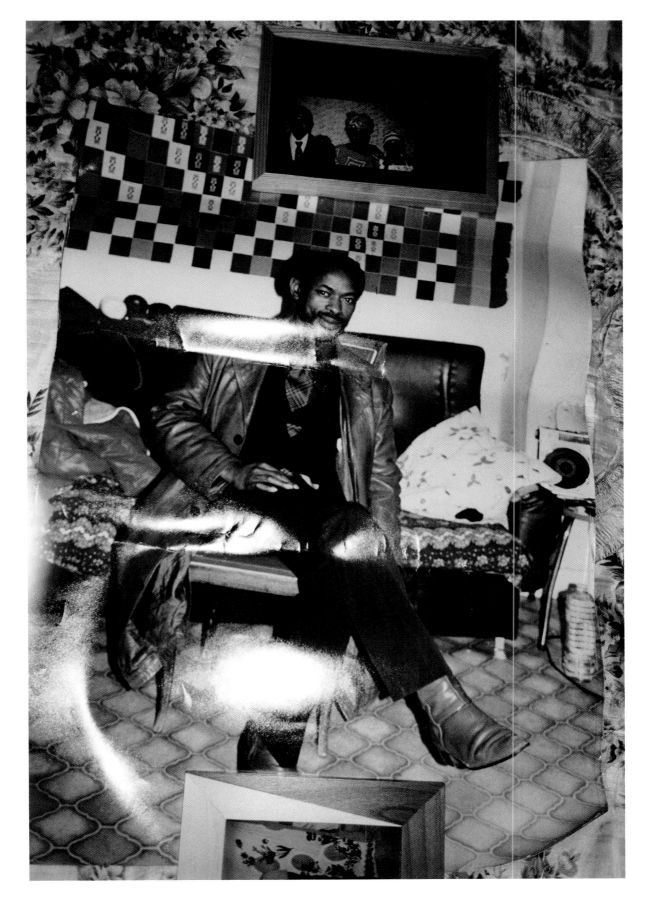

CRÉTEIL
Chez Bruno Pounewatchy
(Central African Republic).
They came to Paris in 1963.

PARIS
Chez Anete Karwatowski (Poland).
he came to Paris in 2000.

193

XIXème ARRONDISSEMENT

Chez Christina Mavropoulos (Greece/Turkey).
(Above left.)
Her grandfather came to Paris in 1925.

IVRY-SUR-SEINE

Chez Christina Lage (Argentina).
(Above right.)
She came to Paris in 1997.

MALAKOFF

Chez Monsieur Rabah (Algeria). They came to Paris in 1965.

MALAKOFF

Chez Monsieur Rabah (Algeria).
They came to Paris in 1965.

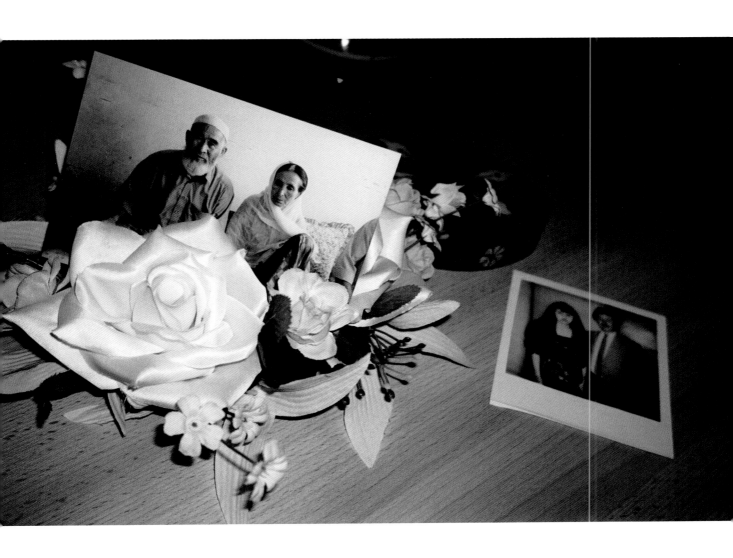

ÉRAGNY-SUR-OISE
Chez Aziz (Afghanistan).
They came to Paris in 2000.

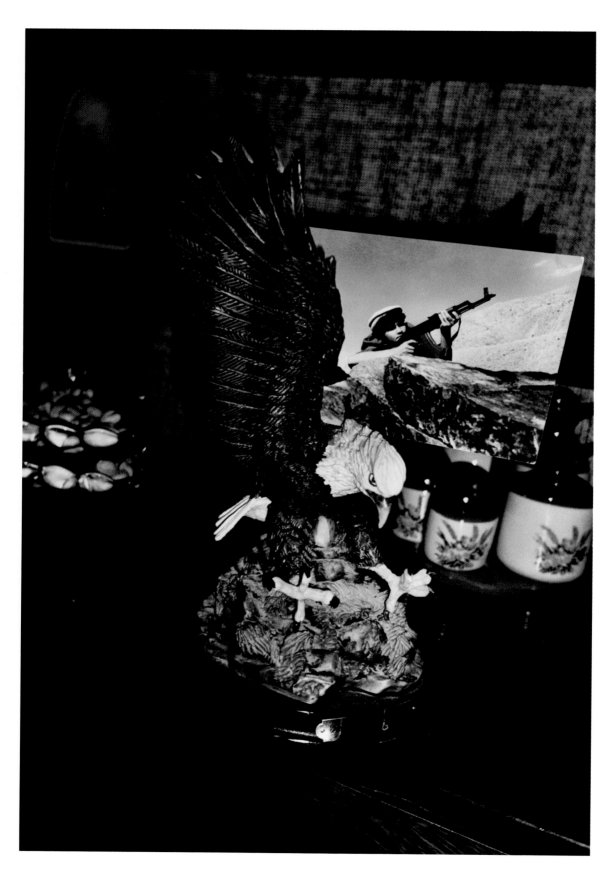

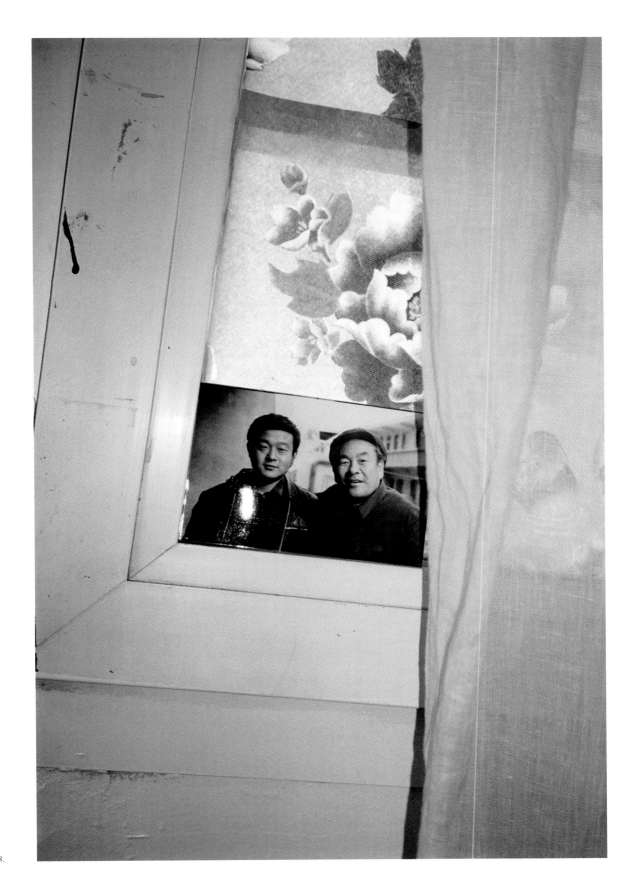

LA COURNEUVE
Chez Hedan (China).
He came to Paris in 1998.

PHILIP JONES GRIFFITHS
INDEPENDENCE AND TRANSITION

From a world arriving in the city to a nation arriving in the world. For half a century Vietnam has successfully defied all military, political and cultural attempts to take it over. But whether it can succeed in maintaining its independence while adapting itself to the demands of the global market remains to be seen.

In the early sixties, as the American military build-up got underway, Ho Chi Minh is reported to have made an offer to Washington that if the Americans left he would roll out the red carpet for their departure. But, he added, they would be welcomed back because the USA had the technological prowess that Vietnam would need. The Americans did not heed his advice – and for the next ten years, instead of politely knocking at the door, they preferred to come crashing through the roof.

Thirty years ago I proposed that an understanding of the Vietnam War had to see beyond the physical carnage, and realize that the USA was endeavouring to impose its values on the Vietnamese. The agrarian Confucian culture that had defined the Vietnamese people for over three thousand years was under a severe attack by US consumer capitalism. The policy was clearly revealed by Professor Huntington of Harvard University, who stated that 'forced-draft urbanization' (the forcing of villagers into the towns and cities as their homes and land were destroyed) could prevent a rural revolutionary movement from coming to power by instigating an 'American-sponsored urban revolution'. This revolution would supplant wisdom and poetry and other traditional claims to status in Vietnamese society with the trinkets and baubles of consumerism. What I observed and photographed in the three years I spent covering the war was a confused and disenfranchised people living in vastly overcrowded towns and cities. With most of their familiar traditional values stripped away, they seized at the substitute status symbols offered by the Americans. The Vietnamese were taught that the brand was more important than the product!

As the war ended, the supply of consumer goods quickly dried up as the US-led economic boycott took effect, and the remaining samples were rarely flaunted for fear of reprisals by the new regime. With the collapse of the Soviet Union, main supplier of aid to the new Vietnam, the leaders felt they had no choice but to open the country to foreign corporations. Vietnam, especially the south, soon displayed the visible signs of foreign commercial penetration.

Today, however, it is obvious that the purveyors of Western goods overestimated the willingness of the Vietnamese to participate. A perceptible change has taken place, especially in the last five years. Many of the wild excesses of the marketplace have been toned down. The public has become more discerning, and is increasingly sceptical of products whose benefits were previously lauded. Many American and other foreign 'joint-ventures' have collapsed, resulting in a steady flow of Western entrepreneurs to departing aeroplanes. Among them the staff of many foreign-owned banks including the Bank of America.

In 1997 the *Vietnam Economic Times* reported, 'Nearly four years have passed since the American trade embargo against Vietnam was lifted. Today, results being posted on foreign business scoreboards, especially for Americans, are in many instances downright disappointing. Some are viewed as flat out failures. Tales of woe circulate in the watering holes frequented by foreigners, with vivid accounts of projects delayed, goals not attained, scuttled schedules and busted budgets. Clearly there are lessons to be learned from the past three years.'

According to the Economist Intelligence Unit, based in London, one of the worst places in Asia for foreigners to do business in is Vietnam – only slightly better than Pakistan. The world business community despairs at this, but a more sanguine view might be that it shows that Vietnam is no pushover for avaricious corporations.

Historically it never has been. One of the first Americans to visit Vietnam, John White, went to Saigon in 1819 to buy sugar. He was given the run-around for months, and concluded, 'All these vexations, combined with the rapacious, faithless, despotic, and anti-commercial character of the government, will, as long as these causes exist, render Cochin China the least desirable country for mercantile adventures.' Indeed.

All of this indicates resilient resistance by the Vietnamese to any kind of foreign domination. The Vietnamese have always been adept at taking what suits them from other cultures while rejecting what they consider undesirable. Certainly, nowadays, the signs of commercial globalization are everywhere to be seen, but there are increasing restrictions on the more egregious examples. The government recently passed legislation curbing advertising billboards, and is actively removing the most obvious eyesores.

Together with exports of oil, rice, coffee and fish, one of Vietnam's other sources of wealth is its industrious, resourceful, and well educated workers. They have become desirable as 'cheap labour' to many multinational corporations. Nike is now the biggest private employer with 46,000 workers making 22 million pairs of shoes annually – figures for the year 2000. Anxious to see their operation for myself, I was forbidden entry. The Vietnamese government Foreign Press Department tried to intervene on my behalf but was also rebuffed. Critics claiming that modern multinationals wield more power than their host governments will not find this surprising.

I did get to visit another factory, Biti's in Bien Hoa City, who make over seven million pairs of shoes annually. The employees work in well lit and well ventilated buildings (fumes from toxic glue used to stick on the soles is always a problem in shoe manufacturing) that could easily have been originally built as aeroplane hangars. The reasonable working conditions found nowadays in many Vietnamese factories have little to do with the owners' benevolence. The improvements have been won by the trade unions involved, and in many cases by the workers themselves, who have often been way ahead of their official union in making demands. The Vietnamese have a long history of being aware of injustice, and in today's world this manifests itself in a heightened demand for fairness in the workplace and improved working conditions.

Yet, the enduring image of thousands of young people sitting silently sewing bits of plastic together cannot but raise fundamental questions about the purpose of life. At the end of the day shift I waited with my camera for the mad dash for the main gate of the factory. Instead, the workers left marching silently in single file. If the setting inside was reminiscent of Chaplin's *Modern Times*, then their departure had all the spontaneity of a scene from *Night of the Living Dead*.

The cheerleaders of consumerism declare that such repetitive and dehumanizing activities are somehow ennobling because money is being earned with greater efficiency than in traditional agricultural employment. This is taken for granted in the 'developed' world, but in Vietnam, a country that has always embraced a symbiotic relationship between man and the land, the assertion is not so clear.

Eighty per cent of the Vietnamese live in the countryside, adhering to the values of their forefathers. They present the greatest challenge to the advertisers, those handmaidens of consumerism, while at the same time remaining a bastion of every virtue the nation possesses. The task is to retain the virtues, and hence a national identity. This is clearly understood by the Vietnamese, for, as one American diplomat declared in the sixties, 'To make progress it is necessary to level everything. The inhabitants must go back to zero, lose their traditional culture, for it blocks everything.'

Now is an exciting time for Vietnam – the cities especially seem to be on the move. Thanks to the Internet (the largest provider is owned by General Giap's son-in-law!) the youth are well informed about world events as well as their own history. The official magnanimous view that the horrors of the Vietnam War should not be mentioned is being actively questioned in the coffee shops of Hanoi.

Vietnam has still a long way to go before achieving true independence, but there are signs that it is rapidly learning to reject the worst and embrace the best that the West has to offer.

THE GROWING OF RICE is what defines the Vietnamese people. Their southwards migration along the coastline of present-day Vietnam was accomplished by seeding the land with rice fields. Today, near Hanoi, billboards cast a shadow over the land (overleaf). Vietnam. 2002.

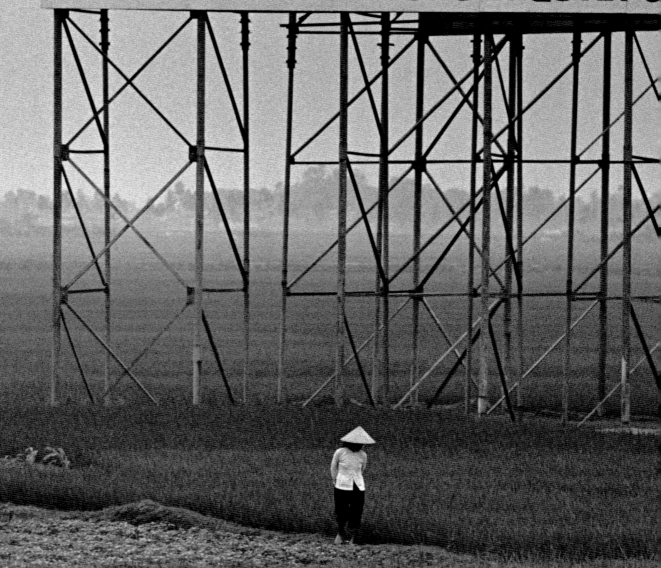

BOYS ON THEIR WAY HOME WATCHING TV

(opposite, top), the major way in which the people of the world are exposed to foreign values. For a reasonable $6, teenagers can visit one of the new recording studios, sing a song – the latest computer software will correct any out-of-tune notes – and get it burnt on a CD with their photograph on the cover (opposite, below). They are often sent to impressionable relatives in California. The CD is seen as a most glittering jewel in the eyes of a poor child (above). Vietnam. 2002.

PROMOTIONS' ARE PART OF THE 'NEW' VIETNAM.
They are considered an indispensable tool to inspire
consumers to buy (opposite, above). Vietnam. 2002.

VIETNAM IS THE WORLD'S second largest exporter
of coffee. However their farmers are woefully underpaid
for their beans (opposite, below). Vietnam. 2002.

ONE UNIVERSAL OBSERVATION is the subtle
way in which the Caucasian stereotype has been
accepted as superior. Consumer capitalism depends
on persuading people to be dissatisfied with what
they've got, and this even extends to their very
identity (below). Vietnam. 2002.

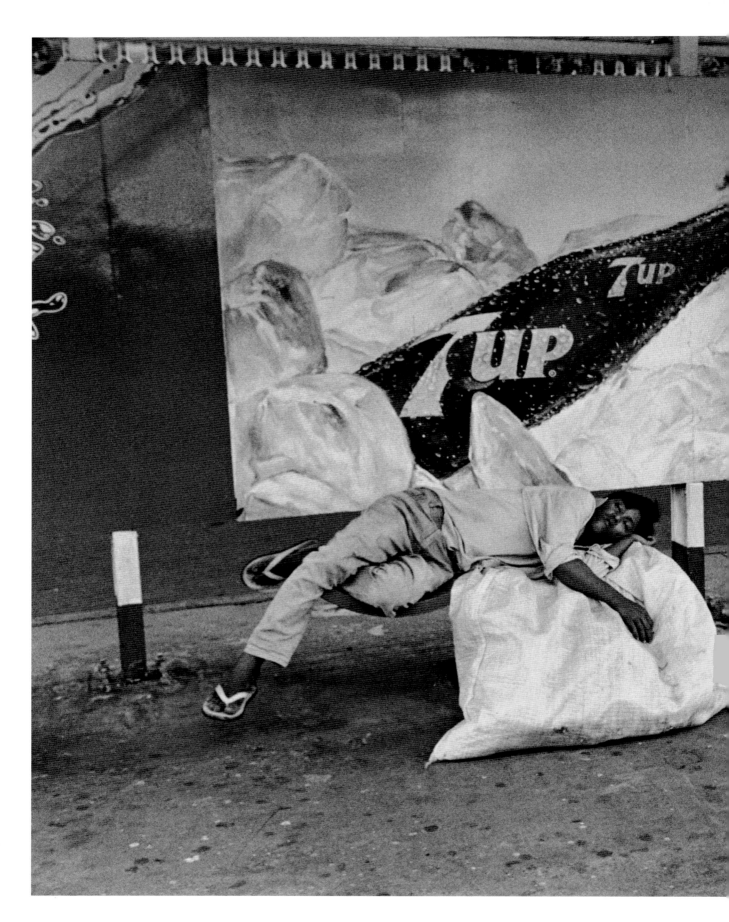

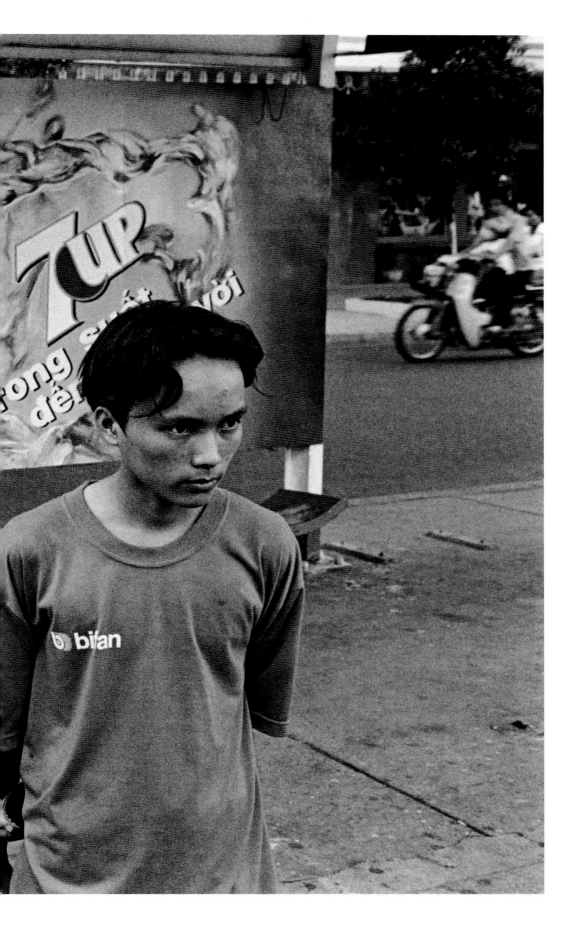

POSTER ON A BUS STOP in Ho Chi Minh City that provides shelter from the sun and rain, and a place for the weary to rest. Soft drinks are widely advertised in developing countries to compensate for falling sales in the US. Vietnam. 2002.

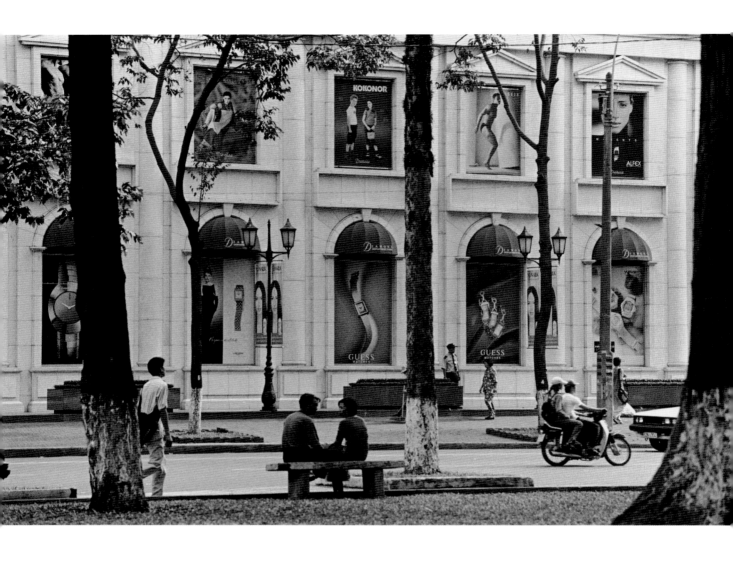

THE DIAMOND PLAZA SHOPPING CENTRE
in downtown Ho Chi Minh City has its windows
replaced with advertisements. Vietnam. 2002.

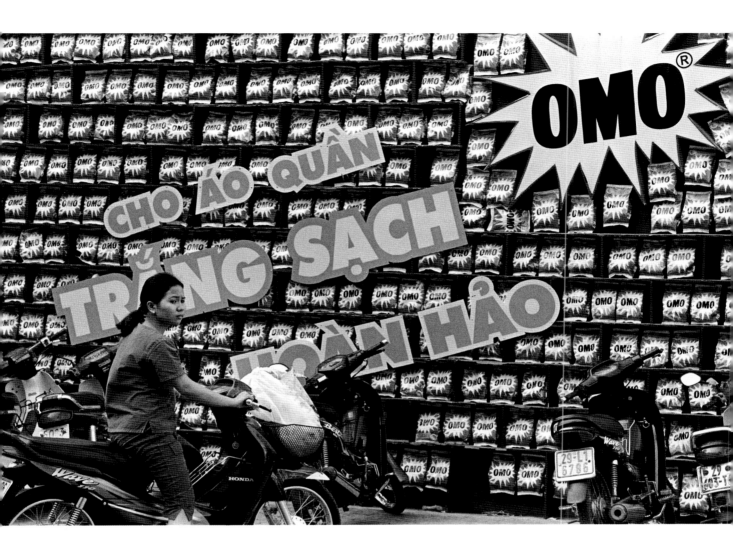

ON THE 'MORE IS MORE' PRINCIPLE,
the Anglo-Dutch giant Unilever has blanketed
Vietnam with washing powder ads. Vietnam. 2002.

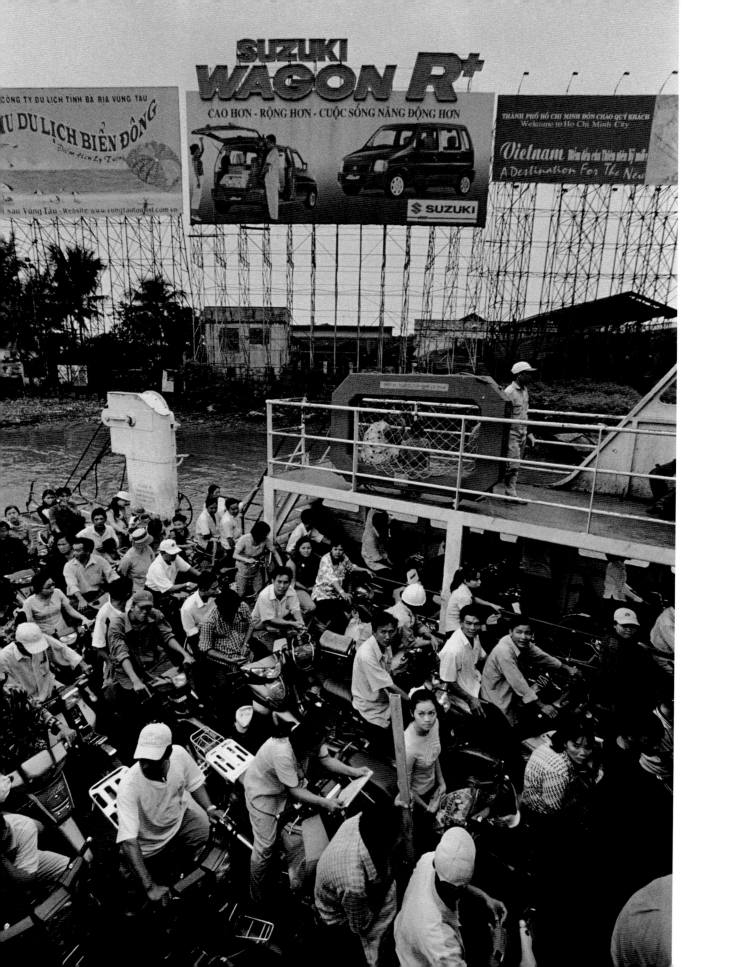

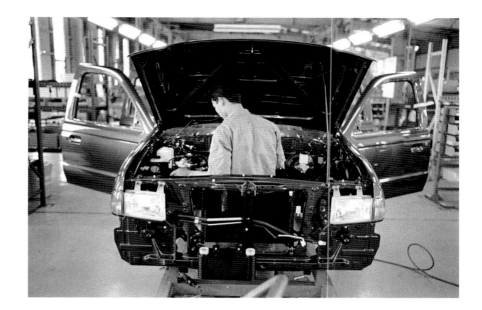

WORKER AT THE FORD CAR factory,
joint venture that was set up in 1995
top). Sales are 'sluggish', but today's low
gure of 5.5 cars per 1,000 people enables
manufacturers to be optimistic about the
ture. Vietnam. 2002.

FACTORY WORKERS AT BITI'S
ootwear Company assemble 7 million
airs of complicated sneakers every year
entre). They are sons and daughters
f men who fought the war wearing
andals made from old car tyres.
ietnam. 2002.

BITI'S 2,000 EMPLOYEES leave silently
single file at the end of the day shift
bottom). Vietnam. 2002.

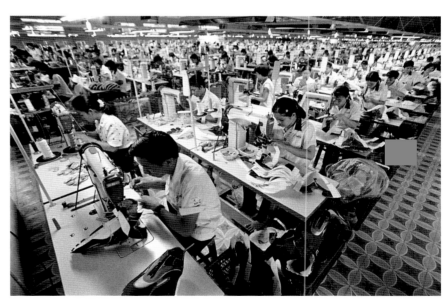

ACH MORNING PEOPLE
re ferried over the Saigon River
very few minutes to their place
f work (opposite). Vietnam. 2002.

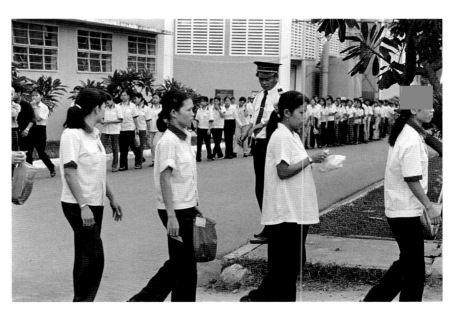

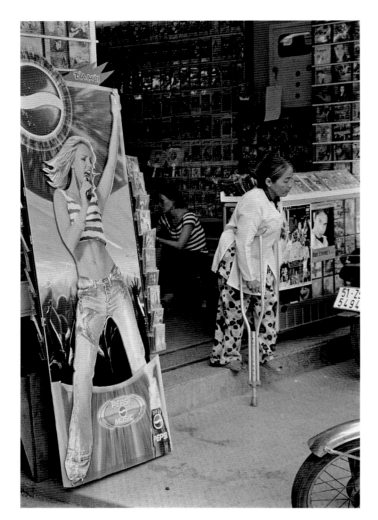

FOREIGN PENETRATION can be observed
everywhere in Vietnam. A curbside cutout of Britney
Spears (above left) dressed in a way no Vietnamese
mother would approve of. Vietnam. 2002.

ADVERTISING EQUATES JOY AND HAPPINESS
with products and services – a connection that is
not always apparent (above right). Vietnam. 2002.

HE HIGHEST RATE OF MOBILE PHONE GROWTH

n the world is, after China, in Vietnam. They are
narketed as status symbols to a people that
raditionally thinks of silence as a virtue.
ietnam. 2002.

THESE GIRLS WERE DANCING on a raised platform in a shopping mall in Hanoi watched by tired shoppers and their fascinated children. With the increasing popularity of Western music there have been exhibitions of pelvic-thrusting in the most unlikely places. Vietnam. 2002.

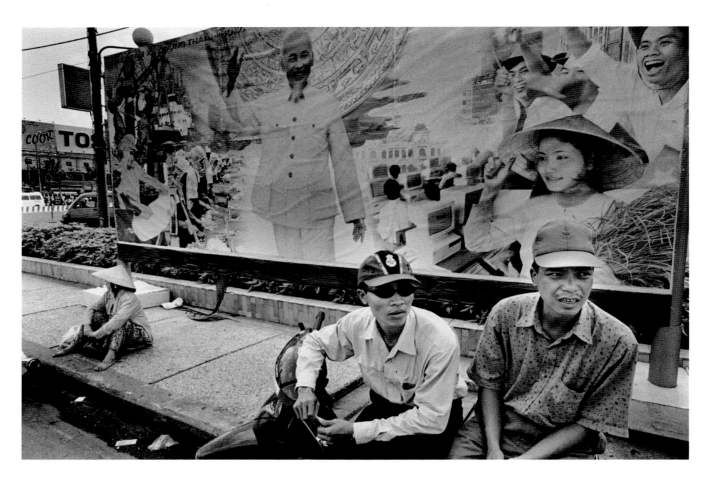

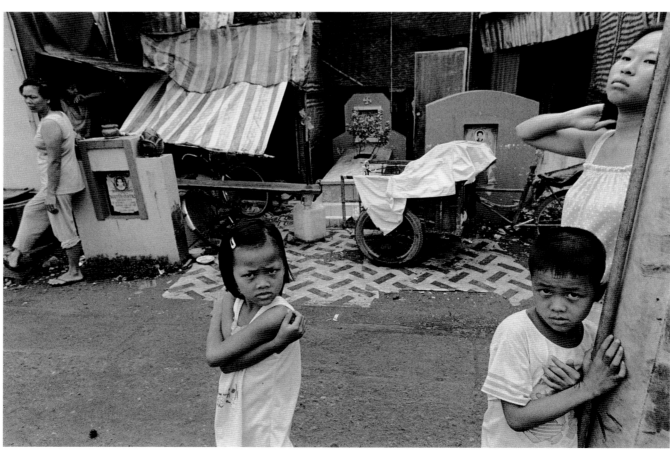

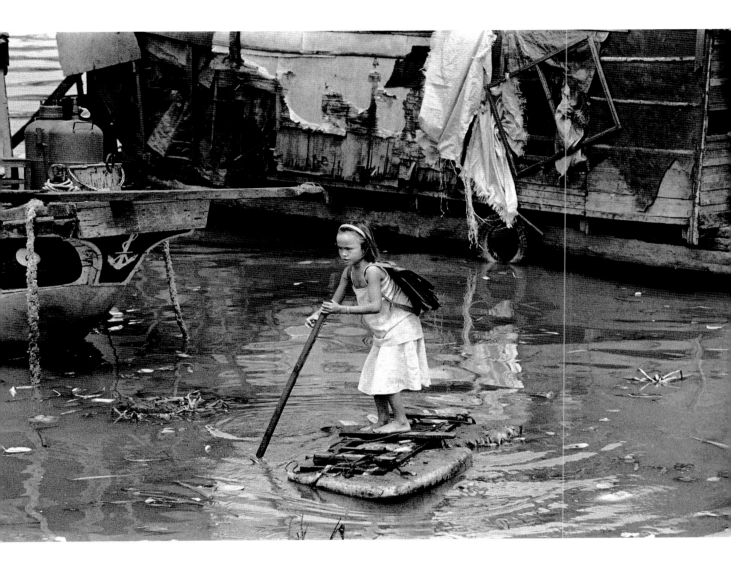

THE POSTER SHOWS HO CHI MINH beaming over
a set of activities that he may well have approved of
(opposite, above). He would have endorsed fish exports
but the first computer arrived in Vietnam long after
his death. Vietnam. 2002.

POOR FAMILIES LIVING IN OVERCROWDED AREAS,
typical of much of Ho Chi Minh City, are allowed to live
among these graves on condition that they keep them
in good repair (opposite below). Vietnam. 2002.

THIS GIRL LIVES WITH HER FAMILY ON THEIR BOAT
moored on the Saigon River. To get to school, she punts
herself to the bank standing on a piece of Styrofoam
packing material (above). Vietnam. 2002.

AMERICAN VISITORS TO VIETNAM are always
surprised by the lack of animosity towards them.
This salesman is demonstrating a dancing, smiling,
GI Joe to bewildered tourists and locals. Vietnam. 2002.

TOMBSTONES ARE CARVED in this street in
Hanoi. The shop (opposite) displays an uncollected
plaque made for a multinational corporation whose
product undoubtedly contributed to an increase
in customers. Vietnam. 2002.

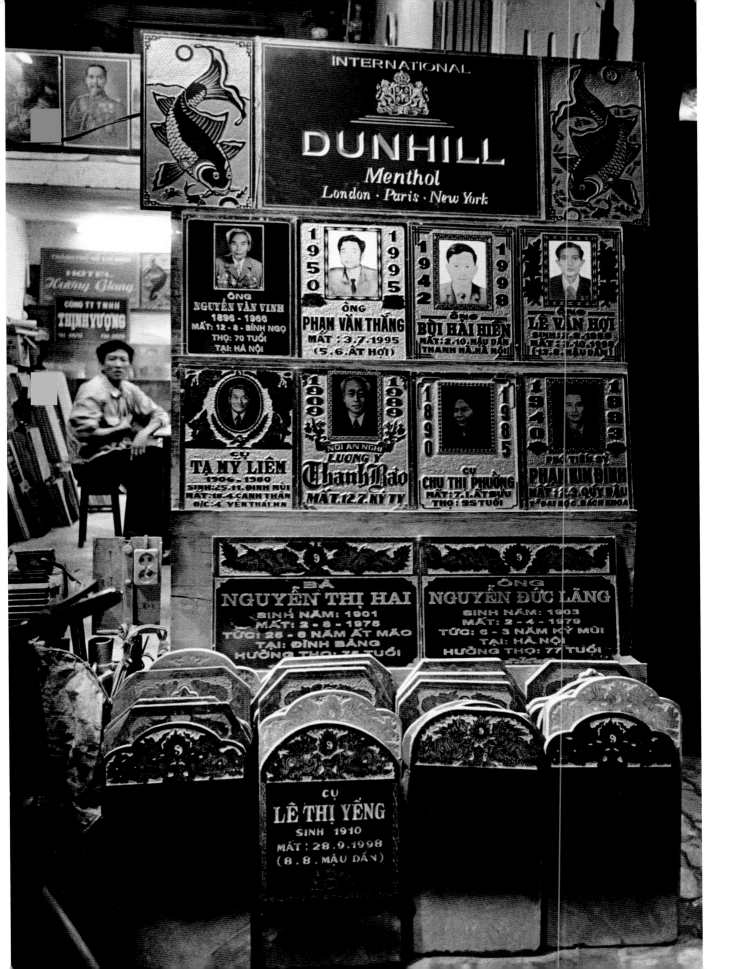

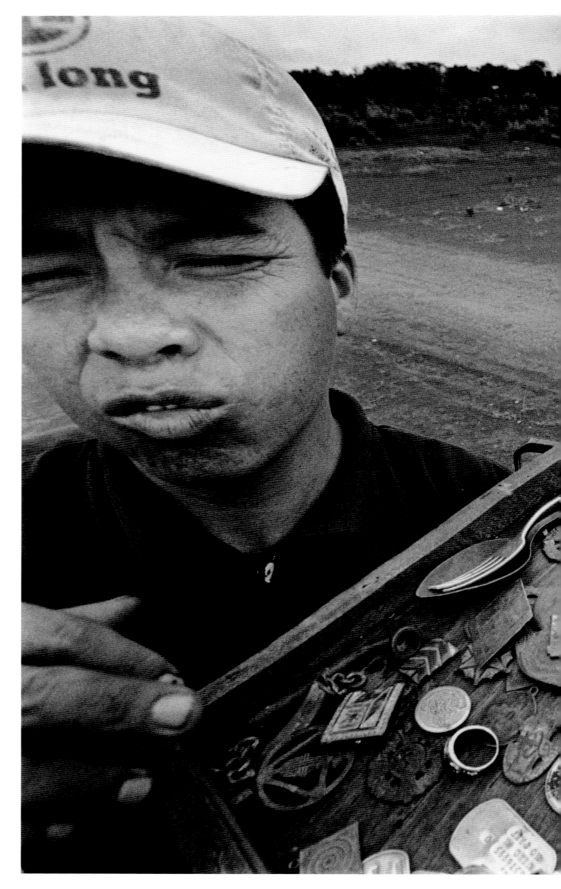

THE US MARINES IN KHE SANH
were under siege for 77 days. Alas,
the attack was a decoy to lure
troops away from the lowlands
so that the Viet Cong could launch
the Tet Offensive. Today, Khe Sanh
is firmly on the tourist trail with
children selling trinkets.
Vietnam. 2002.

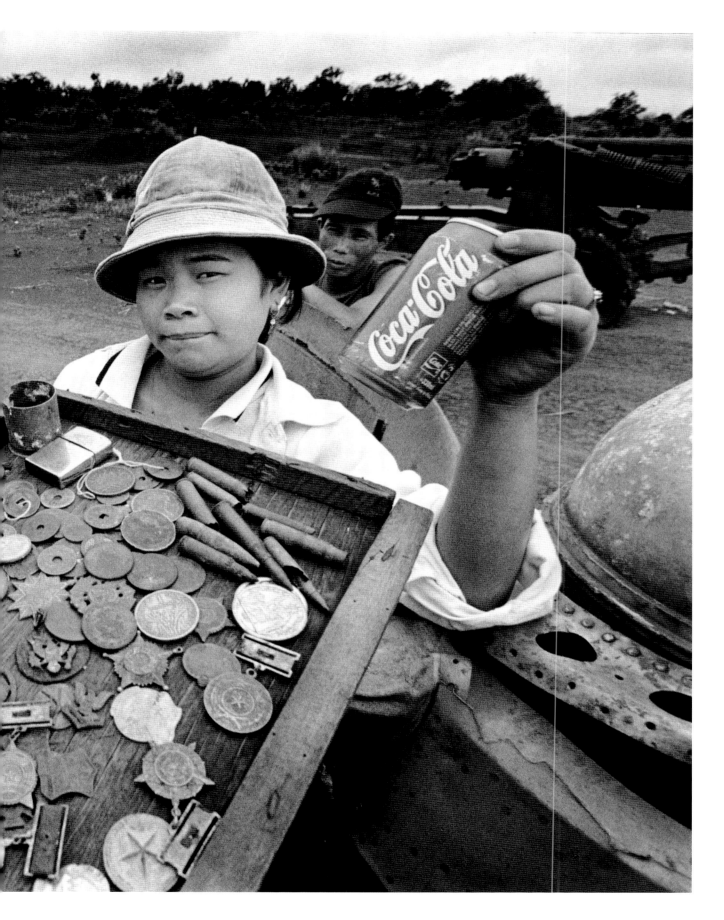

AKINBODE AKINBIYI BLACK ATLANTIC DIVINITIES

From resistance to an economic takeover to the resistance and survival of a culture. During the early globalizing period of the transatlantic slave trade, African religions found their way to Brazil. In an environment that sought to destroy African culture, these religions took on a central role in the preservation and restructuring of cultural identity. The Nigerian Òrisha cults have survived with unabated vitality in Brazil.

Feet pounding the dust in crazed fear, chests heaving and constricting as we run through the bush and farmland to escape. The screams and pleas of those caught and dragged away like animals to the slaughter. Crying quietly in the stillness, acutely aware of the numbing fear and the silent vegetation all around. Later they catch us, beat us for wasting their time, drag us to the others lying dazed under the shadow of a baobab tree, all shackled together, feet to feet, necks to necks. From freedom to shackled subjugation in seemingly an instant, lying in our excreta amid the flies and the burning heat of the afternoon sun.

What is there to relate of the long march southwards, along paths and through forests totally strange to us, the shackles eating into our flesh, festering and gangrening? Or of the sudden, surging sound of the sea? We smelt it long before we came up to it, smelt the salty taste of the humidity of a region we had only vaguely heard tales of – the lagoons and swampy islands, of men who lived on the water, seemingly moved in and even under it, spirit beings beyond comprehension.

Days and nights spent in a cramped space, the air thick with our effluents. We whisper quietly, understand that we are in a kind of gathering house. Many die of disease, of a completely broken will to live. What is especially terrifying is the constant pounding of the sea, the sound of the crashing waves, the salty sea taste in the air. If only we had known then.

Those who survived the weeks of creaking wood, the sludge of sea-sickness vomit and shit, the screams of those who lost it all, the rolling and plunging and heaving from side to side, acquired a deeper understanding, a longing for the essential virtues of life.

In Brazil not all were immediately sent out to work on plantations. Many remained in the ports of disembarkation, learnt urban trades and, most importantly, organized themselves into quietly subversive groups of conscious Africans. Members of the same ethnic group quickly found each other. Their common language speeded up the sharing of vital information. Social structures were set up similar to those on the home continent. Leaders were acknowledged and obeyed. Many escaped into the vast interior of Brazil and either set up autonomous settlements or joined existing ones. In this they worked closely with the indigenou Indian population.

Differing cultures came together the indigenous Indian, the Catholi Portuguese, the enslaved and dispossesse African. The European element dominated and sought to eradicate all other ways. Th indigenous Indians suffered especially, an in Brazil were almost totally wiped out. Th inhuman treatment of the importe Africans was no less severe, the only differ ence being that for almost four centurie there was a continual flow of Africans to th New World. In the nineteenth century mos were from the Yoruba people of the wes coast of Africa from what is today south west Nigeria and the south of Benin repub lic. Bitter civil wars and the break-up of thei kingdom led to a steady supply of capture men, women and children to the slave port of Ouidah, Porto Novo and Lagos. Bot Europeans and local Africans were involve in this trade. Brazil finally abolished thi terrible human traffic in 1888, the las country to do so in the Americas.

Yorubas were the most numerou among the imported slaves of the fina decades, and this is one of the mai reasons why the Yoruba religion survive

o vigorously in Brazil. Imported into the orth-eastern ports of Brazil, their culture, anguage and religion became a dominant spect of the counterculture. Yorubas, forbidden to speak their language and practise their culture during the slavery years, rganized secretly, and when freedom ame they quickly emerged. Their religion, ased on Ifa divination and the worship of lodumare, the Almighty, through his nmediate servants or Òrishas, gained in nportance and acknowledgment.

Today the Yoruba religion, known in razil as Candomblé, is perhaps the most frican of the African-Brazilian religions. he more syncretist Umbanda emerged in ne 1930s with the first massive migration to ne big cities from the poor rural areas of the orth-east. Prior to the nineteenth century, frican slaves imported into Brazil came rom as far away as present-day Angola and ne Congo. Forced into their slave masters' hurch, they prayed outwardly to the atholic saints, while maintaining their eliefs in their own deities and saints, ometimes even secretly hidden as sculptural objects under the Christian altar.

Many freed west African slaves returned o their land of origin. They pooled their esources and hired ships to take them back. Once on home soil, they formed a distinct roup of returnees, many with urban skills. oday the ports all along the west African oast still display recognizable areas where ne returnees settled and built in their razilian style. In Lagos the area today known s Campos on the Island still shows many ne examples of Brazilian-style architecture.

Some of the returnees decided to go ack to Brazil. The last decade of the nine-

teenth century and the early decades of the twentieth saw a constant coming and going between the north-east of Brazil and the west African coast. Foodstuffs, textiles and religious objects necessary for the practice of divination and the worship of the Òrishas were imported into Brazil. Some families sent their children to school in Africa. Others in Africa sent their children to school in Brazil. Today, a hundred years later, some have relatives on both continents, still in close contact.

In both Umbanda and Candomblé the emphasis is on healing and coming together, the bonding knowledge that carried the dispossessed through the centuries of suffering and despair. It explains our inner strength, our will to overcome and move on, to forgive. Today in Brazil the African-Brazilian religions are inclusive not exclusive. Anyone and everyone can and does take part. The seriousness and depth of knowledge in Ifa divination and Òrisha worship convince. Adepts learn of healing plants, of particular offerings to particular Òrishas, of rituals meant to cleanse and rejuvenate, of healing and encompassing. Simplicity and purpose of will are paramount. Get to the heart of the matter, talk briefly about it, perhaps advise, offer healing words, and then move on, giving thanks in offerings.

Brasília was inaugurated as the new capital of Brazil in April 1960. It represented a brand new beginning, with bold architecture and city planning to give form to the postwar optimism. Away from the heavily populated narrow coastal strip, it represented the will to open up the vast Brazilian interior, and at the same time set

a new direction in achieving the potential of its many natural resources.

A few months later that same year, Nigeria achieved its independence from Great Britain. Lagos as its capital was a city of perhaps a million inhabitants, ordered, with functioning public facilities and a strong sense of a bright future. Some forty years later, the city has exploded into a megalopolis of between twelve to fifteen million inhabitants. Years of neglect and administrative incompetence has made it known worldwide for its traffic go-slows, its power-cuts and unreliable water supplies, its abominable phone services, its crime.

Most Lagosians are hardly aware that from the seaboard so near them many were shipped into slavery. Some perhaps know of the survival in various forms of their culture and religion in the Americas, know of Òrisha worship in Brazil, Cuba, Haiti, the United States. Few though can imagine the vitality and joy of Candomblé and Umbanda ceremonies in and around Brasília, thousands of kilometres away from their source. Almost deprived of their humanity, Africans took with them the one thing you cannot trade in, their spirituality. For many it was their lifeline in overcoming ultimately even themselves in the need to encompass all in the long journey forward.

SACRIFICIAL OFFERINGS probably to Obaluaiye, the Yoruba deity or Òrisha who oversees pestilence and diseases (overleaf). He punishes evildoers and the insolent. The Yoruba religion came to Brazil with the inhuman slave trade that flourished from the 16th to the 19th century. Yorubas were transported in vast numbers in the 19th century from today's south-west Nigeria and the Benin Republic. Praça dos Orixás, Brasília, Brazil. October 2002.

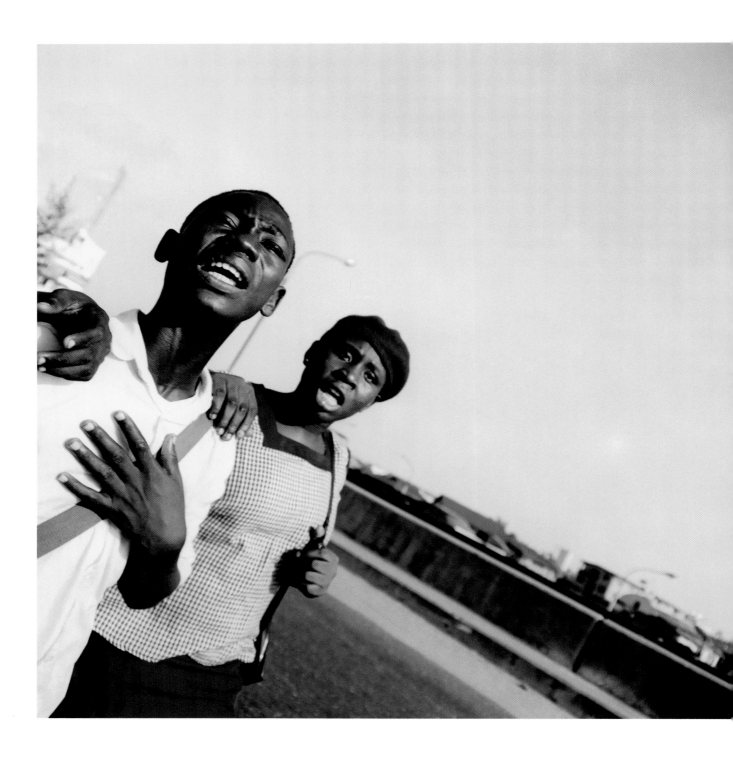

WALKING THE WALK.
Obalende, Lagos, Nigeria.
November 2002.

SACRED SHRINE TO OGUM. Yoruba Ògún, Brazilian
Ogum is the deity/Òrisha of metal, of iron, of ironsmiths,
of utensils wrought from iron, thus of war and of modern
day technology – the motor car, for example. The shrine is part
of the complex of the Candomblé centre, Ile Ase, in the satellite
town Ceilândia of greater Brasília. Candomblé is the Brazilian
name given to the religion that originated in Yorubaland.
Ceilândia, Brasília, Brazil. October 2002.

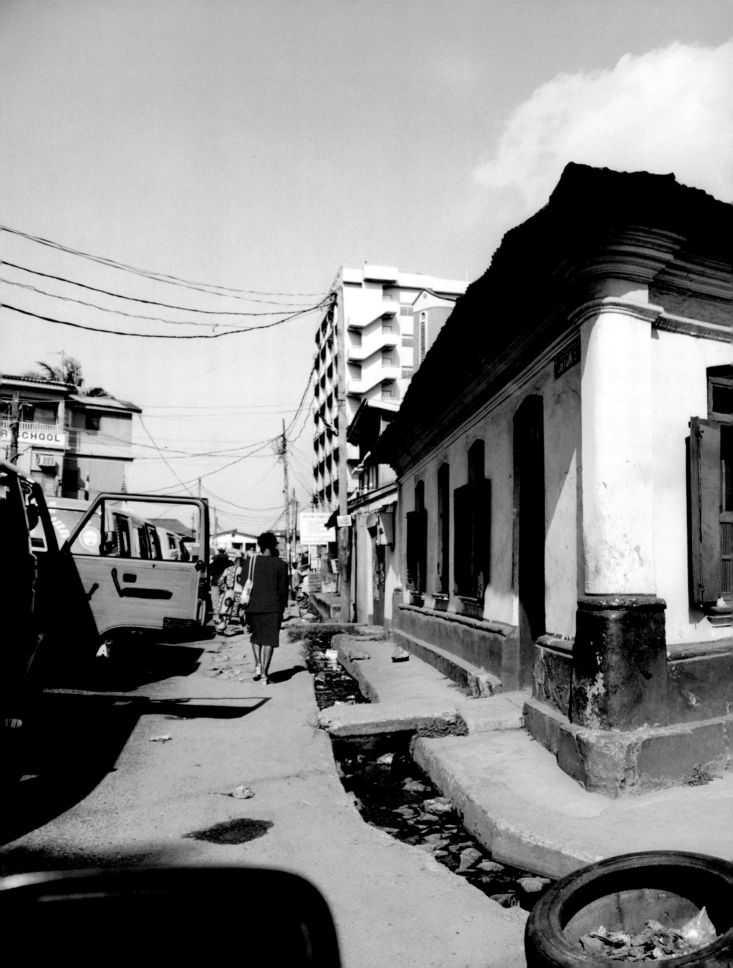

ONE OF THE FEW REMAINING EXAMPLES
of Brazilian architecture (opposite) built by
returning freed slaves after the abolition of
slavery in Brazil in 1888. Lafiaji, Lagos Island,
Nigeria. November 2002.

QUEUING FOR CONFESSION (above)
during the annual Festa de Nossa Senhora
Aparecida, the patron saint of Brazil and Brasilia.
Esplanada, Brasilia, Brazil. October 2002.

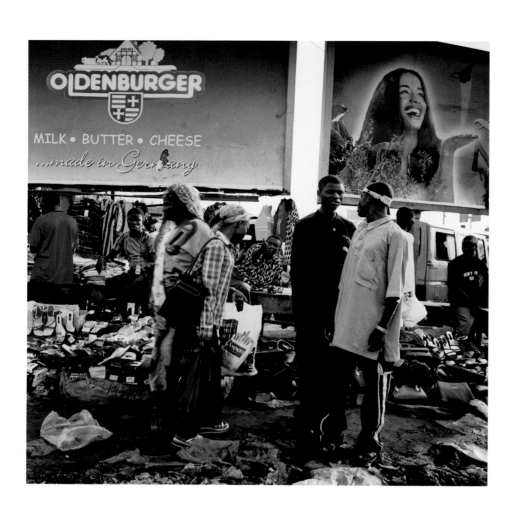

THE MOST CONGESTED NODAL POINT
in west Africa's most populated city (above).
Oshodi, Lagos, Nigeria. November 2002.

VIEW OF SECTOR A SUL (opposite).
Esplanada, Brasília, Brazil. October 2002.

THE THREE FIGUREHEADS of the Candomblé
centre Ile Ase in the satellite town Ceilândia, greater
Brasília. From left to right, Ìyákékeré, Babalórìsha
and Ìyagánmu. The sculpture behind them represents
the Yoruba deity/Òrisha Oxaguiam, in Yoruba Oshagiyan,
who is responsible for creativity and justice. Ceilândia,
Brasilia, Brazil. October 2002.

WALL DECORATION DEPICTING FIGURES
from Yoruba mythology and religion. On the
extreme right is a depiction of Egungun, the
deity/Orisha of masquerade, of moral inquisition.
Lafiaji, Lagos Island, Nigeria. November 2002.

CATEDRAL METROPOLITANA Nossa Senhora Aparecida.
Esplanada, Brasília, Brazil. October 2002.

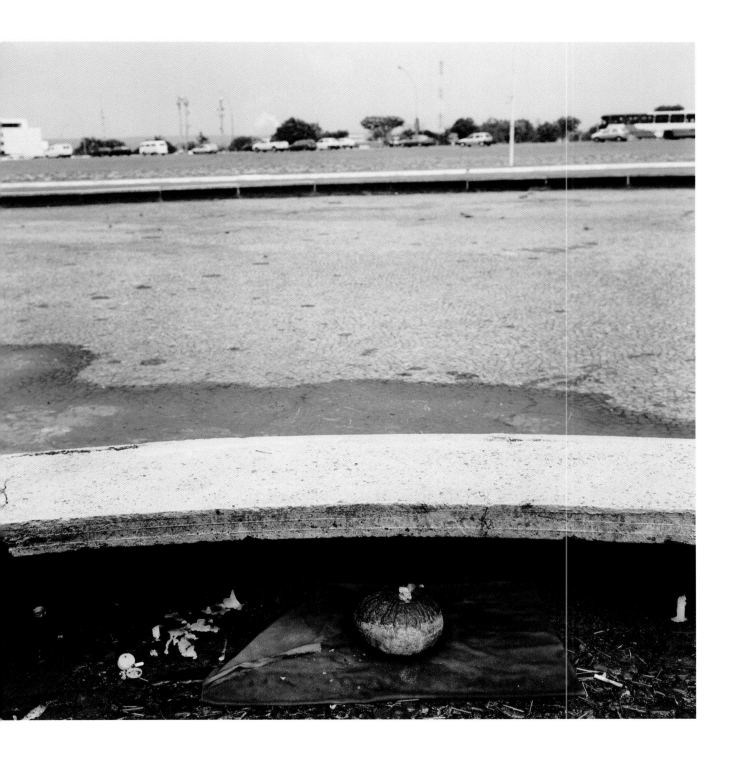

SACRIFICIAL OFFERINGS AT A LANDMARK SQUARE

long the Eixo Monumental. The nature of the offerings
nd their location at a Christian cross implies beliefs
rom Umbanda, the widespread African-Brazilian
yncretic religion, formed from African religious beliefs,
Catholicism and indigenous Indian religious beliefs.
Praça do Cruzeiro, Brasilia, Brazil. October 2002.

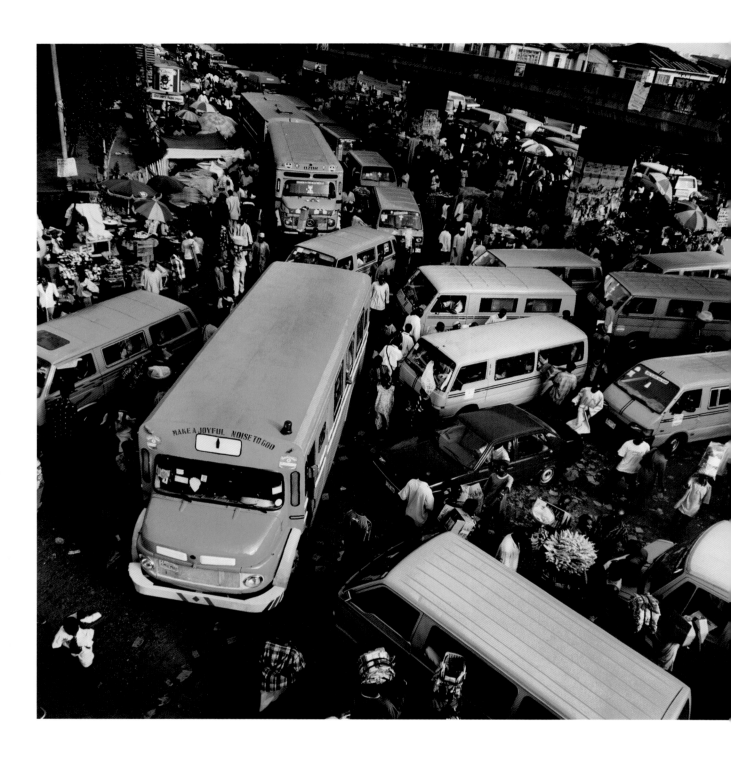

AN IMPORTANT NODAL POINT
in the vehicular nightmare of this megalopolis.
Obalende, Lagos, Nigeria. November 2002.

OKING OUT AND DOWN ON THE PLANO PILOTO.

rre de Televisão, Brasília, Brazil. October 2002.

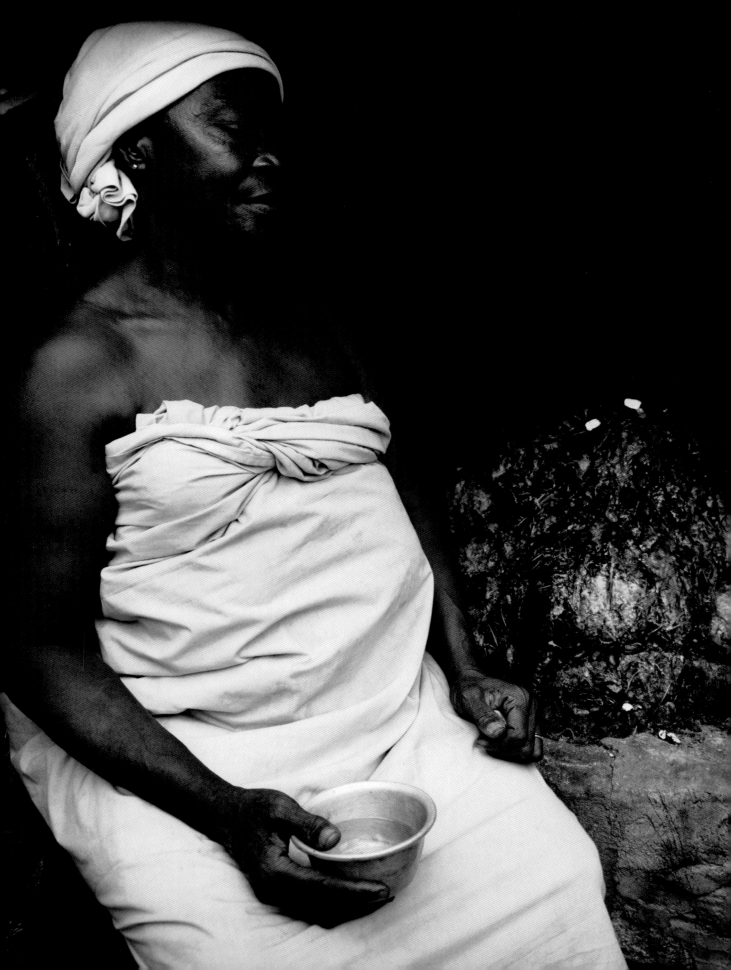

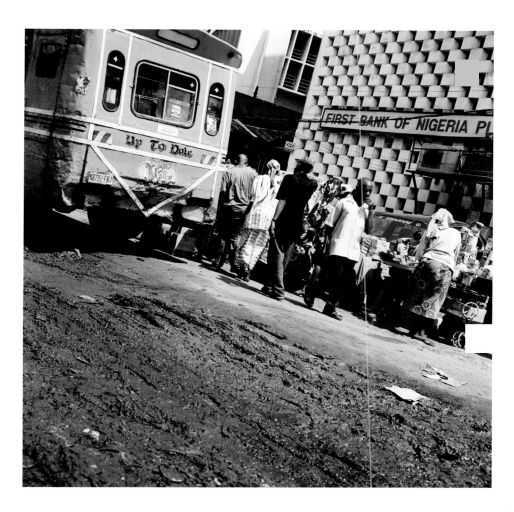

CHIEF MRS MOSUNMOLA KOSOKO (opposite)
sitting before a shrine to Şango, the deity/Òrìsha
of thunder and lightning at the Iledi Idi-Iroko centre
for Yoruba religious worship. She acknowledges
her power and high position. Ijeh, Obalende, Lagos,
Nigeria. November 2002.

NNAMDI AZIKIWE STREET (above).
Lagos Island, Nigeria. November 2002.

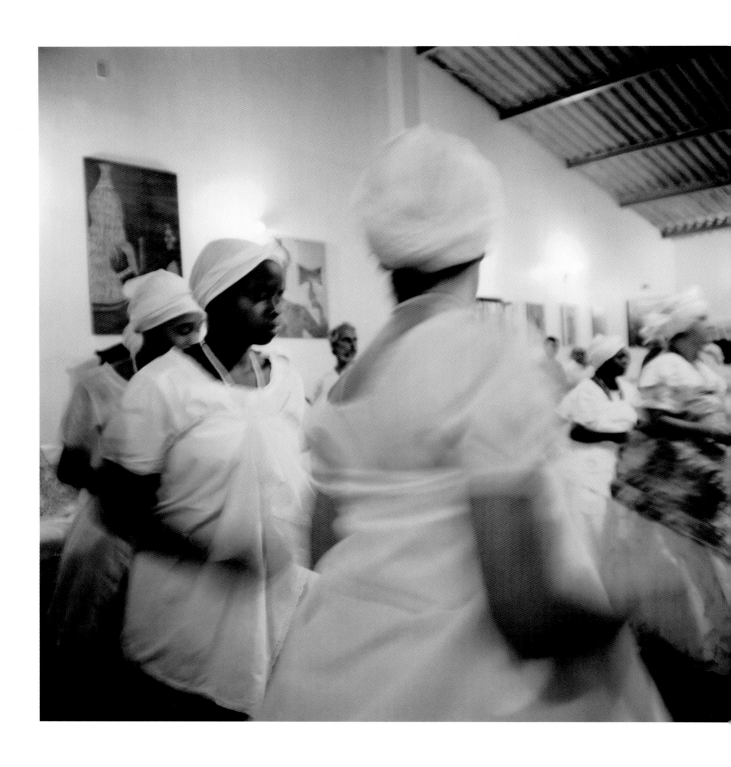

CANDOMBLÉ FESTIVAL in the Templo do Axé Bara Leji,
casa de Tito de Omolu, Mansões Bitencourt. Santo
António do Descoberto, Goiás, Brazil. October 2002.

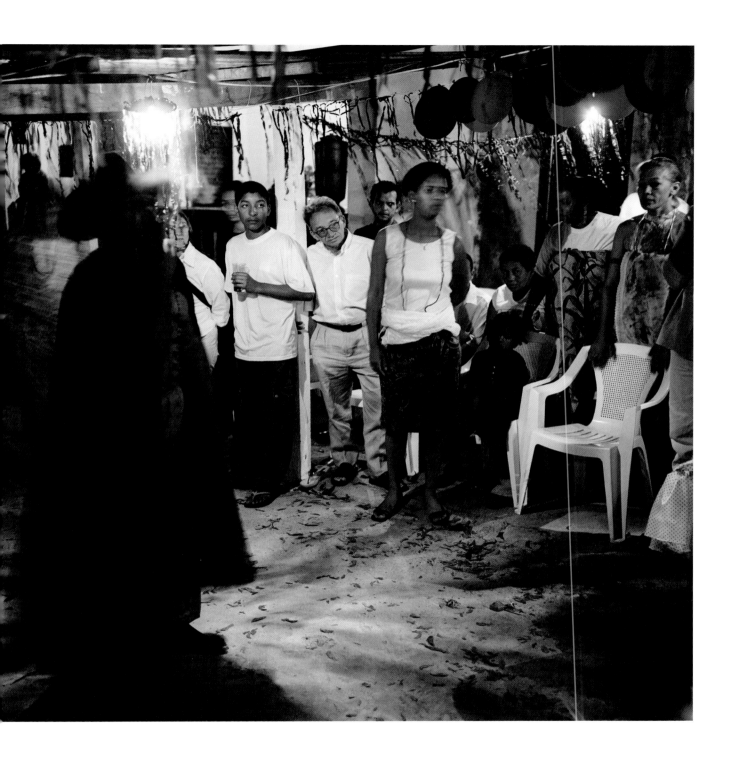

UMBANDA CEREMONY in the satellite
town of Sobradinho II, greater Brasília.
Sobradinho II, Brasília, Brazil. October 2002.

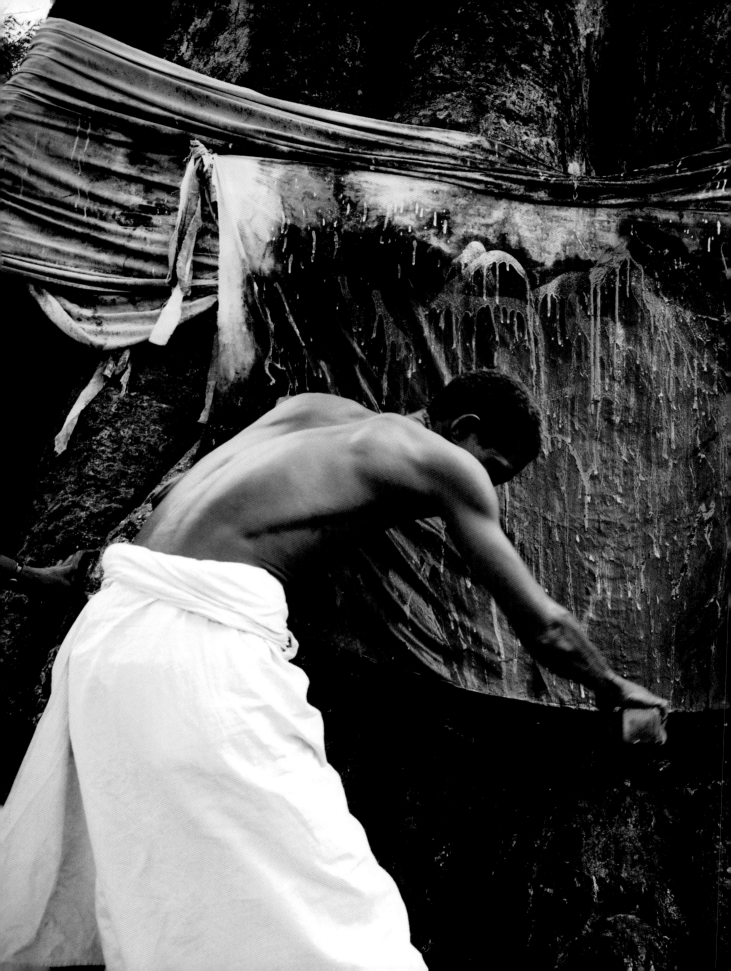

THE IROKO TREE SHRINE at Iledi Idi-Iroko
(opposite), the centre for Yoruba religious worship
at Ijeh, part of the Lagos municipality of Obalende.
The Iroko tree is an important spiritual power-
focus in Yoruba religious belief. Ijeh, Obalende,
Lagos, Nigeria. November 2002.

THE SCULPTURAL FIGURE of the Yoruba
deity/Òrìsha Òṣun in the Candomblé complex
of Ile Ase at Ceilândia, greater Brasília (above).
Òsun ensures fertility, endows love, is
responsible for sweet water. Ceilândia,
Brasília, Brazil. October 2002.

SERIOUS BIBLE PRAYER on the Atlantic
coastline. The costume is added incentive.
Bar Beach, Victoria Island, Lagos, Nigeria.
November 2002.

OYI CEMETERY.

gos, Nigeria. November 2002.

The text on the monument reads:

IN MEMORY OF OUR
BELOVED HUSBAND AND FATHER
THE HON. MR. JUSTICE
Ezekiel Akinola Cole
BORN ON 27TH. DEC. 1917
DIED ON 14TH JULY, 1982
ETERNAL REST GRANT HIM O LORD

~

"LIVES OF GREAT MEN
ALL REMIND US
WE CAN MAKE OUR LIVES SUBLIME
AND DEPARTING
LEAVE BEHIND US
FOOTPRINTS IN THE SAND OF TIME"

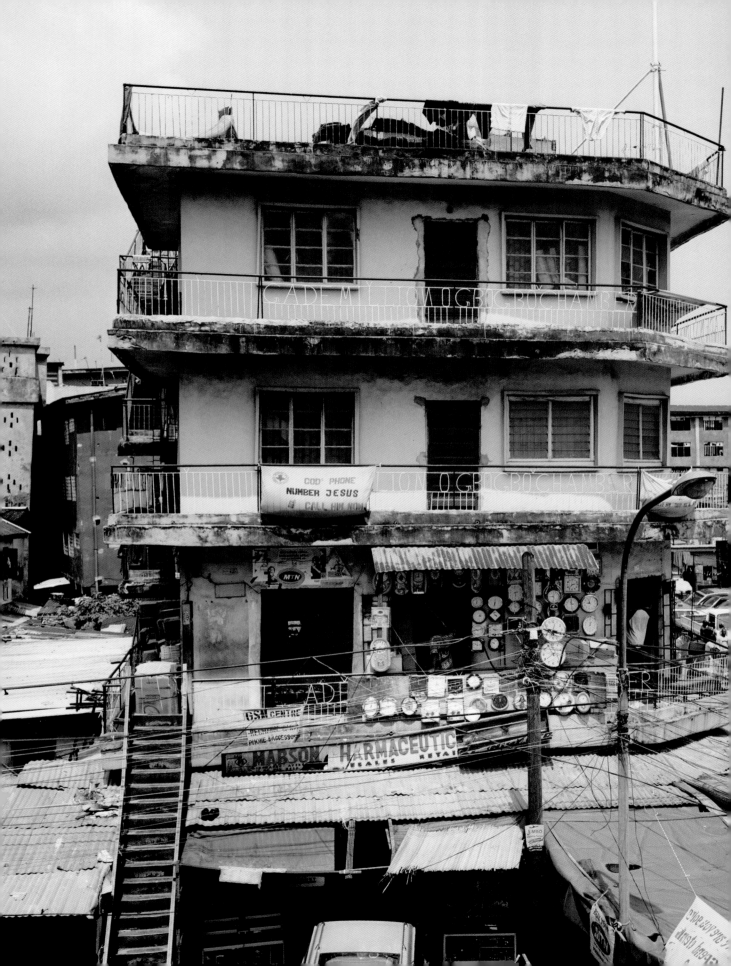

ISALE EKO (opposite).
Lagos Island, Nigeria. November 2002.

ÓGÙN'S SHRINE AT THE CENTRE FOR YORUBA
religious worship at Iledi Idi-Iroko (above). On the left
is Chief Rasaki Kosoko, the head priest of the centre.
Ijeh, Obalende, Lagos, Nigeria. November 2002.

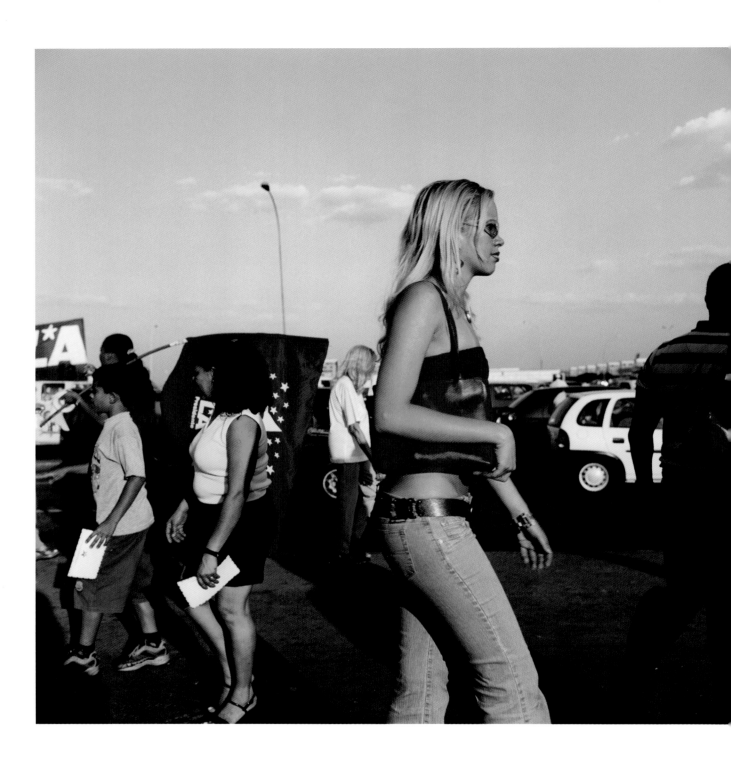

THE COMMERCIAL AND TRANSPORT HUB
of the Brazilian capital. Rodoviária, Brasília, Brazil.
October 2002.

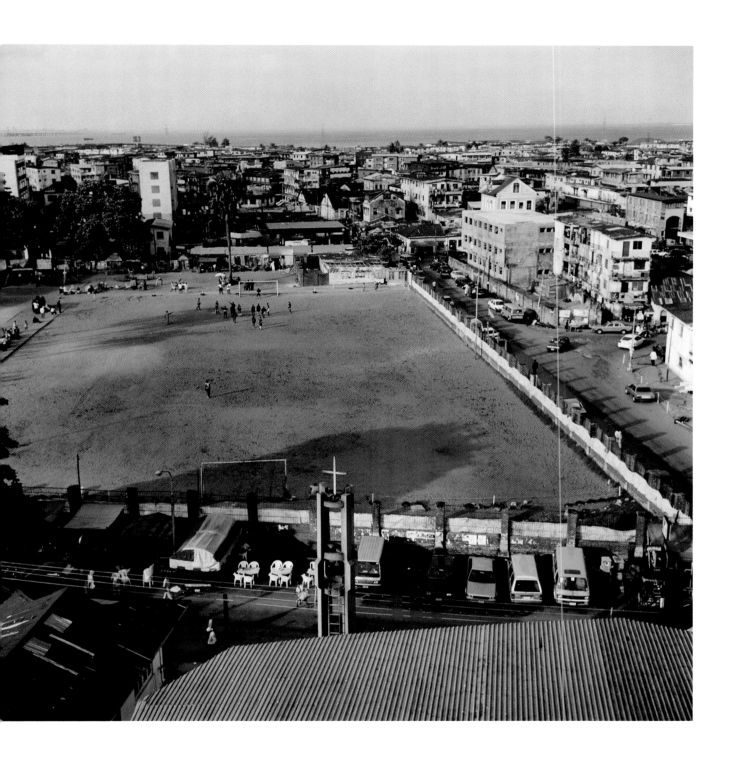

ART OF THE AREA OF LAGOS ISLAND

ce populated by the Brazilian returnees
yesteryear. Where football is now passionately
ayed was once a cemetery. Campos, Lagos
and, Nigeria. November 2002.

ALPHA BEACH, Lekki Peninsular, Lagos, Nigeria.
November 2002.

PHOTOGRAPHERS

AKINBODE AKINBIYI (Nigeria, 1946)

Born in Oxford, he studied literature in Ibadan, Lancaster and Heidelberg, and now lives in Berlin. He took up photography in 1974 and has been a freelance photographer since then. In 1987 he received the Stern Reportage Fellowship. This enabled him to continue his long-term project on the megacities of Lagos, Cairo, Johannesburg and Kinshasa, begun in 1982. He is a founding member of the Cultural Center in Clermont Township/Durban UMZANSI, and has acted as Curator of the African Photo-Biennale in Bamako in 2001 and 2003. His work has been published in magazines like *du* and *Revue Noire,* and has been shown in numerous exhibitions, most recently 'Africa and the City' at the Centre de Cultura Contemporània de Barcelona, Spain.

ZIYO GAFIC (Bosnia-Herzegovina, 1980)

Studied world literature and took up photography in 1995. Having witnessed the war himself, he felt obliged to record the scars that the war has left on the people and the country, first for a local magazine in Sarajevo then as a freelance. Taking part in a workshop, he met Magnum photographer Paul Lowe, and with him he established the first gallery dedicated to photography in former Yugoslavia. In 2001 he won a World Press Photo prize for 'The Last Bosnian Village', and another in 2002 for his documentary work on war crimes and returnees in eastern Bosnia. He was also awarded the Kodak Prize at the 14th International Festival of Photo-journalism in Perpignan in 2002. He is a member of Agencia Grazia Neri/Milano.

PHILIP JONES GRIFFITHS (Wales, 1936)

Studied pharmacy in Liverpool and practised in London. In 1961 he became a full-time freelancer for the London *Observer.* He covered the Algerian War in 1962, and then was based in Central Africa, moving from there to Asia. He photographed in Vietnam from 1966 to 1968. He went back to Vietnam in 1970, and won fame for his 1971 book on the war, *Vietnam Inc.* This book crystallized public opinion and was instrumental in shaping Western misgivings about the US involvement in Vietnam, ultimately helping to bring the war to an end. The outcome of three years of reporting, *Vietnam Inc* is one of the most detailed surveys of any conflict. It was republished in 2001.

An associate member of Magnum since 1967, Jones Griffiths became a member in 1971. In 1973 he covered the Yom Kippur War, and then worked in Cambodia during the period 1973 to 1975. In 1977 he was based in Thailand, covering Asia, and this period resulted in another book. In 1980 he moved to New York to assume the presidency of Magnum Photos, a post he held for a record five years. He has made numerous documentary films, and his photographs have appeared in every major magazine in the world. His assignments, often self-initiated, have led him to over 140 countries in all five continents.

TIM HETHERINGTON (England, 1970)

Oxford University degree in Classics and English. Worked as a writer and editor of children's books. After studies in photojournalism at Cardiff College, he became a photographer in 1997. In 2001 he was awarded a Fellowship of the National Endowment for Science, Technology and the Arts, NESTA. His recent work has focused on new ways of representing and imaging Africa. In 2000 and 2002 he won World Press Photo prizes for his work in Liberia and Sierra Leone. He has been a member of Network Photographers/London since 2001, and holds numerous workshops.

THOMAS KERN (Switzerland, 1965)

Founding member of Lookat Photos. He worked in Ireland, Kurdistan and the Balkans, and was held captive by Iraqi security forces during the bombing of Baghdad in 1991. Based in San Francisco, he is now concentrating on issues linking Central America and the USA. In 1996 he won two World Press Photo prizes for work in Iran and Dagestan.

BERTIEN VAN MANEN (Netherlands, 1942)

Worked as a fashion photographer for several years before becoming a freelance photographer in 1977. Her first book, published in 1979, focused on the lives of migrant women in the Netherland During the 1980s her assignments led her to various countries, including Algeria, Nicaragua, the USA and eastern Europe. A book on women in the Roman Catholic Church was published in 1985. Photographing the people of the former Soviet Union and in China changed her style. The images, shot with a small format camera on colour negative film, were published in the books *A Hundred Summers, A Hundred Winters* (1994) and *East Wind West Wind* (2001). Her work has been exhibited in museums worldwide. She has won numerous awards, and her photographs are to be found in every major photo collection, including the Metropolitan Museum, New York, the Museum of Modern Art, New York, and La Maison Européenne de la Photographie, Paris. In 2003 she was shortlisted for the Citibank Photography Prize. Bertien van Manen lives in Amsterdam.

SHEHZAD NOORANI (Bangladesh, 1966)

A freelance documentary photographer and a consultant on social issues for national and international organizations since 1987, Noorani's focus has been to capture visually the existence of those who are on the lowest rungs of South Asia's social, political, and economic ladder. He has edited photographs for numerous publications and multi-media presentations, and has helped to set up picture libraries for organizations like UNICEF and Map Photo Agency, Dhaka. In 1999 he was awarded the Mother Jones International Award for Documentary Photography for his project 'Daughters of Darkness' on commercial sex workers in South Asia.

CRISTINA NUÑEZ (Spain, 1962)

Born in Figueras, she studied English Literature at Cambridge University and acting in Paris. Based as a photographer in Milan since 1994, she works for several magazines. In 1996 she was awarded the 'Mosaique' programme award by Luxemburg's Ministry of Culture for a book and exhibition project on spirituality in Europe.

1999 she produced photographs and texts for
the book *io sono* on liberation from drugs. In 2002
she founded the photo agency Somos to promote
young Italian photographers.

ANDREAS SEIBERT (Switzerland, 1970)
Born in Wettingen, he studied German literature
and philosophy in Zurich. Since 1997, he has been
based in Tokyo as a freelance photographer
working for numerous magazines. His work,
in colour as well as in black and white, gives
emphasis to Japanese society in transition.
In 2001 his documentation of Yokohama's port
was published in the book *Cross Culture*. He is
working on a long-term project on the life of the
Japanese Gyosho (Tokyo market women who
sell vegetables). He has been a member of
Lookat Photos since 2001.

STEPHAN VANFLETEREN (Belgium, 1969)
Born in Kortrijk, he studied photography
in Brussels before becoming a freelance
photographer in 1992. His radically intense,
black and white social documentary work
covers disappearing phenomena of everyday
life in his homeland Belgium, as well as current
events in conflict zones, such as Kosovo and
Afghanistan. The work for his book *Elvis & Presley*,
published in 2000, a collaboration with Robert
Huber, is on show at various galleries in Europe.
His awards include the World Press Photo
Children's Award in 2001. He has been affiliated
with Lookat Photos since 2000.

THE EDITORIAL TEAM

DANIEL SCHWARTZ Editor (Switzerland, 1955)
A member of Lookat Photos since 1997. He was
the first foreigner to travel the entire length of the
Great Wall of China, in an eight-month forbidden
journey from 1987 to 1988 that resulted in an
acclaimed book (Thames & Hudson), published
in a new and enlarged edition in 2001. His book
*Delta: The Perils, Profits and Politics of Water in South
and Southeast Asia*, published by Thames & Hudson
in 1997, covers ecological and political issues in
Bangladesh, Burma, Cambodia and Vietnam.
In 1998 he followed the trail of money, from the
Asian currency crisis via Afghanistan and Europe's
financial centres to Wall Street. He is working on
a new book on Central Asia. His work has been
widely published and shown in major individual
and group exhibitions.

NICOLE AEBY Photo Editor and Researcher
(Switzerland, 1966)
Studied economics in Zurich, and from 1985 to
1987 English and Fine Arts in London. After an
internship with Contact Press Images in New York
and Focus in Hamburg from 1988 to 1990, she
became a founding member of Lookat Photos
in Zurich, and has been Managing Director of this
photographers' agency since then. She has given
numerous workshops on photojournalism
(e. g. at the Zurich School for Art and Design and
at the MAZ Media Formation Centre, Lucerne). She
was jury-member of the World Press Masterclass
(1998), the Swiss Press Award (1998/1999) and the
World Press Photo Award (2002).

CARSTEN STÜTZ Text Editor (Germany, 1968)
Studied literature, politics and philosophy at the
Universities of Konstanz and Marburg. Based in
Zurich since 1996 as a freelance journalist and
literary critic, he writes on a wide range of topics
for German and Swiss newspapers and magazines.

ACKNOWLEDGMENTS

AKINBODE AKINBIYI
Sincere thanks to:
In Brasilia: Deputado Roberto Freire; Dr Maria
de Lourdes Sequeira; Babalórishà, António de
Ossoce; Pai Tito; Bonfim and Elton in Sobradinho II,
Brasília; Adriana and Marco António of Fundação
Palmares; Professor Roberval Marinho; Leila,
Anna Lucia and Leani of Deputado Roberto Freire's
office; Jardir Marinho.
In Lagos: Yinka Doherty; Rapana Wilson; Chief Rasaki
Kosoko; Dr Abosede Emanuel; Uche James-Iroha;
Toyin Sokefun; Tunji of Yinka Doherty's chambers; BJ.
In Berlin: Marta Freire and Wagner Carvalho.
And to all the many others who deserve grateful
thanks for helping me. Once again, thank you all
very, very much. I hope the images and text,
indeed the whole project, meet you well.

ZIYO GAFIC
I was never turned down in Bosnia. Everything
I wanted to photograph I managed to. Whether it
was a family that had just recognized the remains of
a loved one, or people praying in church, no one said
no (with the regrettable exception of the US Marines
who wouldn't let me photograph their birthday party
in Sarajevo). There could be many reasons for this, but
the one I want to believe is that these people felt that
by being photographed a small part of their burden
would be taken away and they could experience relief.
I would like to thank them for letting me be present
in their moments of grief and joy.
There are a few people that I didn't photograph, but I
feel a strong need to thank them: none of this would
be possible without my parents Fikreta and Muhamed
and my sister Zaina; Ozren Kebo and Senad Pecanin
gave me the first chance; Trio-Fabrika organized
the best (after-work) brainstorming I've ever seen;
Eva Klonovski, Sejo Koso and Amor Masovic of the
Government Commission on Missing Persons allowed
me to work with them during many exhumations and
identifications; two men are guilty for my becoming
a photographer – Aidan Sullivan and Paul Lowe –
thanks a lot for your unselfishness; Grazia Neri
showed me the bright side of photography.

PHILIP JONES GRIFFITHS
My gratitude to those who helped me on this project
– Nguyen Ngoc Lan and Le Mai Hong in Ho Chi Minh
City, Nguyen Huu Chung in Hanoi and my friend
Do Hoang Nam. Those who provided valuable advice
and direction – Lisa Miller, Richard Vogel, Dick Hughes,
Bradford Edwards and Greg Booth – made my work
a pleasure. And, as always, meeting the people of
Vietnam was inspirational.

TIM HETHERINGTON
Liberia: Joe Glackin; the Silesian priests of
Don Bosco; Ged Naughton & Jo Kitterick at CAFOD;
Power From Heaven.

Kenya: George Mureu and members of the GTA; Patroba Ojwang; Sampson Lipoka; Mariella Furrer. Sierra Leone: Rabih and Josephine Torbay; Barbara Davidson; Joseph Campbell and Moses; The Sierra Leone athletics squad; Mr Woobay; Mr Mansaray. Angola: the staff of the International Committee of the Red Cross in Angola, especially Alain Kolly; Caspar Landolt; André Paquet; Geraldine Abrassart; Agathe Stricker; Pierre-Luc Chevaux; Neto Gaspar Junior; Felix Maza; Max Deneu; Dikuiza Kiomboloca; Michael von Bergen; Juan Martinez, Gareth Morris at Olympic Aid; Ronald Doorten at VVAF; António da Luz of Angolan Federation Sport for the Disabled; Gilles Delecourt of Handicap International; Celestino Tenda Daniel, director of the Orthopedic Centre, Luanda. Miscellaneous: Andy Aitchison; Adrian Evans; Stuart Freedman; Jon Levy; Grazia Neri; Judah Passow; Mykel Nicolaou; Samantha Thomas; Alice Wynne Wilson.

THOMAS KERN

My thanks to Milena for her advice, patience and understanding; to Cinthia and Hugh Stilley for looking after me so well during my stay in Michigan; and to Ed Kashi for his view of things.

BERTIEN VAN MANEN

Andreas Wald, Berlin; Dominique Gaessler, Paris; Valérie Massart, Paris; Lida Mc Grory, Maidstone, Kent; Rebecca Reinhart, Paris; Willem van Manen, Amsterdam; Marie Christine; Jeanette Tessier; Anne Espion le Mestre; Klaudi Sluban; Dominique Dolmieux; Alexis Cordesse. Hedan, Duka and Sabine, Mélic, Dalida, Leila Yousfi, Anete Karwatowska, Mme Siby of the Association des travailleurs du Mali en France; Armelle of the Association de femmes de Franc-Moisin, Hung, Guissou, Bruno Pounewatchy, Bianca Shanaa, Leila, Christina Lage, Christina Mavropoulos, Aziz Abdul, Ezidi Zarathustra Akdogan, Cecilia Ortiz, M. Fofana, M. Rabah, M. Coly, M. Maïga, Jamina Daf, M. Ouéfi and Mabrouka, M. Mzé, Amina Saïdi, M. and Colette Taninga, Aslan and Zarema, Paris.

SHEHZAD NOORANI

Bangladesh: Mahmud and Sujan, photographers from the Map Photo Agency, Dhaka, for their advice and help in arranging a boat trip in Bhramaputra River; Ms Masuma Pia of Matri, Dhaka. Hamid Bhuyan, Society for Social Services, Tangail (NGO working in Kandahpara Brothel, Tangail). Chinno Mukul (NGO). Nepal: Sangeeta Lama, journalist, Kathmandu; Maiti Nepal, NGO, Kathmandu. India: Ruchira Gupta, journalist and women's rights activist, Bombay; Sunjay, Kamatipura Brothel, Bombay. Sri Lanka: Ms Maureen Seneviratne and Kevin Balthazar, PEACE, Colombo; M. Nizar & Suzanne Wooster, UNICEF-Colombo; Professor Harendra De Silva, National Child Protection Authority, Colombo; Faraza Faroque, journalist, *Sunday Times*, Colombo.

CRISTINA NUÑEZ

Thanks to: Donata Sartorio; Etro; Moschino; Roberto Cavalli; Gianfranco Ferrè; Ariela Goggi of Italian *Vogue*; Peter Lindbergh; Asia Argento; Adrien Brody; Andrea Manzo of Overpaint; Giovanna Calvenzi; Susanne Eriksson; Barbara Donaubauer; Manuel Vignati; Alek Wek; Mor War.

ANDREAS SEIBERT

I would like especially to thank: all those who put their trust in me and who allowed me to photograph them; Jie Ming, without whose talent for spontaneous negotiation and communication I would scarcely have been able to do my work in China; Makoto Yasui for devoting so much time and thought to this project; Ryuichiro Suzuki and the late Greg Davis for their stimulating ideas on this subject, and for their critical comments on the pictures; Susanna Baer for her support – I could not have wished for better.

STEPHAN VANFLETEREN

I want to thank Bruno from Médecins Sans Frontières, Belgium; An and Geert from The Steenhouwer, Antwerp; the people of COK, Antwerp; Robert from Lookat; Marianne from the newspaper *De Morgen*; and all the other people who helped me with good advice and support in the work process of this story. A special and deep thanks for all the people who let me in their lives with or without my camera. And, of course, my wife and three children for their patience and understanding during the difficult research for this project.

DANIEL SCHWARTZ

I should like to express my gratitude to Walter Fust, Director of the Swiss Agency for Development and Cooperation (SDC) of the Swiss Ministry of Foreign Affairs for providing the opportunity to conceive and produce *Tales from a Globalizing World,* and for his great trust in me. Sophie Delessert and Harry Sivec, SDC Media and Communication, followed the project with enthusiasm. Toni Linder was supportive at an early stage. I extend my thanks to them as well as to all those who have taken care of the project's many administrative and legal matters.

Photographers normally put their confidence in magazine editors or curators of museums. In this case, however, ten photographers agreed to be commissioned and edited by one of their own kind. They had to question my vision and also understand each other's part in the search for their own statements. They have achieved a unique collective project, complex in the making, that draws its strength from their individual ways of expression and temperament. I hope I was able to create for them an ideal working environment, and I wish to thank them for the intense discussions, not only with me but also with my close collaborators, during the course of the project, for their hard work and the powerful photo-stories that they produced.

From the beginning, the project has greatly profited from the valuable suggestions and astuteness of Nicole Aeby who acted as photo editor and researcher and from the obstinate accuracy and lucidity of Carsten Stütz who was both the photographers' and my critical text editor; both also contributed to aspects of the project outside their own field. The photographic prints for book and exhibition were made by Ursula Heidelberger, Regula Müdespacher and Sabine Wagner of Laboratorium, Zurich, as well as by Tanya Braganti, New York, for Philip Jones Griffiths and by Michael Windig, Fotovaklaboratorium de Verbeelding, Amsterdam, for Bertien van Manen.

Architect Yves Habegger designed the exhibition, and his display of the photographs is in itself an interpretation of the project's wider theme of globalization. Christian Guggenbühl, www.formatguggenbuehl.ch, Zurich, ensured meticulous mounting and framing of the photographs. Stefanie Keller, www.keller-construction.com, Zurich, was in charge of communication design. André Müller of Vues, Zurich, designed the project website. Journalist Anne-Muriel Brouet was responsible for promoting the project in Geneva. I would like to extend my thanks to all of them. Finally, I would like to make a special mention of Van Tran who sometimes wondered about the progress of my own photography as the myriad details of the project demanded my attention. A striking phenomenon of today's globalization, and starting point of the project, is the growing global divide in development that exists between the First and the Fourth World. With major implications in the age of information revolution, this issue provides the background of the World Summit on the Information Society (WSIS), held in Geneva 2003 and in Tunis 2005. While the exhibition 'Tales from a Globalizing World' was not conceived to illustrate the summit's agenda, it was first shown in the Maison communale de Plainpalais in Geneva, Switzerland (13 November– 12 December 2003), coinciding with the first phase of the WSIS, in which the Swiss Agency for Development and Cooperation (SDC) of the Swiss Ministry of Foreign Affairs played an important role. Part of the proceeds of this book will go to Drik Picture Agency in Dhaka, Bangladesh, www.drik.net which through its training programmes and other media activities is successfully promoting the region's young photojournalists.